Anthony Caro: Drawing in Space

ANTHONY CARO

Drawing in Space

Mary Reid

Lund Humphries

First published in 2009 by
Lund Humphries
Wey Court East
Union Road
Farnham
Surrey GU9 7PT
UK

and

Lund Humphries
Suite 420
101 Cherry Street
Burlington
VT 05401-4405
USA

www.lundhumphries.com

Lund Humphries is part of Ashgate Publishing

British Library Cataloguing-in-Publication Data

Reid, Mary.
 Anthony Caro : drawing in space.
 1. Caro, Anthony, 1924- --Criticism and interpretation.
 I. Title
 730.9'2-dc22

ISBN 978-1-84822-030-0

Library of Congress Control Number: 2009921431

Edited by Susie Foster
Designed by Andrew Shoolbred and Greg Taylor
Set in Griffith Gothic Light
Printed in China

Front cover (detail):
Emma Dipper, 1977 (plate 43)
Steel, rusted and painted grey
213.5 x 170 x 320 cm (84 x 67 x 126 in)
Tate Gallery, London
(B1173)

Contents

Acknowledgements

A project of this magnitude reflects the dedication and expertise of many creative and talented individuals. It was a great pleasure to be part of this team, which was comprised of so many exceptional people. I would like to extend my gratitude to Lucy Myers at Lund Humphries for shepherding me through the entire process with a good deal of understanding and patience. My appreciation also goes to Cilla Kennedy from Lund Humphries and Elizabeth (Wiz) Patterson-Kelly from Barford Sculptures, who scrupulously tracked down all the necessary images and accompanying credit information. Susie Foster, editor extraordinaire, is to be commended for her high attention to detail and superior ability to untwist some of my knotted sentences. I wish to acknowledge Denis Longchamps and Frances Thomas for their helpful and insightful feedback on the initial drafts of my essay and designer Andrew Shoolbred, who has created a beautiful, open and clean design, which does the sculptures featured a great justice.

I have been extremely fortunate to have had an incredible mentor and role model throughout my career – Karen Wilkin. I give my sincerest and most heartfelt thank you to Karen for her ongoing support, and for her shrewd critical advice and editorial suggestions that ensured my contribution was accurate and of some benefit. The opportunity to respond to the work of a modern master was a true honour. I would like to thank Anthony Caro for creating such an impressive and awe-inspiring body of outstanding sculpture.

Mary Reid

Preface: The Sculptures of Anthony Caro

Since the mid-1950s, when Anthony Caro first announced himself as a young sculptor to be reckoned with, he has restlessly explored an unpredictable range of sculptural possibilities, testing limits and positing new ideas about the nature of eloquent three-dimensional objects. The results of these explorations have, over the years, set new standards and established new definitions of what sculpture can be, even radically changing our conceptions of the very nature of sculpture. Through his expansion and transformation of the legacy of construction in metal pioneered by Julio González and Pablo Picasso, and further developed by David Smith in the USA, Caro has created a new, multivalent language of three-dimensional abstraction.

A work by Caro can be as exuberant and linear as a Barcelona balcony or as severe and planar as a medieval sarcophagus. He has conjured up intense feeling by making one piece of steel touch another and told turbulent histories by forcing clay, wood, and metal to coexist. Caro remains eager to try materials new to him, curious about the formal, structural and expressive inventions they will stimulate, continuously challenging his own discoveries, exploring their implications but refusing to settle for known solutions. The rich, varied, and surprising body of work this protean sculptor has produced over his long working life bears witness to both the breadth of his definitions of what sculpture can be, at any given time, and his continual questioning of those definitions.

The Caro pendulum has swung between extremes of linearity and robustness, abstractness and allusion. He has countered his mastery of line and transparency with investigations of our responses to mass and perceptions of interior and exterior, even experimenting with literally enterable sculptures. He has made rigorously abstract constructions that resemble nothing but themselves, intimate table-based pieces, monumental constructions like metaphorical architecture, and complex multi-part cycles of narrative works that pulse in and out of explicit illusionism. And more. The range and variety of Caro's sculpture notwithstanding, there are also common threads that run through all of his work, from the beginning of his career to the present. The volumes in this series, each by a different critic, examine the various aspects of Caro's evolution individually, tracing the permutations of different themes – narrative, volume and mass, line and openness – throughout his work, over time. Each volume is independent and explores different territory, but cumulatively, by tracing these dominant themes, the series provides new insight into the achievement of one of the undisputed giants of modernist art.

Karen Wilkin

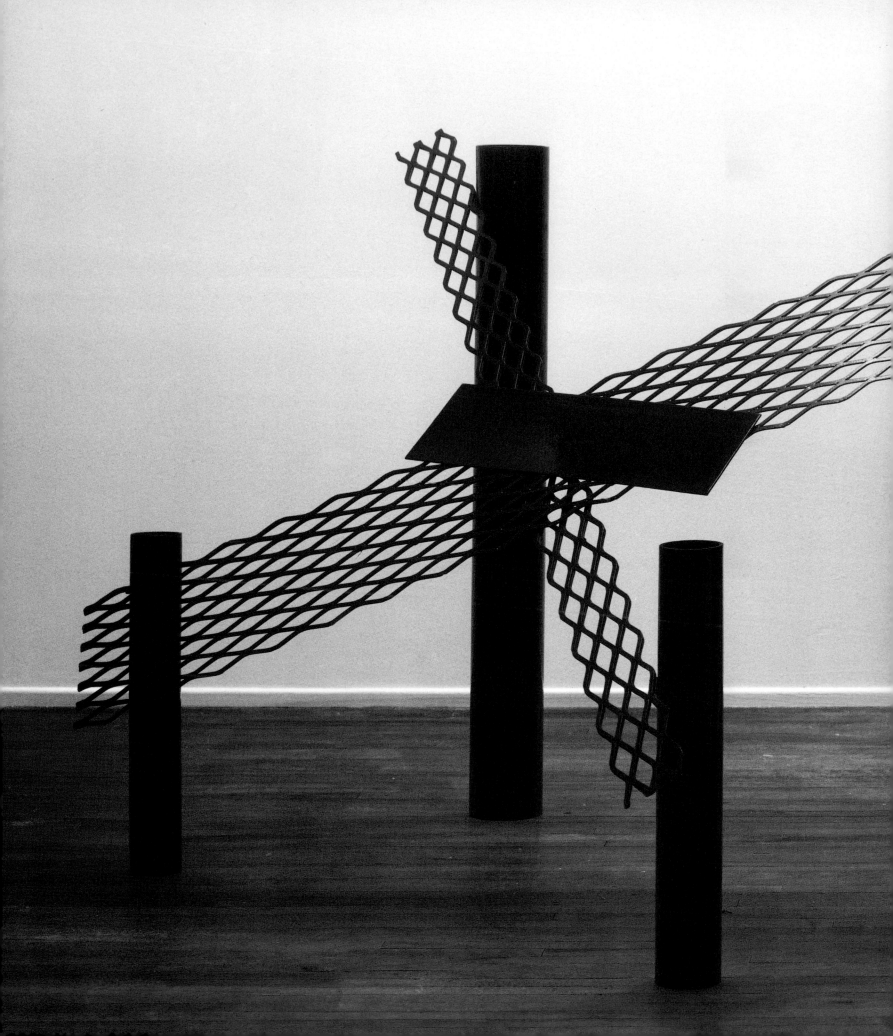

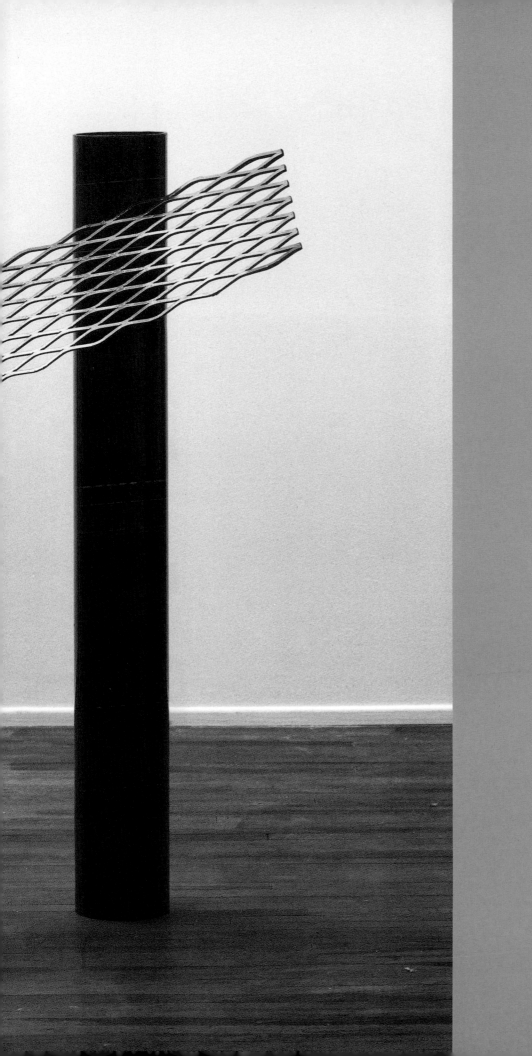

Drawing in Space

Line and Body

In his work sculptor Anthony Caro explores and exploits an inherent incongruous tension between line, balance, movement, gravity and space through a practice that has been termed 'drawing in space'. By taking line into the third dimension, Caro creates a paradox between real three-dimensional materiality and the illusion of weightlessness. He furthers this contradiction by incorporating the ground plane as an integral element of any composition, elevating its function from one of mere convenient support. His ability to draw in space with thin steel rods, I-beams, tubes, girders, mesh panels and an assortment of miscellaneous found metal scraps has created a body of exceptional sculptures that traverses his entire six-decade career.

In a state of constant experimentation and development, Caro is unlike many other artists who dedicate themselves to a few related lines of inquiry. His working methods have taken an extraordinary number of directions: he has followed some concepts to conclusion; dropped some initial thoughts for new ideas that have sparked his imagination; and picked up threads of research that to the outside observer may have seemed long forgotten or solved. Because of this Caro has never been pigeon-holed within one genre; his work cannot be defined by just one style, aesthetic, or mode, yet one can trace a continuum, an engagement with drawing in space throughout his prolific practice.

Caro first gained critical attention as a figurative sculptor working in clay, plaster and bronze. Although this work was well received, he was not satisfied and took a radical departure from modelled forms. His experiment to work with common building materials such as steel beams and aluminium tubes provided him the opportunity to create a series of open, linear, drawing-like sculptures and it was this body of work, so new and fresh in its appearance, that propelled him onto the international art scene, securing his reputation as an artist of great talent. Although Caro has moved through differing and at times parallel streams of investigations, over the course of his long career, his interest in line, in drawing in space, has been a recurring topic of discovery played through a variety of formats. Yet with all his works, no matter how different their formal qualities may be, Caro's attitude towards the relationship of the sculpture to the body and the expressive character of line remains constant.

When creating, Caro always considers the way a sculpture is perceived, the real experience of looking in the round and, more significantly, the visceral, intangible relationship between the human body and the presence of the work itself. Caro has made it clear that his work does not have direct reference points to any actual thing except the sculpture, itself. He has said that:

> The language we use in sculpture is the language of sculpture: that
> has to do with materials, shapes, intervals and so on Certain
> things about the physical world and certain things about what it is

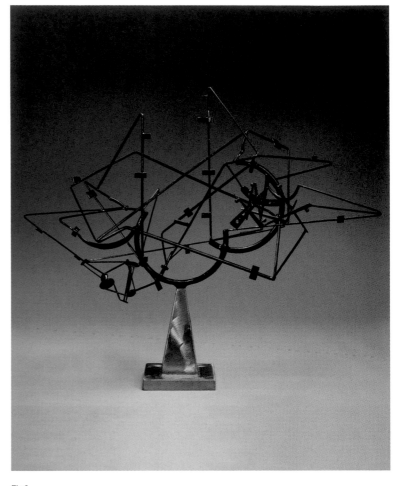

Fig.1
David Smith, *Star Cage*, 1950
Various metals, welded and painted dark blue
114 x 130.2 x 65.4 cm (44¾ x 51¼ x 25¾ in)
The Frederick R. Weisman Art Museum at the
University of Minnesota, Minneapolis
The John Rood Sculpture Collection

PREVIOUS PAGE
Red Splash, 1966 (plate 25)

like to be in a body are tied together. Verticality, horizontality, gravity, all of these pertain both to the outside world and to the fact that we have bodies, as evidently does the size of sculpture.[1]

It is, in fact, from the relationship of our bodies to Caro's sculpture that we create our personal interpretations.

For Caro 'the value of an artwork lies in its depth of introspective and emotional content expressed through and enmeshed with the fullest understanding of the medium.' Yet he also understands that 'to the spectator a sculpture is essentially a surrogate for another person',[2] although he says that he doesn't 'want [his] sculpture to relate to the spectator in this imaginary sort of way. It has to do with presence, more as one person relates to another.'[3] Consciously and unconsciously, we constantly develop relationships with other people. This same process of finding connections, directly or innately, is the means by which we should engage with Caro's creations. Just as he attempts to find the 'meaning of me'[4] in his work, we too, search for an understanding of ourselves, in addition to the many other interpretations embedded in his sculpture.

Over Caro's long career, this fundamental idea about meaning residing in sculpture's ability to be a metaphor for real physical, human experience has taken many forms and utilised many different materials; however the ability to express through line has remained a continual interest. The infinite quality and character of line – line that can be made by both machines and human hands – provides the artist with a multitude of possibilities. The magic in Caro's sculpture is inherent in the way the linear elements come to life, expressing emotion, fragility, vulnerability, strength, or happiness, yet never saying a word.

Caro has a remarkable ability to create work that is full of feeling out of machine-made 'dead' materials. His sculptures speak to us without using verbal language; instead we are dependent on our other senses and human perception, particularly our sense of sight, along with touch, our sense of the weight of gravity, our ability to gauge movement and speed, our concept of time, and most importantly the power of our imagination. We become highly receptive to the dialogue that is taking place between us and the work of art. This remarkable experience of communicating with an inanimate entity and finding our inner truths is all a consequence of how linear elements are transformed through Caro's creative process of drawing in space.

He is by no means the first sculptor to be interested in creating open, abstract, linear work. Caro assimilated the idea of constructed sculpture from his predecessors Pablo Picasso, Julio González and David Smith (fig.1), taking it to a place of his own – a place where line, mind, eye and body do not align as one but instead trace parallel paths to transforming space. Caro's engagement with drawing in space, highlighting various machinations and manipulations, alternating between delicacy and boldness, has been a constant impulse throughout his impressive and extensive oeuvre.

The Beginnings/Early Drawing

This long process of discovery and play with line was not immediately evident at the start of Caro's career, but there are particular instances that mark his first sparks of interest. From 1947 to 1952, he attended London's Royal Academy Schools where he was schooled in an academic tradition. This training provided him with a solid understanding of sculpting the human figure, yet was devoid of reference to what had been happening in the art world during the preceding 50 years. The advent of Modernism, which heralded in Cubism and Surrealism, celebrated primitive art, and strove to tap into the unconscious mind as a source of true and pure creativity, was considered an assault to the core values, lessons and aesthetic style taught at the Royal Academy Schools. Hence much of this subject matter was largely ignored by the teaching staff and students as a consequence were never truly aware of the significant changes that the very concept of art itself underwent in the first half of the twentieth century.

Despite this attempt to shield him from the 'corrupt' impulses of contemporary art, Caro was dissatisfied with the Academy's environment. He wanted to know more and began looking for it in other places. In 1951, he convinced the pre-eminent English sculptor Henry Moore to give him a job as a studio assistant. Moore became an important mentor who greatly broadened Caro's understanding of art by exposing the young artist to Surrealism, Cubism, and the whole modern movement. Moore's modest collection of African and pre-Columbian art and artefacts, which decorated his home and studio, further enlarged Caro's experience. In addition, Moore allowed Caro to borrow books from his personal library and the senior sculptor and his young assistant would have impassioned conversations about art. Moore shared his own working process, as well. Several times, Caro gave his life drawings from school to his mentor to critique; Moore marked the corners of the broadsheets with notations as to how the figure should be approached in three dimensions. Caro supplemented these experiences with his own research and by visiting museums and galleries, which eventually led to him being introduced to the works of the American Abstract Expressionists. All of this new visual information had a tremendous impact on the young sculptor and his view of art-making began to shift dramatically.

This new perspective is apparent in Caro's work from this formative period. His interest in paring down line to its minimum, yet retaining a complex and expressive mode, is evident in the numerous drawings and monotypes he created between 1953 and 1956 in the series *Bulls* and *Figures*. The monotypes (fig.2, plate 1) were created by a method known as 'drawing blind'. This technique entails placing a piece of paper face down onto a prepared zinc plate. Impressions are made on the back of the paper using a tool of some sort, whilst not being able to see what the image being created really looks like. Once completed, the paper is pulled off the plate and the image drawn on the back will have been imprinted in the reverse onto the front of

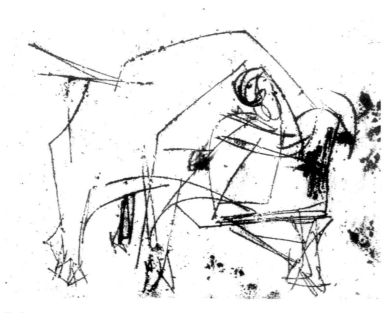

Fig.2
Bull, 1953–4
Monotype on vellum
19.7 x 25.4 cm (7¾ x 10 in)
(D154)

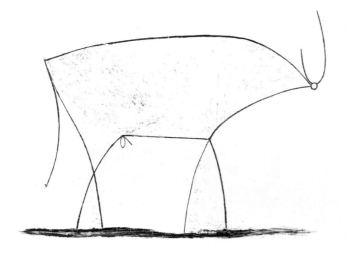

Fig.3
Pablo Picasso, *The Bull (Le Taureau)*, state XI, 17 January 1946
Lithograph
Composition: 29.2 x 41 cm (11½ x 16¼ in)
Sheet: 33.2 x 44.4 cm (13 x 17½ in)
The Museum of Modern Art, New York
Acquired through the Lillie P. Bliss Bequest

the paper.[5] The artist does not know what the end result will look like until the paper is removed from the plate, hence the notion of 'drawing blind'. This technique is, in many ways, similar to how Caro would approach making abstract sculpture approximately a decade later. He seems able to be cognizant of all potential perspectives of the work he is making, even those he cannot readily see, and to take them all into account, intuitively and literally. Caro's grasp of line in space and on paper is as quick as it is assured.

Caro's early monotypes are characterised by their graffito-like appearance. Certainly, these linear compositions of warriors and animals hark back to ancient petroglyph symbols of primitive cultures. This subject matter was of great interest to Picasso, whose aesthetic influence at this time Caro freely acknowledges: 'all *Bulls* [and] *Figures*, both sculptures and drawings, are influenced by Picasso of that period. It was the subject matter that I was drawn to.'[6] In 1945, Picasso produced a series of 11 lithographs that began with a fairly three-dimensional depiction of a bull and moved it along stage by stage until it became a very linear, stylistic outline (fig.3). Undoubtedly Caro was familiar and quite inspired by this series, given the quality of line and the paring down of imagery to the absolute minimum. However images of bulls have very different associations for the Spanish Picasso than for the English Caro. For Picasso the bull symbolised ferocious sexual aggression, whereas Caro's bulls are more a product of the time, a response to a persuasive tension, anger and fear that marked this period of discovery.

It is how Caro interprets Picasso's imagery and takes it in his own direction that is of interest. Caro's images from 1954 to 1955 (plates 2, 3, 4), made with brush and ink on newsprint, dominate the entire surface of the paper; filling the space, as if imprisoned, they push out almost beyond the boundaries of the edge. The line is heavy and powerful yet it is still as expressive as the sparse markings of the contemporaneous monotypes of the same subject. We can read these early efforts as intimating how Caro will translate this skill of drawing on a two-dimensional surface into the three-dimensional realm. His abstract sculptures decades later fill the space, envelop it, define it and challenge traditional understanding.

It is important to highlight these examples of Caro's early engagement with linear compositions for several reasons. The expressionist sculptures for which Caro first became known in the 1950s were massive in their overall form and construction. They were substantial, modelled and built up, and had little to do with drawing in space and evoking notions of weightlessness. In fact, they were concerned with quite opposite notions: with the effects of gravity, and abstracting the human form to obtain the truest depiction of emotion. Because of this, it is often assumed that the linear, drawing-like language of Caro's first abstract constructions from the early 1960s was a direct result of his working in steel, since metal has tensile strength that allows it be extended into space.[7] Contrary to these misconceptions, Caro was already exploring ideas of line in space for an extended period before 1960. His interest in line does not come about by pure chance nor is it a fleeting

preoccupation or a function of his materials. Instead, as he develops his sculptural language, it becomes a constant source of inspiration and delight.

Grounding in Abstraction

By 1959, Caro was becoming increasingly dissatisfied with the direction of his practice; he had begun to think that the figure got in his way and limited what he wanted to express and achieve.[8] A studio visit from the pre-eminent American art critic Clement Greenberg further challenged Caro to rethink his position on figurative sculpture. Later that year, Caro was awarded a grant to travel to the USA, where he visited several museums and art schools and met with many artists and critics, on both the east and west coast. He became interested in the work of the abstract painter Kenneth Noland and continued his conversations with Greenberg. Upon returning to England in 1960 Caro interpreted Greenberg's potent advice 'if you want to change your art, change your habits'[9] to mean that to push his sculpture further, he needed to abandon his current practice of modelling with plaster and clay. In response to this desire to proceed in a new direction, Caro turned to working with metal, a method unfamiliar to him yet provided a whole new visual vocabulary, and thus began his first forays into abstraction.

One of Caro's early experiments in abstraction is *Midday* (1960; plate 5), which is made from steel girders and I-beams bolted together, with every nut showing. There are a number of significant elements to this work: the abstract nature of the composition, the use of architectural building materials and, most importantly, the lack of a base. There is no front or back; *Midday* is composed in the round and is to be viewed as such. From every place we stand a new perspective is offered, a unique viewpoint as valid and full of information as the last.

By employing common steel girders as well as their fastening mechanisms, Caro elevates the status of banal construction building materials to that which has the potential to become *Art*. Yet for the artist, the use of this type of raw material was not intended to reference literally or metaphorically the vocabulary of modern construction. However, by co-opting these types of materials for his own ends, Caro further legitimises the qualities and aesthetics of modern architectural design and its power to evoke a response – a response which embraces the machine of modernity and all the optimism that this implies.

In early works such as *Midday*, Caro successively freed his work both physically and philosophically from the traditional base, whose role was to elevate and separate the viewer from the sculpture. This is well demonstrated in monuments of royal figures, which were placed in town squares to remind citizens of the presence of the king in his absence. When viewing a statue of this type, one would normally have to look up and be visually dominated by the figure depicted (often on horseback). It should be noted that Caro was not the first sculptor to place work directly on the ground, but he was the first to eliminate the base altogether from his sculpture. In the early 1950s David Smith had already been creating works that were intended to be placed directly on the ground. However, contrary to Caro's work, Smith incorporated a base-like structure into the totality of a whole piece. As Greenberg noted:

> From his very beginnings as a sculptor (he started out as a painter) [Smith] has struggled with the problem of base or pedestal (or 'frame'). Caro, who was 20 years younger, had eliminated the problem immediately and entirely when he went over into steel sculpture in 1960 Smith became acquainted with Caro, and with his work, when the English artist came to this country in 1963 for a teaching stint at Bennington College. He made no bones about his admiration for the younger man's art, for the point of it, and turned it into his own independent advantage.[10]

In contrast to Smith, by removing this 'added value' of the base, and eliminating any vestiges of its presence, Caro brought his work down to human level, to operate in our world, to live in the same environment and occupy the same plane as the spectator. His work was not about an oppressive commanding presence or about reverence; it was now about operating on an equal footing, democratic, and thus exploring the relationships of the real world.

In a letter of 1965 to his friend and dealer for several years, Ian Barker, Caro further explained the significance of removing the base for his work:

> ... we live in a world full of objects, tables, chairs, crockery, motorcars, etc. What makes sculpture more special, isolates it in fact, from all of this? Often it is the delimiting of its world from ours We put it on Its base and stick it on the mantelpiece, [it is as if] the base says, 'My world ends here – now yours, the spectator's, starts'... . Now if you bring the sculpture off its base it begins to have only those merits that are intrinsic in its nature – either it is lifeless junk or it carries an intention, it has poetry about it or it's nothing.[11]

Caro does not envision his work placed on a nondescript, secondary element that separates it from the ground. Every part of his abstract sculptures is subject to the same forces and exists on the same plane that we, too, stand upon.

Composed largely of substantial planes that intersect space, *Midday* is just too heavy to be considered as an example of drawing in space. Instead, it stands as evidence of Caro's engagement with line in the third dimension and as a continuation of the bold lines and forceful rectangular compositions indicative of his *Bull* drawings. A precursor to his open, drawing-like works such as *Early One Morning* (1962; fig.4), *Midday* through its use of industrial materials, elimination of the base, and exploration of balance and weight

sets the stage for Caro to fully embrace his impulse to draw in space resulting in an extraordinary series of works that illicit associations of weightlessness and movement.

Defying Gravity

The first true manifestations of Caro's linear sculpture can be seen in three key pieces: *Early One Morning*, *Hop Scotch* (1962; plate 8) and *Month of May* (1963; plate 9). Much has been written about these three works. *Early One Morning* and *Month of May* were included in the large solo exhibition in 1963 at Whitechapel Art Gallery in London, which was enthusiastically received by the national media. *Month of May* and *Hop Scotch* were included a year later in the quinquennial international contemporary art exhibition *Documenta III* (27 June to 5 October 1964), in Kassel, Germany. All three works were created with prefabricated industrial materials including girders, plates, bars and rods.

The extraordinary receptiveness to Caro's new work may have been due to its radical departure from traditional sculpture, which was normally modelled from clay, cast in bronze or carved in stone, and placed on a base. Moore had taken up the new direction towards figurative statues that was championed first by Auguste Rodin and then expanded upon by Jean Arp and Constantin Brancusi, but like his predecessors Moore was still very much a modeller and carver; his view on sculpture was as a mass, which he saw as being like a clenched fist, with the knuckles pushed out from the inside. Moore's work occupied space, it did not question it. Caro chose not to pick up the baton from Moore. The direction he took was completely different. Caro was constructing sculpture, using linear elements as a means to draw, to denote and define space exploiting both the fragile and powerful characteristics this act embodied. Moore had introduced him to the work of Picasso and González, Caro's artistic fathers, and he had seen the work of David Smith in exhibitions; now he was taking ideas about collage and drawing in his own direction, and the art world at large took notice in a significant way.

Playing with very human concepts of expectation, visual perspective and visceral response, Caro challenged his academic training – and the new possibilities for his sculpture were not what was to be expected from a classically educated artist. What we normally expect from a sculpture is not what we get with a work by Caro. Instead his abstract works play with our eyes, our sense of distance, our ability to understand movement and speed, if ever so subtly. We find that we become personally involved in looking and relating to his abstract sculptures, and respond in way that is guided by our own innate instincts.

Probably the most celebrated work among Caro's early experimentations, *Early One Morning*, includes some of the largest steel girders employed in his first exploration of this new material for making sculpture. He opens the sculpture into space by incorporating long, slim tubes and flat sheets of aluminium.

As with *Midday*, Caro heightens the importance of his 'new' raw materials and transforms them; no longer just building materials, these common construction items now can be considered *Art*, yet at the same time their plebeian origins are not hidden. Caro retains the manufacturer's stamp on the steel beam, while the bolts and rivets used to attach the larger aluminium panels provide the viewer with a neat diagram of support. In fact, the dotted lines created by the bolts on the large vertical plane to the 'rear' of the sculpture mimic, in reverse, the shape of the two rods pointing to the sky. The overall scale of the work is impressive. *Early One Morning* was the largest piece Caro had made to date and, with this new type of sculpture, size was important.[12] At over 6 metres (20¼ feet) in length, *Early One Morning* is large enough to fill a room and also able to make a bold statement in an open, natural arena. The piece has a strong horizontal and vertical presence, along with the large flat planes which double as a screen or as tabletops. A true sense of magic is embodied in the three slim pipes that curve up. Looking at the single pipe that so delicately balances itself on the edge of the horizontal crossbar, one fears that the slightest breeze could send it toppling. The robust material from which *Early One Morning* is constructed from is in direct opposition to the fragile tension of this balancing act.

Its overall composition, through the relationships of its parts to the whole, evokes the sense of weightlessness and airiness. Greenberg certainly noted that 'weightlessness' was another one of the essential characteristics in this new tradition of sculpture.[13] In 'Anthony Caro', the only essay dedicated solely to Caro's work, first published in 1965, Greenberg writes:

> Michael Fried speaks aptly of Caro's 'achieved weightlessness'. It is a kind of weightlessness that belongs, distinctively, to the new tradition of non-monolithic sculpture which has sprung from the Cubist collage. Part of Caro's originality of style consists of denying weight by lowering as well as raising the things that signify it … . By opening and extending a ground-hugging sculpture laterally, and inflecting it vertically in a way that accents the lateral movement, the plane of the ground is made to seem to move, too; it ceases being the base or foil against which everything else moves, and takes its own part in the challenge to the force of gravity.[14]

Caro further enforced this characteristic of defying gravity by blanketing *Early One Morning* in a particularly powerful yet uniform colour. The red equalises the parts, neutralising the material it is made from, and given its high key tone, one could even speculate that the entire piece has been made from moulded plastic – a truly modern and light medium. However Caro notes '... I found certain materials, like plaster and plastics, difficult and unpleasant to cope with simply because they do not have enough physical reality. It is not clear enough where the skin of them – not the skin, the surface of them – resides.'[15] By painting his sculpture the artist causes his raw material to shift

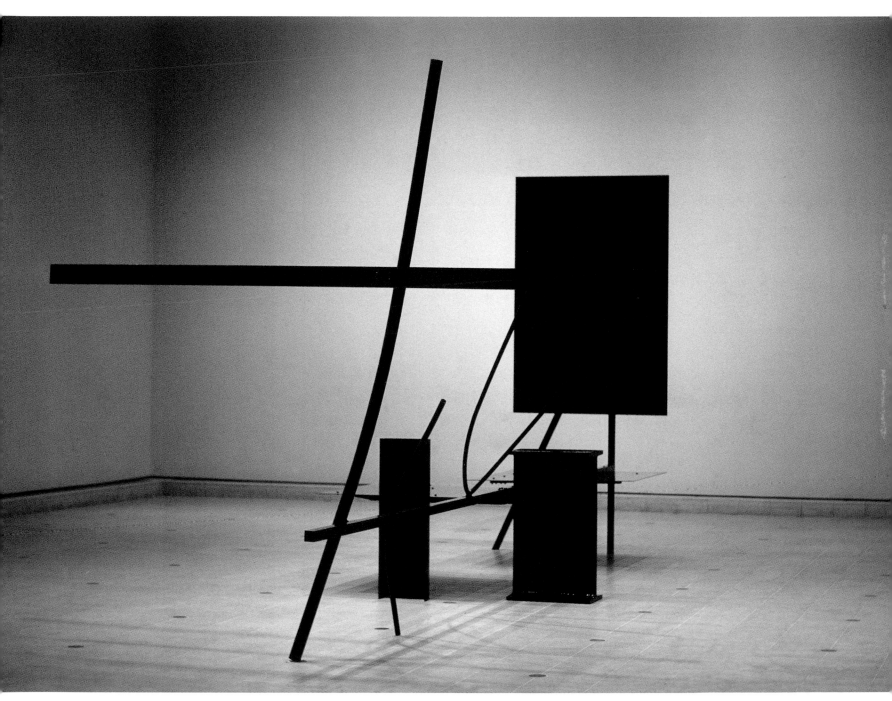

Fig.4
Early One Morning, 1962
Steel and aluminium, painted red
290 x 620 x 333 cm (114¼ x 244 x 131 in)
Tate Gallery, London
(B830)

– as one moves around the work, the skin/surface is transforming in real time. We take in this change, perhaps even instigate it. The change that takes place in front of us, also takes place within us; we move as the sculpture moves.

Early One Morning is indicative of how the artist is able to draw 'blind'. Working all night, Caro built the sculpture in his home garage studio and filled the entire space. Although he could not get any distance from the piece the sculptor seemed to understand intuitively the various angles and viewpoints that the work would possess. It was not until the next morning, when he was able to haul the work out of the studio into the open air, that he could stand back and get a full sense of the piece. *Early One Morning* was first painted green, which did not satisfy the artist who then switched the colour to its present red.

Made in the same year as *Early One Morning*, although very different, is *Hop Scotch*. Taking on a more horizontal orientation, the entire work is unpainted yet it is unified with the natural silver shine of the aluminium from which it is made. Again Caro takes a playful approach to his composition that marries the title to the piece. The children's game, hopscotch, was initially a training regime conceived during the Roman Empire to improve the footwork of soldiers by having them quickly navigate an obstacle course in full armour. Although it is unlikely Caro had this association in mind when he was making the sculpture, it is a compelling interpretation given the gleaming metal and the work's title.

Like *Early One Morning*, *Hop Scotch* was made in his one-car garage home studio. Caro explains his process of making the work:

> I had these tubes, they just fitted exactly across my ten-foot studio from one side to the other. I stuck *Hop Scotch* across like a ladder, like a mad ladder, across my studio ... it was stuck to the walls on both sides ... then, all the pieces that go across, holding the thing together, held with pieces of string at the beginning. Bolting them into position was a hard job, but getting the thing working in the way I wanted it was fine. Then, when that was made, and the thing could stand up even though it was fragile, then I was able to put it through 90 degrees and finish it.[16]

As this reference to a 'ladder' leads us to expect, the several long horizontal pipes dominate the composition whereas the shorter bars hint at suspended gymnasts or foot soldiers played off of the three substantial corrugated rectangular panels. The criss-crossing of lines gives the piece a rhythmic quality evoking musical associations of the sound qualities of an experimental instrumental composition or even as a visual, three-dimensional manifestation of a sheet of new music. Bright, shiny and dynamic, *Hop Scotch* animates the area it inhabits yet does not invite the viewer into its space. It can be read as a children's jungle gym that has taken on a life of its own, perhaps possessed, dismantled or in a state of becoming. *Hop Scotch* announces its potential to become something else, to shift, or to transform. It invites the viewer to do the same.

Painted in secondary colours – orange and magenta – with one primary accent – green – *Month of May* evokes the spring growth alluded to in its title. According to New York's Museum of Modern Art curator William Rubin:

> Caro polychromed *Month of May* in an attempt to clarify what he realised were its visually complicated configurations. He intended the three colours to emphasise the structural characteristics of its various components – magenta for its straight-edged members (the I-beams on the ground and the cantilevered diagonals); orange for the randomly bent and angled pipes, and green for the longest, cursively extended pipe.[17]

The delicate orange pipes reach up, bent at wide angles; these woven arms chase the sun, attaching themselves to the parallel magenta bars like vines to a trellis. The two short, substantial I-beams ground the entire work, acting like the big boots one might wear to walk in the muddy earth. The most fantastic element in the work is the graceful, curling, green pipe, which transverses the entire length and height of the sculpture.

For me, *Month of May* seems connected to nature, and growth. The entire piece appears to float, dancing tentatively on spindly legs, like a fawn or calf walking for the first time. Full of lightness and air, *Month of May* is a cheerful work, which makes clear Caro's enthusiasm for his new investigation of abstraction. With his sculptures liberated from the base, they hold the potential to move freely and at times even seem to leap into the air. None does so more than *Month of May*. Caro states 'all sculptors have dreams of defying gravity. One of the inherent qualities about sculpture is its heaviness, its substance. There is an attraction in the dream of putting heavy pieces calmly up in the air and getting them to stay there. I have tried to do this ... in *Month of May*.'[18]

Like *Early One Morning* and *Hop Scotch*, *Month of May* was also created by wedging tubes and bars across the span of Caro's small garage studio, collaging elements, adding and subtracting and then connecting them with the minimum elements needed to hold it all together. The tightness of his garage studio actually played a very important part in providing the tension necessary to create these early works. Akin to the method of drawing blind that he employed for his monotypes a decade earlier, Caro was drawing in a closed space, working intuitively, not really having a complete sense of what the piece looked like outside of the confines of the walls that held it together until it was pulled out into the light of day.

Due to the use of colour, the placement of the various elements, the bends and curves of the tubes and the optical illusions created, where the heavy horizontals seem to float, we conveniently overlook that the smaller elements in *Month of May* are holding the larger pieces together. When looking at the

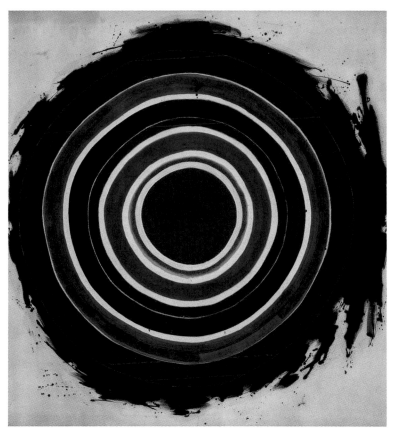

Fig.5
Kenneth Noland, *Beginning*, 1958
Manga on canvas
228.5 x 243.5 cm (90 x 96 in)
Hirshhorn Museum and Sculpture Garden

Fig.6
Twenty Four Hours, 1960
Steel, painted dark brown and black
138.5 x 223.5 x 89 cm (54½ x 88 x 35 in)
Tate Gallery, London
(B819)

work, we not only take in the whole, we take in the parts; we are not looking at a solid mass but instead we construct connections that are both present and at times only suggested. *Month of May* is a sculpture of parts, of detached lines, that draws out a form, yet with one quick move of the viewer, the form shifts, as the lines change position, reflecting how malleable and illusive drawing in space can be. As the sculpture changes, so do we in our perceptions and understanding. *Month of May* successfully manifests Caro's desire to strip his work back to the barest essentials while at the same time maintaining all of the integrity and potent expression possible in placing a line in space.

Economy of Line

In 1963, Caro was invited to Bennington College, Vermont, where he became a visiting faculty member until 1965. While in Bennington he renewed his contact with teaching colleague Jules Olitski and his fellow painter Kenneth Noland who lived nearby in South Shaftsbury. Like Caro – their close

contemporary – they were young, ambitious artists who had found their distinctive voices. Both Noland and Olitski shared an interest in rejecting Abstract Expressionism's gestural, wet-into-wet painting and instead created colour-based abstractions with big expanses of fairly unmodulated, thin colour, an approach that would be later termed 'Colour-Field' painting. In addition, the sculptor David Smith, a generation older, who was associated with the Abstract Expressionists, visited often from his studio at Bolton Landing, New York, about 150 kilometres away.

During his first visit to the USA in 1959, Caro had been quite taken with Noland's 'Circle' paintings (fig.5). It has been argued on numerous occasions that Caro's first abstract sculpture *Twenty Four Hours* (1960; fig.6) was a direct response to these bold, forthright works.[19] Caro and Noland were exact coevals and formed a lasting friendship, based in their mutual, respectful, questioning of each other's work, as well their shared interest in the inter-section between painting and sculpture and how one practice informs the other. Noland had previously studied sculpture with the Russian artist Ossip Zadkine before he decided to concentrate on painting. At this time, Caro,

Noland and Olitski were constantly in each other's studios, looking at each other's work and engaging in passionate discussions about art. Both Noland and Olitski provided Caro with important feedback and suggestions that propelled him towards a more refined, elegant exploration of line.

In particular, Noland had earlier encouraged Caro to stop moving back to assess his work, as a painter would with his or her canvas, and to resist the urge to correct what was created instinctively. As a result, Caro consciously determined to work with his new materials close up. Caro's receptiveness to advice given by Olitski and Noland was in part due to his enthusiasm for the work these two painters were making at the time. Caro has often said that he found more stimulus for his own work in painting than in sculpture. 'Painting in the 1960s,' he said, 'has gone further along the road to abstractness of feeling ... it was better to go to painting than to old sculpture because painting gave one ideas what to do but no direct instructions on how to do it.'[20] Caro was constantly looking for ideas and means by which to depict unexpected forms as 'real' as anything else we encounter in the world. He found that painting provided some clues and certainly more information than traditional sculpture had up to that point. Caro has continued to find stimulus in paintings, both contemporary and historical, frequently consulting the work of Henri Matisse, Édouard Manet and even Peter Paul Rubens and Duccio di Buoninsegna for advice on how to solve certain problems or using their work as a point of departure for his own sculptures. In terms of his contemporaries, Caro seems to have found particular resonance in Noland's 'Circle' and 'Stripe' paintings; Olitski's effusive soft grounds also intrigued the sculptor. Noland's paintings, in particular, seem to have stimulated Caro to make his most pared-down, 'ground-flung' works to date.[21]

Noland also encouraged the concept that provocative ideas were not exhausted in a single work of art. Caro recalls 'Ken kept saying to me ... "Make a series, because you get through more and you can develop ideas and you don't need to put it all into one thing."'[22] This directive was taken from David Smith, who had discussed his process of working in series with Noland, who consequently passed it forward.[23] Caro took this advice to heart.

The works created at Bennington in the autumn of 1964 can be separated into two distinct series: one that incorporates the I-beams which Caro had used in his London studio and another that exploits a zigzag shape derived from the 'Z'-shaped steel he found in the USA.[24] All eight pieces he produced at that time are substantial in size and weight and, with the exception of *Prospect* (1964; plate 10), explore the horizontal nature of the ground plane, spreading out at the viewer's feet. Closely related to Noland's 'Stripe' paintings, these sculptures could be characterised by their stripped-down appearance, where Caro was considering how economical a sculpture can be yet still be interesting to look at, still have something to evoke, and not just be a line lost in space. It is also the way the pieces move through space that is essential to their 'being'. Instead of merely lying on the ground, they seem to skim the surface, embodying the illusion of weightlessness, yet this attribute is in complete contradiction to the extreme horizontality and frankness of the industrial materials employed. Named after the place where Noland lived in Vermont, *Shaftsbury* (1965; plate 11) is a prime example of these low-lying Bennington pieces. Another is *Titan* (1964; plate 12), which, with its deep blue colour, stands as a continuation of Caro's previous experiments in London. Sprawling along the floor, the piece stretches out its stubby appendages. Linear in character, it is built from larger pieces of steel, incorporating both an I-beam and the new Z-shaped panels. It is certainly more substantial in comparison to *Month of May*, reminiscent, in fact, of earlier, bolder works such as *Midday*, but far more elongated. In contrast to *Titan* is *Pulse* (1964; plate 13), which falls squarely into the 'American' group. The work is composed of two zigzag elements precariously balanced on their corners and kissing each other point to point; they delicately support a long steel rod, which runs across the top surface of each zigzag extending well beyond them. *Pulse*'s mastery is found partly in its simplicity but even more in its ability to evoke a fleeting and illusive sensation of tension – like walking along a tightrope.

Like *Month of May*, *Pulse* is painted in several hues rather than, like *Titan*, in one uniform colour. The long slim rod is set off by the colour green, while the two larger steel Z-panels are pink. This decision to use more than one colour to highlight different parts and rhythms in one work was questioned by Greenberg and Noland.[25] In 1965 Greenberg stated:

> I know of no piece of his ... that does not transcend its colour, or whose *specific* colour does not detract from the quality of the whole (especially when there is more than one colour). In every case I have the impression that the colour is aesthetically (as well as literally) provisional – that it can be changed at will without decisively affecting quality.[26]

After a conversation with Greenberg regarding Caro's recent coloured work, Noland wrote in a letter of 1964 to Caro: 'One thing that became apparent to me was the colour problem. When they are painted all one colour it releases and opens the sculpture much more than when the colours are different on different parts. They are so open conceptually that separate colours are not needed.'[27] Further to this debate around colour, the American art critic Michael Fried, the first to write enthusiastically and perceptively about Caro's steel sculpture, had mentioned in an essay of 1963 that 'As for Caro's colour, it does not come easily to him.'[28] Noland's suggestion to keep the colour uniform is also further complemented by the fact that the works created at Bennington were made in a more professional manner than Caro had been able to achieve previously, in his London studio. At Bennington, the joins of each work were welded, while the bolted pieces were machine-screwed together. Thus when an entire sculpture was painted a single colour the viewer's eye was able to run unencumbered over the surface and the space which it defined.[29]

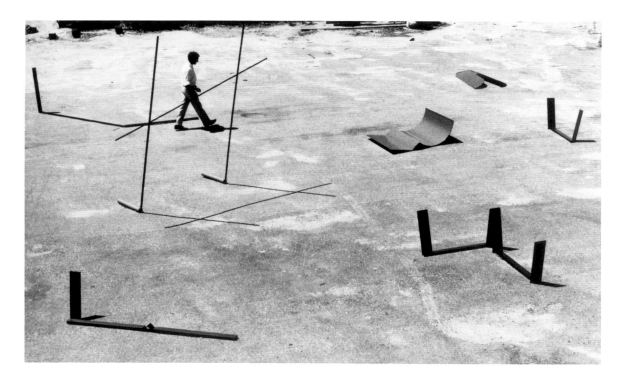

Fig.7
Caro at Bennington walking among his sculptures, c.1965

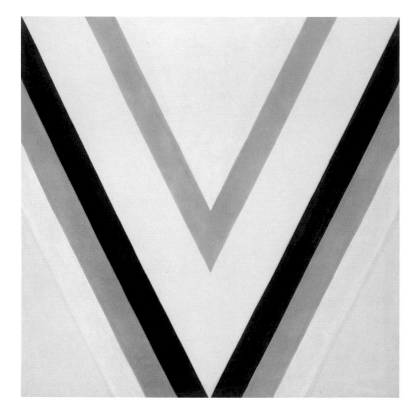

Fig.8
Kenneth Noland, *New Light*, 1963
Acrylic on canvas
176.8 x 177.2 cm (69½ x 69¾ in)
Ulster Folk and Transport Museum

During the summer of 1965, Caro returned to Bennington to teach for six weeks. At this time several conversations with Olitski took place where Caro was encouraged to move away from the weightiness of his work, and to strip down his materials to just a few elements. Caro recalls:

> I started off with some very thin very light things and I remember I was going to put in some walls ... [but] Jules Olitski came up to me instead and said, 'Why'd you put a wall in? Just leave it – just let it go.' To see how close I could get to emptiness, nakedness. That was an extraordinary thing to do then ... it seemed that it might be possible, while keeping the realness of the material and the realness of the object, to get as close as possible to a line.[30]

The result was what the two artists coined as Caro's 'naked sculptures'. As already mentioned, another important influence was Noland's 'Stripe' paintings of the same period. Moving away from the 'Circle' motif, Noland began creating an extraordinary series of hard-edge abstract works that relied on a geometric 'V' formation, the 'Chevrons', in which bold, straight bands of flat colour radiated from a point (fig.8). These experiments of creating areas of pure colour on unprimed canvas took advantage of the availability of newly developed acrylic paints. More significantly, the 'Chevrons' were, like the 'Circles' that preceded them, a deliberate reaction against the lack of clarity and often muddied colour of gestural Abstract Expressionism that had

dominated the New York art scene from the 1950s well into the early 1960s. Although on first acquaintance, Noland's 'Circle' and 'Chevron' paintings may have appeared rather simplistic compositionally, the subtlety of the colour relationships on which the paintings depend creates considerable complex associations. Certainly this achievement with pure line and colour would have been greatly inspiring to Caro.

With these new ideas percolating, Caro began, while at Bennington, to create some of his most economical works to date. *Eyelit* (1965; plate 16), for example, is literally a dark-blue line in space that angles out quite dramatically from a solid tubular foot. Speaking of *Eyelit*, Caro remarked 'I was trying to get close to the edge of the thing hardly being there'.[31] While the heavy foot sticks to the ground, the much thinner arm stretches towards the sky, weightless and ready to move on its own. The tilt of the leaning arm seems very precarious, almost at the brink of tipping over. In *Eyelit*, Caro was able to achieve an extraordinary balancing act where size, space and weight all play crucial roles. Vicariously sharing the sculpture's apparent risk of falling braces my senses, yet it is the thrill of discovering that edge, that point where you can suspend your body in space just on the verge of instability, that is so eloquently embodied in this work. As viewers of Caro's drawing-like sculptures we establish a symbiotic relationship of sorts. Because they are open, linear and constructed, as we move, so the sculptures seem to shift position and transform. Although not literally kinetic, they suggest motion, while simultaneously outlining and shaping space. This illusion is further enforced by our own visceral responses: as works such as *Eyelit* seem to defy gravity, our own bodies take part in this experience, this sensation. We too navigate through space like the lines of the sculpture.

Another example from this period is *Smoulder* (1965; plate 17). Painted in a luscious purple, the sculpture literally reclines, beckoning to you. Constructed with two different sized bars and one fairly substantial solid rod, the piece takes on the form of an odalisque as it sprawls out, bending along the ground and arching up to the sky. The title is aptly attached to this work as it does indeed quietly and even secretly evoke a hidden heat in its lines and angles, like the smoke from a slow-burning cigarette.

Sleepwalk (1965; plate 18) is one of the most complex and exciting pieces from this series – a combination of the magic of *Eyelit* and *Smoulder*. *Sleepwalk* is so delicate that it is seems almost to flee from the naked eye. I find myself consciously blinking to make sure that what I am seeing is still there and has not disappeared. In this work, Caro enlarges his reach by pushing the expansiveness of his work, making sculptures that literally encompass larger boundaries of space, and testing how much (or how little) it takes to hold, command and define an area. *Sleepwalk* exerts authority with very little means. The body skims the surface of the floor as the arms extend up and out, to grasp the air that surrounds them. I imagine that when lit in a certain way, *Sleepwalk* would create intriguing patterns of shadows, producing an interesting play on the physicality of sculpture, of what is real and what is illusion.

Table Pieces

From 1963 to 1965 Caro's new linear work was exhibited, celebrated and written about widely, yet he himself remained in a state of challenge, evolution and change, and began to take his experiments of the past five years in a new direction. During the summer of 1966, in a conversation with Caro, Fried 'pointed out what is significant about the table; it is level but unlike the floor it has an edge ... it relates to the hand, not only in size but it usually has a handle which refers to the hand, cups, and pitchers and so on.'[32] This exchange inspired the always open-minded Caro to begin making smaller works, to be placed on a table or plinth. He became very interested in exploiting the nature of the table, and created work that would not merely sit on the flat surface but would engage with the very edge of it. Instead of 'grounding' his works, Caro began 'tabling' them.[33] Incorporating a table or edge as an integral element of the creation of more intimately scaled works enabled him to overcome the impractical nature of placing work of this scale on the floor and further removed the possibility that smaller-scale pieces would be considered simply maquettes for larger sculptures.[34] Although much smaller in scale than the generously sized steel constructions that established Caro's reputation in the 1960s, these *Table Pieces* are complete works of art in their own right, each very much a fully worked-up drawing as opposed to a quick sketch. In many ways, Caro's *Table Pieces* are very similar to the act of drawing itself: given their intimate scale, studio assistants and machinery are not required for their construction. It is just the artist and the material interacting. As he works, Caro's hands and arms move through space, in gestures that are similar to placing a pencil to paper, yet here he is placing fragments together, making connections, and establishing new relationships.

However, this task was not as easy as just stated. In the catalogue introduction to a 1977 exhibition of the table sculptures Fried writes 'The basic problem [Caro] had to solve may be phrased quite simply: How was he to go about making sculptures whose modest dimensions would strike the viewer as intrinsic to their form – as an essential aspect of their identity, rather than as merely a contingent, quantitative fact about them?'[35]

Quite complex in their overall presence, the *Table Pieces* are indicative of Caro's penchant for experimentation and in many ways more a consequence of the impulsive collaging process he employed. For him 'collage is direct and clear. "Put" or "cut" means no long or complex fabrication as with casting in plaster or bronze. So one can be spontaneous'[36] By this time, Caro had begun to work in a larger studio – a former piano factory in Camden Town – where he could create more impressively scaled pieces, as well as maintaining his garage studio adjoining his home. He recalls that he used to make table sculptures in the evenings and always found that he preferred to build these works in his home studio. For Caro it 'would be rather like drawing – making table sculptures Making my table sculptures is fun, very loose. I go in there and I put some music on ... and I've got a lot of steel hanging around, and I

mess about until something starts to come.'[37] It was through the process of collaging that Caro was able to solve the question of intrinsic form as outlined by Fried above. By incorporating 'handles' into his table sculptures these elements would extend towards the viewer, as if presenting an invitation, to remind us of the possibility of holding, grasping, or engaging in a physical way with what was being presented – allusions to the action of the hand reinforces the table sculptures' scale. The *Table Pieces* not only invite, they offer up temptation. We want to reach out, take hold, and try to understand or discover the 'function' of these objects. We imagine how these sculptures might move with the assistance of the human hand, similar to another form of gesture – drawing.

With their incorporation of handles, and their orientation to the edge of the table, these sculptures present a front to the viewer, in contrast to the 'grounded' sculptures that insisted on being experienced in the round. Like reliefs or paintings, the table sculptures imply a single preferred viewpoint. Given their pictorial nature, along with their incorporation of identifiable household objects, the *Table Pieces* are very much akin to the still-life genre in painting. However, as they are dependent on the perpendicular flat surface planes of the top and sides of a table, with parts of the composition that sit on top and others that hang below the edge, unlike a tightly compacted still-life painting depicting foliage, fruit, fish and flowers, these sculptures are very linear, pared down and open. Even with a prescribed front and edge, and pictorial interpretation, they maintain their three-dimensionality. Another important characteristic of these intimate works that separates them from Caro's larger sculptures is that, because of their size, they invite one to come close to them and become engrossed by the nuances of their surfaces and formal details.[38]

Two exceptional early examples from this ongoing series are *Table Piece VIII* (1966; plate 20) and *Table Piece XVII* (1966; plate 21); both works incorporate handles and are indicative of Caro's desire to strip back to the essentials of sculpture. *Table Piece VIII* incorporates a steel bar, which may be a remnant or cutaway from an earlier, larger-scale work. In the centre of *Table Piece VIII* three scissor handles move along the bracket in a wave-like progression, providing the sculpture with a sense of movement. Barely touching the corner, a broad, curved band arcs downwards, as if acknowledging the floor below. The sculpture appears solid and substantial, in comparison to the fragile *Table Piece XVII* whose elegant central line balances a small segment of expanded metal mesh at its bottom tip while it reaches upwards; the central handle delicately fingers the angled block that acts at once as punctuation and counterweight, literally and metaphorically keeping the sculpture tight to the edge of the plinth and preventing it from slipping down.

Although the *Table Pieces* were more intimate than his first abstract sculptures in steel and perhaps more appropriate for a domestic setting, Caro continued to refer to the pristine white-cube gallery presentation by placing them on perfectly white anonymous bases. The edges of these bases are active

components of each work, and the dimensions and proportions of the plinths are also important considerations. Together, sculpture and plinth recreate a microcosm of pristine gallery display. The desire for the *Table Pieces* to exist in the messy, cluttered environment of 'real' life cannot be completely fulfilled. Isolating the *Table Pieces* on the immaculate plinths, however, emphasises both Caro's ability to draw in space, loosely and surprisingly, and his ability to engage and keep the viewer's attention.

Containment

Always working on multiple threads of ideas and series, Caro also created a number of large-scale works in his Camden Town studio during the same summer of 1966 that he began to work on the small *Table Pieces*. In these works, he began to include mesh panels that both defined space by denoting a physical plane and allowed the viewer to look past the limits of the sculpture into that 'other' space behind or within the structure. As we move around the sculpture the mesh panels also oscillate between opening up and closing off space visually and metaphorically; depending on one's perspective, we are either allowed to see in and through or are blocked and held at bay. In this light, the mesh element in the previously discussed *Table Piece XVII* can be seen as indicative of the continuity of Caro's concurrent explorations at various scales. Among the large works of this period, two sculptures in particular stand out: *Carriage* (1966; plate 22) and *The Window* (1966–7; plate 27). In both works, the viewer is directed to consider the space at the centre of the sculpture;[39] this is accomplished with abstract linear forms and with the use of mesh screens that simultaneously delineate and open the space.[40] Both works feel like rooms unto themselves with the mesh panels functioning almost like windows.[41]

Painted in a greenish blue, *Carriage* is among the earliest of Caro's linear constructions in which he clearly defines an interior and exterior space; he does so by incorporating two mesh panels on one side and utilising a single mesh panel on the opposing end to create see-through, yet physically expansive, 'walls'. These panels face each other, at different orientations, and engage in a conversation of sorts, each proposing, because of the shifting angles, different ideas about pattern, alignment and transparency. One side of the work features two different-sized mesh panels layered over each other at an angle. The effect creates a dizzying pattern of lines, a kind of steel 'moiré', which shifts and plays as one moves around the work. By layering the mesh panels, a more solid plane of colour and construction is offered for the eye to consider yet the optical effect of this layering causes more a sense of disembodiment. Although inherently stable, the use of mesh creates the effect that the 'wall' is in a state of shifting, with the potential of breaking down and disintegrating before our very eyes. Space is contained within the piece at a very human scale. But while we may feel an urge to enter this interior

room, we are never invited into it; the implied and literal barriers of Caro's boldest strokes of 'drawing' (as well as the constraints of museum-going etiquette) prevent us from straddling the spine of the sculpture to view both sides simultaneously.

The Window is a much larger and impressive work, yet it too creates an interior and exterior space, and makes use of the see-through qualities of a large mesh panel. As he does in *Month of May*, Caro uses different colours to set off various aspects of the work. Here, he employs forest green and olive green. The majority of the work is painted forest green, while three distinct elements – the large mesh screen, the bar that crosses the middle of the screen and the bent pipe on the opposite side – are demarcated in olive green. In doing so, Caro creates a tension between these key parts of the sculpture and the rest of the work itself. The large mesh panel literally squares off with the opposing solid panel. An inside/outside character is created with a few well-positioned lines and two imposing screens, each different yet, at the same time, perhaps a metaphorical mirror of the other; the result imbues the work with an imposing presence.

Colour

The mutable qualities of the mesh panels play almost the same role that colour does in Caro's sculptures of this period. As the use of steel mesh provides a shifting layer to the overall surface of the works, a layer that plays with the effects of illusion and transitory, emotive responses, so does colour. In 1967 art critic Rosalind Krauss discussed Caro's use of colour in more positive terms than Fried and Greenberg had in the past, using *Carriage*, along with another painted work incorporating mesh elements, *Red Splash* (1966; plate 25), to exemplify her point:

> Caro's new sculpture seems to shift back and forth between possible readings. On the one hand the works seem to ask to be read as a series of constructs, mere representations of space. On the other, they approach the viewer as real things, potently occupying his space. Colour becomes the structural element that acts in the gap between these two states. For in the moment when the works come closest to approximating fleshless abstractions, one becomes aware of the potential loss of actuality in one's experience of the work, and that loss is spelled out by the compelling opulence of colour.[42]

For Greenberg and Fried, Caro's use of colour often seemed secondary to his three-dimensional invention, something applied afterwards, upon the advice of Caro's wife, the painter Sheila Girling, once the work was completed. Krauss eloquently describes the power of colour in Caro's work. For her and for Caro, the character of the work itself dictates the choice of colour. This might occur

intuitively, and in consultation with Girling, but it is certainly not an after-thought. Caro sometimes admits to a certain anxiety about colour,[43] but his use of polychromy evokes a range of responses and adds fundamentally to the quality of line that he employs; witness, among many other examples, works such as *Month of May* and *The Window*. In 2005 the artist remarked that '... colour is so seductive in the end. You start enjoying the colour ... colour always hits you first before form I thought ... those wonderful 60s when everything was breaking open and we were fresh and free and throwing away all our attitudes about authority and everything.'[44]

Tabling

Caro's most widely discussed work from the 1960s is *Prairie* (1967; plate 28), perhaps because it was featured on the cover of the February 1968 issue of *Artforum*. Over the years, as well, it has been discussed at length by several critics, most notably Michael Fried. *Prairie* is a significant work. The long, low parallel bars, and the corrugated table, evoke the essence of horizontalness. In several articles, *Prairie*'s source of inspiration has been wrongly attributed to the geographical region of central North America (which in Canada is called the Prairies). This is certainly understandable given that this part of the country is commonly associated with a big sky, low horizon line, warm yellow light and a landscape that is decorated with wonderful patterns created by the furrows in ploughed fields. These qualities coupled with the formal characteristics and colour of *Prairie* further enforce this connection. However, this relationship is a misnomer as the work was not made in direct reference to the plains landscape of North America. Perhaps by a lucky coincidence, the title 'Prairie' was actually derived from the name of the matt yellow paint colour used for this work.

The most dramatic aspect of the sculpture is the potent illusion generated by four long pipes that seem to float above the ground. Being slightly lighter in colour than the rest of the piece further reinforces this effect, as does the fact that they are supported, each in a slight way, only minimally. The structure below opens up like wings, balancing a low corrugated tabletop over which the pipes appear to hover. Like a magic carpet, the appearance is completely enchanting and almost otherworldly. Transitory in nature, *Prairie* extends and commands the horizontal surface of the ground, almost drawing in air from under itself. The square upright panel docks the work, anchoring it, as if to keep it from floating around the room. In reference to *Prairie*, Caro notes 'I realised that if you can make the floor act as part of the sculpture and not just the base, then the pieces will float and move anyway.'[45] And Michael Fried poetically sums up 'It is as though in *Prairie* ... illusion is not achieved at the expense of physicality so much as it exists simultaneously ... *Prairie* compels us to believe what we see rather than what we know, to accept the witness of the senses against the constructions of the mind.'[46] As with *Month*

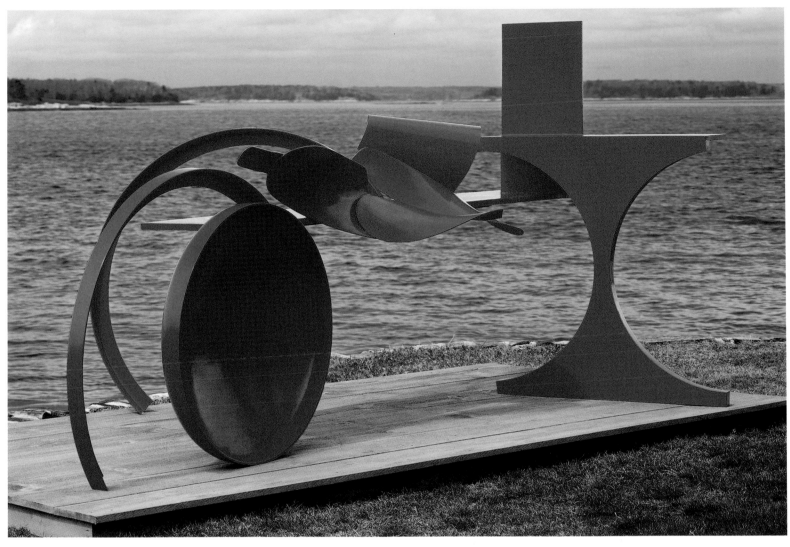

Fig.9
Sun Feast, 1969–70
Steel, painted yellow
181.5 x 416.5 x 218.5 cm (71½ x 164 x 86 in)
Private Collection, Maine, USA
(B933)

of May, the table motif comes through again in this work, yet in a more pronounced fashion.

In 1968 Caro purchased a number of ploughshares and aircraft propeller blades from a sale of agricultural machinery. As is usual for him, he did not work with these elements right away, but instead kept them in his studio soaking up the patina of the studio environment until he was 'ready' to work with them the following year. According to Caro, 'the curving planes of the ploughshares intrigued me to go into a different sort of curving as well ... I started making a series of sculptures more to do with the process of change.'[47] *Orangerie* (1969; plate 35) and *Sun Feast* (1969–70; fig.9), with their evocations of the surrealist work of Joan Miró and the *gouaches découpées* of Henri Matisse, are among Caro's most lyrical works. Both *Orangerie* and

Sun Feast depend on these new-found materials, with their twirling and twisting shapes. And both works are painted in striking colours that emphasise the kinetic qualities of the cursive planes; the light playing upon the colour modulates and alters its appearance, making the sculptures seem even more weightless and drawing-like.

A glorious work of twirling ribbon-like elements, *Sun Feast* is an excellent example of how Caro uses an elevated surrogate horizon line and plays with elements above and below it. As with *Month of May*, the colour and composition seduces us into forgetting how the sculpture is actually being supported, thereby seemingly to visually defy gravity. The entire work is anchored by the poised slice of the end of a tank yet it takes careful looking to determine this; instead we are captured by the colour, twists and

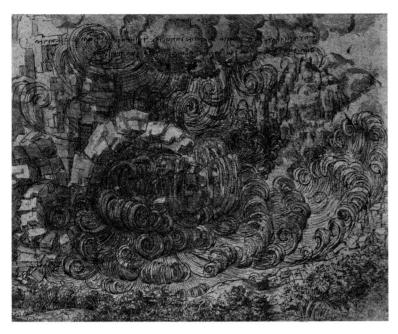

Fig.10
Leonardo da Vinci, *A Deluge*, c.1517–18
Pen and ink with wash over black chalk
16.2 x 20.3 cm (6¼ x 8 in)
The Royal Collection

took his inspiration for this work from the *Deluge* series of 11 drawings by Leonardo da Vinci (fig.10), which depict a powerful, swirling storm. In his sculpture, Caro exploits curling lines, bends and ribbons to their fullest potential, creating the illusion that some elements are in fact not attached at all, but instead float freely about an invisible axis buried somewhere within the plinth. William Rubin praises the work: 'The intricacy and the inventiveness of the configuration derive from the way in which the linear components are multiplied and the manner in which they are juxtaposed, rather than from inflections within any single one of them.'[50] The soft yellow colour of the piece further enforces these associations of light and weightlessness.

The flamboyant and cursive nature of *Orangerie*, *Sun Feast* and *Table Piece LXXXVIII (Deluge)* and their related sisters stands in direct contrast to the earlier Bennington pieces, which are very straight, delicate and angular exclamations in space. As we follow Caro's career the cursive drawing approach versus the more direct linear arrangements seems to swing from one side of the pendulum to the other.[51] The cursive style reappears in the *Writing Pieces* and *Barcelona* works while the *Emma Lake* works are more in keeping in attitude with the 'naked' sculptures from the mid-1960s. Although the appearance of Caro's sculptures is dependent on what material he chooses to work, what is important to note is that as his material changes, his approach to drawing adjusts and morphs to suit.

New Directions

movement of the work as it spins through space. As with *Orangerie*, Caro maintains the 'table' element, which, as mentioned, also operates as the second horizon line. The 'table/horizon' provides a surface from which the various parts of the work can spin about. When Caro began working on the piece he asked his wife her opinion and she read the table as part of the work and so it remained.[48] It is the dramatic use of positive and negative space that makes this work so exciting. A crucial part of its impact derives from the materials themselves. The ploughshares are cropped and altered but because of their twist they present the viewer simultaneously with the linear edge and the expansive plane. Unlike a flat sheet, they transform and oscillate between line and form. The large circular element looks as if it once was part of the opposing I-shaped leg. This spectacular sculpture gives the impression that is has just exploded in the presence of the sun. Like a flower blooming, it reaches out exposing all of its internal workings for the attraction of others; conversely, we imagine that at night it packs itself neatly away. For Caro *Sun Feast* 'works like a concerto ... as if there were things happening where the orchestra plays and then somehow a lighter theme comes in, like a piano, and reflects it in a different way.'[49]

Table Piece LXXXVIII (Deluge) (1969; plate 32) also shows a progression towards more open, elegant, musical formations on an intimate scale. Caro

In contrast, over the course of the 1970s, Caro's sculptures became denser and much more substantial. In 1974, he was presented with the opportunity to work with the York Steel Company in Toronto, Canada. At this time he created the series of *York Pieces* (fig.11) whose massiveness and bulk is a marked, although knowing Caro's interest in change, not a surprising, parallel against the open, pared-down works he created in the 1960s. In the *York Pieces* drawing in space is relegated to the edges, which curve and sway like great folds of drapery. However Caro's interest in drawing in space also expanded and took on new directions during the 1970s. Works from the early part of this decade, known as the *Racks* series, are heavier in their overall composition yet are still decidedly straight and linear, forcefully marking space. Several of these sculptures were started at Bennington in 1971 and then completed in early 1974. Pieces such as *Silk Road* (1971–4; plate 40) point to Caro's move away from painting his sculpture; the steel is allowed to rust, forming a natural, integral 'skin', which is then varnished. Many of the *Table Pieces* Caro made about the same time as the *York Pieces* are still concerned with openness and lines moving through space, but are more organic, following the trajectory introduced with *Table Piece LXXXVIII (Deluge)* a few years earlier. *Table Piece CC* (1974; plate 41) swirls and curls below the edge of the pedestal, while smaller, bulkier shards anchor the

Fig.11
Dominion Day Flats (York Pieces), 1974
Steel, rusted and varnished
216 x 457 x 185.5 cm (85 x 180 x 73 in)
Collection of Kenneth Noland
(B1088)

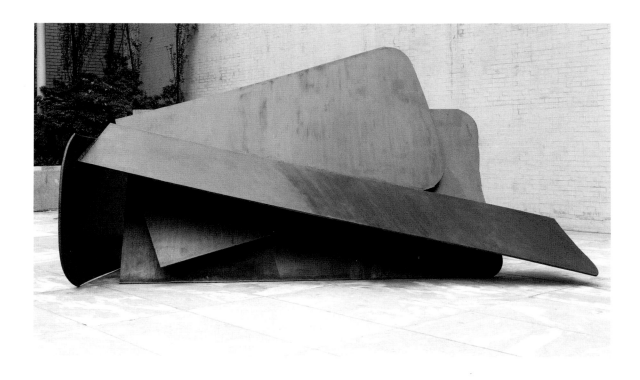

explosion of swimming lines. Some pieces from this period are inspired by Caro's time at his cottage studio near the Dorset coast, where he would watch the crash and spray of waves against the rocks.[52]

The year 1974 is also marked by experimentation with different types of materials. In order to create a present for his wife to celebrate their 25th wedding anniversary, Caro began to explore how the precious but notoriously difficult to weld material of silver could be adapted to his approach to sculpture-making. He rose to the challenge, creating *Silver Piece 1 (Jubilee)* (1974; plate 42). This piece revels in drawing out the rhythms of light as it plays off of the delicate, linear surfaces, exploiting all the optical effects from shimmering to blinding.

As Caro moves forwards in his quest to, as he puts it, to 'make sculpture real', he also continually picks up threads of interest from the past and brings them forward to the present. Although it might seem logical that the *Table Pieces* would allow for a greater degree of experimentation because of their intimate size, Caro still continued to explore alternatives in his large-scale sculptures, oscillating between opaque, relatively massive forms and light,

open configurations. After the concentrated period of constructing large sculptures with enormous plates of steel in the *York Pieces*, at the York Steel Company, Caro chose to work in a radically different way on his second stint of sculpture-making in Canada.

Emma Lake, Saskatchewan

In 1977 Caro was invited to participate in one of the artists' workshops held at Emma Lake, a remote area in northern Saskatchewan. The Emma Lake Artists' Workshop was founded in 1955 as an antidote to the isolation many professional artists felt living in this part of Canada. Every August, a two-week workshop was organised with a visiting guest artist, critic or curator to expose the participants to new ideas. In the workshop environment, all of the artists work side by side as colleagues, feeding off of each other's creative drives and impulses. Caro found his stay at Emma Lake so stimulating that, in 1982, he and a British colleague, the collector and businessman, Robert

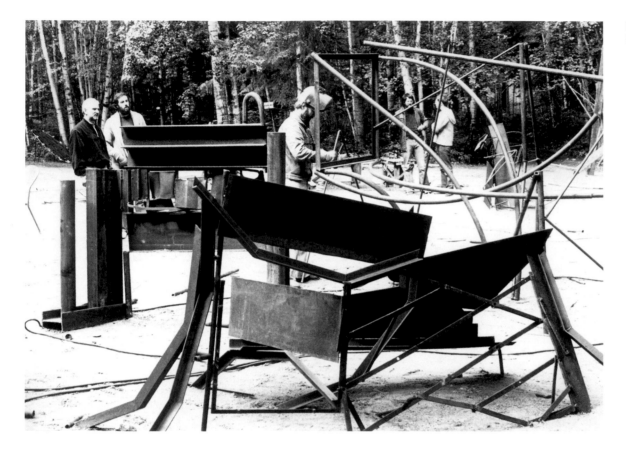

Fig.12
Caro at Emma Lake, 1977

Loder, founded Triangle Artists' Workshop in upstate New York – now based in Brooklyn – a programme modelled on the Emma Lake workshops that brings together selected artists from all over the world to work in close proximity.

While at Emma Lake, Caro employed the Canadian sculptor Douglas Bentham as his assistant. Together, they created more than 20 sculptures that became known as the *Emma Lake* series. Apparently conceived in direct opposition to the massive *York Pieces* made three years earlier, the character of the *Emma Lake* series was actually a consequence of the remote location of Emma Lake and the inherent difficulties of getting materials to the residency. Most of the material employed was tubular steel and angle iron, which was not only readily available but could also be handled easily without the aid of mechanical equipment.[53] (The 'sculpture studio' at Emma Lake, at that time, was the car park.) Because of these human and environmental limitations, the works Caro constructed in the summer of 1977, and then completed in May of 1978, were deliberately linear and relatively light.

The lyrical, cage-like structures of *Emma Dipper* (1977; plate 43), *Emma Push Frame* (1977–8; fig.13) and *Emma Dance* (1977–8; plate 44) could be read as contour drawings of the profiles of the massive *York Pieces*, yet there is an undeniable Picasso influence. To prepare for his trip to Emma Lake, Caro went back to his roots and revisited the drawings of Picasso. This connection becomes even clearer when we consider the gestural relationship between these sculptures and the early works on paper from 1953 to 1954 discussed previously. Although much larger in size, the *Emma Lake* works are plainly related to Picasso's wire constructions of the late 1920s (fig.14). Their structural language, however, is completely Caro's; like his open, linear constructions of the 1960s, the *Emma Lake* pieces both come up off the ground and spread out horizontally, defining the space they inhabit. As it does in the sculptures that incorporate mesh planes, *Carriage* and *The Window*, Caro's drawing claims and activates the space, enclosing a fictional interior yet still allowing the eye to move in and around. The elegance of the *Emma Lake* works recalls the 'naked sculptures' of the early 1960s, while their complexity is indebted to Caro's experimentations in his *Table Pieces*. In the *Emma Lake* works, Caro magically suggests a type of grand cursive script. The *Emma Lake* series proves 'that complex drawing moving in and out of three dimensional space' is not 'beyond sculpture's possibilities.'[54]

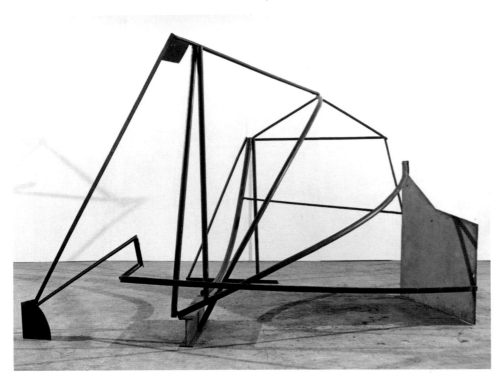

Fig.13
Emma Push Frame, 1977–8
Steel, rusted painted and blacked
213.5 x 274.5 x 343 cm (84 x 108 x 135 in)
Würth Collection, Künzelsau, Germany
(B1172)

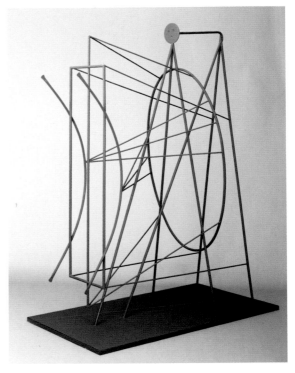

Fig.14
Pablo Picasso, *Project for a Monument to Guillaume Apollinaire*, 1962
Enlarged version after 1928 original maquette, painted steel
198.1 x 74.8 x 159.8 cm (78 x 29½ x 63 in) including base
The Museum of Modern Art, New York. Gift of the artist

Writing in Air

The *Writing Pieces* and *Ceiling Pieces* that followed, in the late 1970s, seem to combine Caro's experience in Saskatchewan and the ongoing investigations of his *Table Pieces*. The *Writing Pieces* are not as 'dependent' on the table edge as the earlier table sculptures. Like the earlier *Table Pieces*, many of the later small-scale sculptures are painted and also include instruments such as wrenches, pincers, tongs, callipers, hatchet blades, nuts and scissors. A much smaller series in number, the *Ceiling Pieces* were intended to be suspended from above, dangling down, effectively shifting the relationship between the viewer and the work. Collectively these two groups of works allow Caro to give free rein to the possibilities of using line. Volume and plane become completely secondary elements. Fluid, cursive, flamboyant line takes centre stage. Caro says he titled the *Writing Pieces* because for him 'they are like writing'.[55] However there is an inherent contradiction in the *Writing Pieces*. Although the title of the series evokes the act of writing, and infers the gesture of moving pen or pencil with ease across a sheet of paper, the arrangements of the works themselves in metal are unexpectedly much more fluid than mere handwriting. With human writing, the gesture comes from the hand and it can be jerky, stunted, mangled and scratchy, while with Caro's *Writing Pieces* it is almost as if the motion flows out from the wrist. Caro takes the action of writing and extends it, abstracts it into broad movements yet still maintains an intimacy that is translated optically, which shapes our understanding of these works. While looking at them we recall the sensation of our own ability to write because they embody how we want and expect handwriting to be: a series of beautiful, loopy, sinuous lines.

For Caro, the 1980s witnessed an even greater expansion of his fields of inquiry. He began to employ materials and approaches he once found it necessary to exclude, if sculpture was to be, in his term 'real', exploring the possibilities, for example, of working with bronze, of constructing enclosed volumes, and even of creating ambiguous narratives. The fluent drawing in space so graphically expressed in the *Emma Lake* series and the *Writing* and *Ceiling Pieces* persists, changes, and is expanded upon, as well. When, in 1987, Caro spent an extended period of time in Barcelona he described the city as 'all about line and drawing'. Struck by fluid, cursive Barcelona's omnipresent wrought-iron balconies, street lamps and other furnishings – all visible evidence of a long tradition of skilled metal working – Caro concentrated on linear elements in the works he produced there. This experience undoubtedly had something to do with his revisiting the concerns of the *Writing Pieces*, a decade after making the initial sculptures with this title, in, for example, works such as *Writing Piece 'Cross Wind'* (1988–9; plate 62) and *Writing Piece 'She's Terrified'* (1988–9; plate 63).

Windows and Benches

Travel has always been an important part of Caro's creative process and the identifiable characteristics of different places are significant for him. The 'geography of a place,' he says, 'certainly is an influence but is more like osmosis. I am not aware of it at the time, it just happens, as if one is learning to speak the language of the place more and more, sometimes the metal itself of a certain region also plays a part.'[56] This idea of embodying a certain spirit of a particular 'place' is probably the most evident, as mentioned, in the work Caro made during his sojourn in Catalonia in May 1987 as part of a special Triangle Artists' Workshop. The 'Art Triangle Barcelona' workshop brought together 25 American, Canadian and British artists, and an equal number of artists from Catalonia and the rest of Spain (plus one Basque), to work alongside each other for two and a half weeks,[57] improvising studios in the half-ruined Casa de Caritat, a former home and school for orphans.[58] During the workshop, Caro created a series of linear, ground-based works, later labelled the *Barcelona* series.[59] Caro was fascinated by the architecture of the city, by the sharp contrasts of light and shade and the traditional Catalonian art of wrought iron.[60] He remarked:

> ... the emphasis on drawing in sculpture struck me as the area I would like to explore in Barcelona ... I requested steel scrap in the form of remnants of disused balconies, balustrades and the common wrought steel which for so long the Catalan craftsmen have excelled in making. Picasso, Gaudí, González and Miró were all alive in my mind; the resulting sculptures introduce something of the drawing of this part of Spain, which I felt I subconsciously assimilated.[61]

Surrounded by this characteristically Catalan scrapyard material, Caro found new ways of drawing in space. It is not surprising that given this environment, Caro drew upon the tradition of open, welded, constructed sculpture, which Picasso experimented with in the late 1920s in collaboration with Catalan sculptor González. However unlike Picasso and González, whose material did not overtly refer to any previous function or character, Caro exploited the recognisable shapes, filigrees and decoration of discarded balconies, grates and grilles. Originally used as a means to block off, secure, separate, protect, and yet keep open, these characteristics and allusions to Catalan ironwork were maintained by Caro as he transformed these unwanted fragments and their residue of meanings into his own impressive sculpture. Because of the inherent, linear, yet cursive aspect of this type of iron work, similar to his Emma Lake experience, these found objects and the nature of the place itself very much prescribed what he was going to produce.

The *Barcelona* pieces are notable for their firmly outlined contours, perhaps a response to the original shapes and functions of the material employed; they are striking too for the questions they pose about positive and negative volumes. A fellow participant in the workshop, Karen Wilkin discussed Caro's process of creating a series of 'windows' and 'benches', loading them with material, and then eliminating what he described, in a characteristic phrase, as 'anything that was not the sculpture', paring the pieces down to drawn lines that move musically through space, freed from the imposed symmetry that was once their function as a gate, grille, or grate.[62] *Barcelona Almond* (1987; fig.15) is typical of the 'window' works Wilkin points to. Although it exists in the round, there is a certain 'flatness' to its orientation; like a door or window, it seems to define one side of a room or separate one side from the other. Is the viewer on the inside or the outside? Are we looking in or out? A remnant of wrought-iron fencing dominates the centre of the work. Although *Barcelona Almond*, at first encounter, seems very upright and vertical in its presence, we soon become aware of shifts away from verticality. The central 'fence' leans to one side, while a long foot extends out in the opposing direction, only to curl in on itself. The skew of the vertical bars is further broken by the slight bends in each that either expand or contract the space in-between. Rising out of this fence is an impressive hat, which curls and bends with more regularity and complexity than the slim rods below. Overall, *Barcelona Almond* begins to take on quite a figurative presence, casually standing in a relaxed position neither welcoming nor confronting. Instead the piece evokes an attitude of ambivalence – a 'what you see is what you get'. In contrast to the lightness and delicacy of the quality of line in *Barcelona Almond*, *Barcelona Concert* (1987; plate 58) presents us with a brute 'bench'. Heavy wrought-iron grilles are piled one on top of the other, at clashing angles; lines seem to pierce each other, compressing space within the centre of the work. All of the openness of the 'window' works has been transformed into a more oppressive interior presence, evoking sensations of being trapped, crushed, and pinned down by an enormous weight.

Almost by osmosis, perhaps by permission, or even 'when in Rome', Caro also produced some incredibly ornate works. Unlike the more linear 'windows' and 'benches', *Barcelona Rose* (1987; plate 59) takes on an almost figural presence yet the density of the larger metal panels pulls the piece into abstraction. Line mixes with planes of steel that fold and drape, evoking references to fabric and the sway of a woman's hip. By virtue of placement, Caro manages to transform the recognisable curlicues appropriated from stock balcony railing. The fragment of the balcony takes on the presence of a mantilla. This tongue-in-cheek reference is further enforced by the title of the piece – a rose, traditionally worn in a Spanish woman's hair, is also an affectation for a Latin beauty. The concept of drawing is obviously most evident in the balcony fragment and the tassel ribbons that fall from the point of the cone-shaped, hat-like 'head', but as in the earlier massive *York Pieces*, drawing also occurs along the edges of the larger panels.

Caro returned to Barcelona later in 1987 for another two-week stint to finish the sculptures he had begun at the workshop, as well as to make arrangements for some of the unused metal from the Barcelona scrapyard to be sent to his studio in London. He incorporated found elements from this cache in a series of *Catalan Table Pieces*.[63] *Table Piece 'Catalan Double'* (1987–8; plate 60) is among the most playful and elegant of the group with lines outlining space, twisting and twirling in ways that recall the 'window' pieces made earlier that year. As noted, the calligraphic nature of the Catalan table sculptures probably provoked Caro's reprise of the *Writing Pieces*, soon afterwards.

The implications of the *Barcelona* series reached a pinnacle of sorts in 1991 with the commissioned work *Sea Music* (1991; plate 61). Located at Poole Harbour in Dorset, the work is over 11 metres (36 feet) high and incorporates a stairway and two viewing platform levels. *Sea Music* has its origins in *Table Piece 'Catalan Double'*, with the basic structure enlarged and altered to accommodate the change in scale, along with other additions.[64] Here Caro draws on a wonderfully grand scale, beckoning out to the sea, mirroring the movement of the water, boats and birds. The work also points to Caro's interest in merging sculpture with architecture, which cannot be followed in detail here but has been discussed in other writings.[65] *Sea Music* is a celebration of Caro's preoccupation with line and space, balanced with his exploration of form, volume and architecture. In many ways it sums up the multiple, alternating streams of creative inquiry that he has followed through-out his long career.

Other Directions

With their exuberant drawing and often playful incorporation of found materials, the *Barcelona* pieces and their descendants were formally experimental, in many ways, but employed materials and methods that were completely

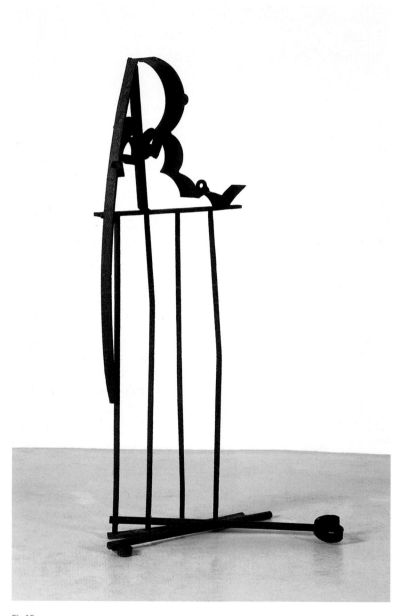

Fig.15
Barcelona Almond, 1987
Steel, rusted and waxed
138.5 x 63.5 x 43 cm (54½ x 25 x 17 in)
Private Collection
(B1896)

familiar to Caro. Beginning in the late 1970s and, increasingly, during the 1980s, 1990s and 2000s, his wide-ranging experimentation also included techniques that he had not used for decades or that were completely new to him. He returned to working with clay, which he had not done since his student days, devised a way of constructing with preformed bronze elements that was identical to his usual practice in steel, began to incorporate massive wooden timbers into his sculptures, and even worked in paper.

Although obviously very different from his steel linear sculptures, Caro's works in paper from the early 1980s provided another means for exploring line moving through space. Unlike his early works *on* paper, these paper constructions are no longer flat; instead, they are very sculptural, collaged and relief-like. In many of them, Caro drew lines onto the surface of the paper prior to the medium being moulded in a form. These markings share an affinity with the action of drawing in his sculptures. Inspired by Noland's series of cast paper 'paintings', made in 1977 in the workshop of the master printer Kenneth Tyler, Caro felt in 1981 that he was ready to work with Tyler on a series of paper sculptures. The result was over one hundred relief pieces, including *Paper Sculpture No.24* (*As You Are*) (1981; plate 53) and two free-standing works, one being *Paper Sculpture No.98* (1981; plate 54). The process began quite simply. Caro has described how 'Ken Tyler ... took a wet sheet of handmade paper and asked me to draw on it; I drew a couple of straight lines. He draped the wet paper across a chair and next morning it was dry and [was] three-dimensional (it set like this as he had incorporated plaster as a stiffener in the paper). It was a revelation.'[66]

Positioned somewhere between drawing and sculpture, the artist felt that 'in the paper sculptures I [got] closer to the graphic idea, to painting ideas and away from being so sculptural.'[67] In his first collaboration with Tyler, Caro was fascinated by the texture and lightness of his unusual medium.[68] In 1990, another opportunity presented Caro with the chance to return to working with paper, picking up where he left off nine years earlier and continuing to explore the sculptural possibilities inherent in the material. He worked this time with a Japanese master at Nagatani's paper workshop located in the small rural village of Obama, Japan.[69] By 1993, the research made possible at the workshop and the lessons garnered from that visit translated into more developed three-dimensional forms in paper, which, in turn, undoubtedly informed Caro's normal studio practice in steel.

Also in 1993, Caro had an opportunity to work for the first time with the noted ceramist Hans Spinner. Their resulting collaboration (which has continued through the 2000s) originally led to the creation of initially abstract stoneware forms that Caro later said insisted on being read as 'heads' when they arrived in his studio and eventually provoked the multi-part series *The Trojan War* (1993–4). The figural and narrative aspects of this remarkable series have been thoroughly discussed elsewhere.[70] It is worth noting, however, that many of the 'body' armatures of works in *The Trojan War* series are informed by Caro's long engagement with linear, drawing-like sculpture

and put it into the service of a kind of ambiguous allusion that is new to his practice in three dimensions. In particular, pieces such as *Hermes* (plate 65) and *Xanthos* (plate 66) reveal Caro's ability to suggest the body with the greatest economy of line. In both works, he pares the body down to just a few suggestive elements, just as he did in his *Warrior* monotypes of 1953 to 1954.

Passages: Lines in Space

Six decades from when he first began to establish his identity as a sculptor, Caro is still fascinated and inspired by 'drawing in space'. His generously scaled galvanised metal works of 2005 to 2007 show us an artist who is still pushing and reaching for new ways to communicate. Consistent with his working method, Caro continues to collage and abstract industrial materials, incorporating grates, tubes, beams, and other found elements. Akin to his use of paint in the 1960s, to even out the various bits and pieces of disparate metal, Caro has opted to have the sculptures galvanised, creating a uniform, zinc-covered surface, whose grey colour would subtly shift and transform in the light. Coloured painted elements are also added as a means to emphasise different features of the structures themselves.

As a group, the galvanised series powerfully suggests the idea of a passageway; however as with many of Caro's sculptures, one cannot physically enter the interior spaces. The transition from interior to exterior, from threshold to exit, must be made with one's eyes and mind. The series is obviously informed by Caro's long experience and broad inquiry over the past six decades, yet certain aspects of much earlier works still make themselves noticed. *South Passage* (2005; fig.16) and *Long Passage* (2007; plate 70), for example, are both constructed with clean bold lines that divide and enclose space in ways very similar to works from the mid-1960s such as *Carriage* or *The Window*. As we can with *Carriage* and *The Window*, with their mesh planes, we can see into a fictional interior through the open, visually permeable elements that surround it, but we cannot enter it. Almost otherworldly in their appearance, sculptures like the pristine *South Passage* and *Long Passage* evoke a type of process or transformation; perhaps they are portals to other dimensions, or machines that might produce the most advanced forms of technologies. Made almost 45 years since his first linear steel works, these *Passages* are indicative of Caro's lifelong continuing interest in drawing in space. Caro's engagement with architecture is undeniable; yet his confidence in shaping space with line is irrefutable.

Caro's impulse to draw in space has dramatically transformed over the years and his impressive output has changed along with his growth as an artist. We began our discussion with his early monotypes and with his brush-and-ink drawings on paper, made while he was working as a studio assistant for Henry Moore. At that time, we see that his use of line oscillates between fine and delicate to strong and bold, and this prefigures his preoccupation with and

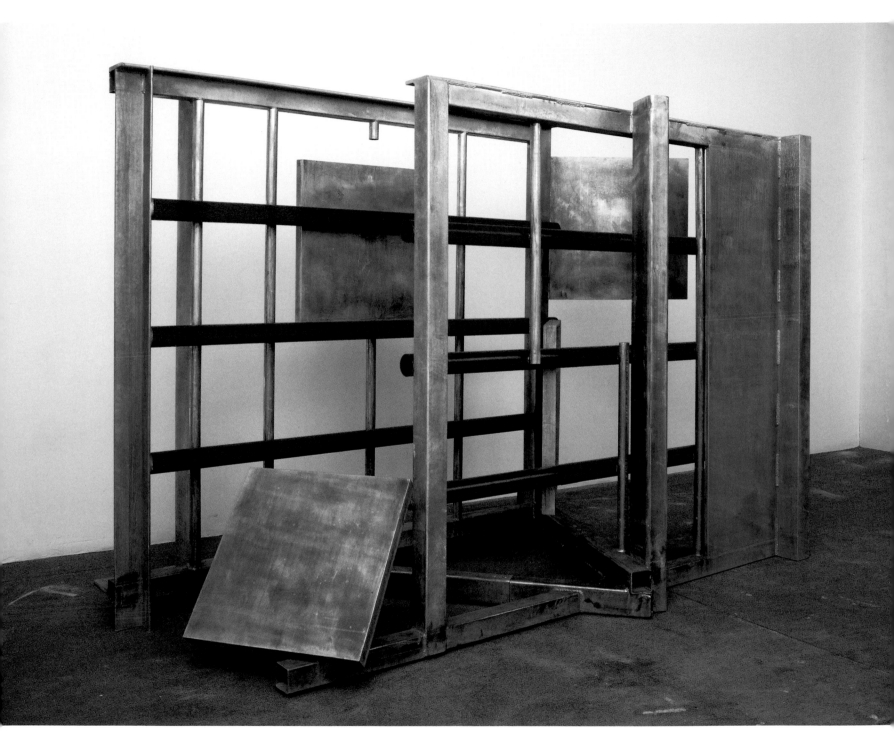

Fig.16
South Passage, 2005
Steel, galvanised and painted red
231 x 346 x 173 cm (91 x 136¼ x 68¼ in)
(T0023)

investigations in drawing in space for the next six decades. The 1960s mark his foray into abstraction and his pursuit of clean, 'naked' sculptures that exploit the economy of line in space to its maximum. An early interest in marking transitory interior and exterior spaces with the use of mesh panels appears towards the end of this decade. During Caro's time at Emma Lake in the mid-1970s, he continued to follow this trajectory, creating cages that wholly contain interior spaces, with a very cursive and elegant approach to line. Running parallel since 1966 are Caro's experiments with *Table Pieces*, which further investigate similar ideas found in the larger composed works, yet also examine other notions of drawing in space, making the most use of the horizontal and vertical planes inherent to a table's edge. In the 1980s his *Writing Pieces* were the culmination of his research and experiments to date, which then substantially altered and changed during his time in Barcelona and the works made there were inspired by the unique character of this city.

Constantly evolving, Caro transferred his practice of drawing in space to producing a series of reliefs with paper and also incorporated it into the various 'body' structures of characters in his *Trojan War* series. This preoccupation with line has never ceased and has most recently manifested in his impressively imposing galvanised sculptures. I am sure that Caro's next iteration of 'drawing in space' will be just as unexpected and as completely captivating and magical as what he has achieved over the last 60 years. Undoubtedly it will be another wonderful adventure in the experience of looking.

When asked if he had a favourite type of line – to Caro admittedly a question like asking if he had a favourite child – he replied 'This question is unanswerable! I want to extend myself, extend what I do. If I had a favourite [line] I would avoid it; I want to try what I don't know, not repeat what I do.'[71] His response aptly summarises this entire text.

NOTES

1 Interview with Peter Fuller quoted in Dieter Blume, *Anthony Caro: A Catalogue Raisonné*, vol.VIII, Acquavella Contemporary Art Inc., New York, 1989, pp 32, 33.

2 This and previous quote, ibid p.33.

3 Caro quoted in Phyllis Tuchman, 'An Interview with Anthony Caro' in, *Artforum*, vol.X, no.10, June 1972, p.58.

4 Fuller quoted in Blume VIII, p.33.

5 Blume VII, Galerie Wentzel, Cologne, Annely Juda Fine Art, London, and André Emmerich Gallery, New York, 1989, p.10.

6 Caro to author, 25 November 2008.

7 Karen Wilkin in, Ian Barker (ed.), *Anthony Caro: Galvanised Steel Sculptures*, exh.cat., Annely Juda Fine Art, London, and Mitchell-Innes & Nash, New York, 2007, p.9.

8 ibid.

9 This paraphrased comment has been quoted numerous times in literature on Caro, for example see Ian Barker, *Anthony Caro: Quest for the New Sculpture*, Lund Humphries, Aldershot, 2004, p.10.

10 Clement Greenberg, 'David Smith: Comments on his Latest Works' in, *Art in America*, vol.LV, no.1, January–February 1966 in, J. O'Brian (ed.), *Clement Greenberg: The Collected Essays and Criticism*, vol.IV, *Modernism with a Vengeance 1957–1969*, University of Chicago Press, Chicago and London, 1993, p.225.

11 Caro quoted in Barker 2004, p.90.

12 Barker 2004, p.106.

13 ibid pp 91, 92.

14 Greenberg, Clement, 'Anthony Caro', *Studio International*, September 1967, vol.CLXXIV, no.892, pp 116–17 (reprinted from *Arts Yearbook: Contemporary Sculpture*, 1965, pp 106–9) in, O'Brian IV, pp 206–7.

15 Caro to Peter Fuller, quoted in Blume VIII, p.32.

16 Caro quoted in Barker 2004, p.104.

17 Quoted in William Rubin, *Anthony Caro*, Museum of Modern Art, New York, 1975, p.177.

18 Caro to Tuchman, op.cit., p.56.

19 Texts that mention the connection between Caro's first abstract sculpture *Twenty Four Hours* (1960) and Kenneth Noland's 'Circle' paintings include: Barker 2004; Terry Fenton, *Anthony Caro*, Academy Editions, London, 1986; Paul Moorhouse (ed.), *Anthony Caro*, exh.cat. with essays by Michael Fried and Dave Hickey, Tate Publishing, London, 2005; and Rubin 1975.

20 Quoted by Tim Hilton in Blume V, Galerie Wentzel, Cologne, 1985, pp 51–2.

21 Greenberg 1965, op.cit. (n.14) in, O'Brian IV, pp 206–7.

22 Quoted in Barker 2004, p.127.

23 ibid p.124.

24 ibid p.127.

25 ibid p.128.

26 Greenberg 1965, op.cit. (n.14), p 207.

27 Quoted in Barker 2004, p.132.

28 Michael Fried in Moorhouse 2005, p.122.

29 Barker 2004, p.130.

30 ibid p.141.

31 ibid.

32 Caro to author, 25 November 2008.

33 Fried in Blume I, Galerie Wentzel, Cologne, 1981, p.32.

34 Barker 2004, p.161.

35 ibid.

36 Caro to author, 25 November 2008.

37 Quoted in Barker 2004, p.167.

38 Fried in Blume I, p.33.

39 Moorhouse 2005, p.42.

40 Michael Fried, 'New Work by Anthony Caro' in, *Artforum*, vol.V, no.6, February 1967, p.46.

41 Moorhouse 2005, p.38.

42 Rosalind Krauss, 'On Anthony Caro's Latest Work' in, *Art International*, 20 January 1967, p.28.

43 Conversation between author and Karen Wilkin, November 2008.

44 Peoples Archive: Sir Anthony Caro, Part 4, Section 21: http://www.peoplesarchive.com/browse/transcript/6483/en// (last accessed on 2 February 2009).

45 Caro to Tuchman, op.cit., p.56.

46 Michael Fried, 'Two Sculptures by Anthony Caro' in, *Artforum*, vol.VI, no.6, February 1968, p.25.

47 Caro quoted in Barker 2004, p.186.

48 ibid p.186.

49 ibid.

50 Rubin 1975, pp 142, 146.

51 Discussion at Triangle Artists' Workshop, Pine Plains, New York, August 1987, quoted by Karen Wilkin in, Barker 2007, p.9.

52 Barker 2004, p.213.

53 ibid p.229.

54 Caro quoted in Barker 2004, pp 239, 240.

55 Caro to author, 25 November 2008.

56 Caro to author, 30 November 2008.

57 Barker 2004, pp 275, 276.

58 Now the site of the Barcelona Museum of Contemporary Art.

59 Barker 2004, p. 276.

60 Blume VII, p.16.

61 Quoted in Barker 2004, p.276.

62 Barker 2004, p.277.

63 ibid p.279.

64 ibid p.288.

65 For a complete discussion of this aspect of Caro's work, see Karen Wilkin, *Anthony Caro: Interior and Exterior, The Works of Anthony Caro*, Ashgate Publishing, Farnham, and Lund Humphries, Burlington, VT, 2009, and Paul Moorhouse, *Anthony Caro: Sculpture Towards Architecture*, Tate Publishing, London, 1991.

66 Caro to author, 25 November 2008.

67 Caro quoted in Barker 2004, p.251.

68 Barker 2004, p.251.

69 ibid p.290.

70 For a complete discussion of this aspect of Caro's work, see Julius Bryant, *Anthony Caro: Figurative and Narrative Sculpture, The Works of Anthony Caro*, Ashgate Publishing, Farnham, and Lund Humphries, Burlington, VT, 2009, and Julius Bryant and John Spurling, *The Trojan War: Sculptures by Anthony Caro*, exh.cat., Iveagh Bequest, Kenwood, London, and Yorkshire Sculpture Park, Wakefield/Lund Humphries, London, 1994.

71 Caro to author, 25 November 2008.

Select Bibliography

Annesley, David, 'Anthony Caro', *Artnews*, vol.LXXIII, no.5, May 1974, pp 92, 95

Annesley, David, Louw, Roelof, Scott, Tim, and Tucker, William, 'Anthony Caro's Work: A Symposium by Four Sculptors', *Studio International*, vol.CLXXVII, no.907, January 1969, pp 14–20

Barker, Ian, *Anthony Caro: Quest for the New Sculpture*, Lund Humphries, Aldershot, 2004

Barker, Ian (ed.), *Anthony Caro: Galvanised Steel Sculptures*, exh.cat. with essays by Karen Wilkin and Kosme de Barañano, Annely Juda Fine Art, London, and Mitchell-Innes & Nash, New York, 2007

Benedikt, Michael, 'New York Letter', *Art International*, 20 January 1967, p.56

Bingham, Russell, 'Interview: Anthony Caro', *Edmonton Review*, 1996

Blume, Dieter, *Anthony Caro: A Catalogue Raisonné*, 14 vols, Cologne, Hannover, London and New York, 1981–2007

Carpenter, Ken, and Shoichet, Dorothy, 'The Caro Connection: Sculpture by Sir Anthony Caro from Toronto Collections', Koffler Gallery/Koffler Centre of the Arts, North York, Toronto, 1995

Cone, Jane Harrison, 'Caro in London', *Artforum*, vol.VII, no.8, April 1969, pp 62–6

Feaver, William, 'Anthony Caro', *Art International*, 20 May 1974, pp 24–5, 33–4

Fenton, Terry, *Anthony Caro*, Academy Editions, London, 1986

Fontein, Jan, and Andreae, Christopher, *Anthony Caro: The York Sculptures*, exh.cat., Museum of Fine Arts, Boston, 1980

Fried, Michael, 'New Work by Anthony Caro', *Artforum*, vol.V, no.6, February 1967, pp 46–7

— 'Art and Objecthood', *Artforum*, vol.V, no.10, June 1967, pp 12–23

— 'Two Sculptures by Anthony Caro', *Artforum*, vol.VI, no.6, February 1968, pp 24–5

— 'Caro's Abstractness', *Artforum*, vol.IX, no.1, September 1970, pp 32–4

Gilbert-Rolfe, Jeremy, 'Anthony Caro', *Artforum*, vol.XII, no.1, September 1973, pp 87–8

Greenberg, Clement, 'Anthony Caro', *Studio International*, September 1967, vol.CLXXIV, no.892, pp 116–17 (reprinted from *Arts Yearbook: Contemporary Sculpture*, 1965, pp 106–9) in, John O'Brian (ed.), *Clement Greenberg: The Collected Essays and Criticism*, vol.IV, *Modernism with a Vengeance 1957–1969*, University of Chicago Press, Chicago and London, 1993, pp 205–7

— 'David Smith: Comments on his Latest Works', *Art in America*, vol.LV, no.1, January–February 1966 in, O'Brian IV, pp 222–8

— 'Recentness of Sculpture', *Art International*, 20 April 1967, pp 19–21

Hughes, Robert, 'Caro: Heavy Metal', *Time*, 5 May 1975, pp 52–3

Ireland, Jock, 'Caro's Steel Hunts the "Real"', *Montreal Gazette*, 4 March 1976

Krauss, Rosalind, 'On Anthony Caro's Latest Work', *Art International*, 20 January 1967, pp 26–9

— 'New York: Anthony Caro at Emmerich', *Artforum*, vol.VII, no.5, January 1969, pp 53–5

— 'The Essential David Smith', *Artforum*, vol.VII, no.8, April 1969, pp 34–41

Lynton, Norbert, 'London Letter', *Art International*, vol.IX, nos 9–10, 20 October–November 1965, pp 23–4, 26

Marshall, Neill, 'Anthony Caro's "Clearing", The David Mirvish Gallery, Toronto', *Artscanada*, nos 152–3, February–March 1971, p.61

Masheck, Joseph, 'A Note on Caro Influence: Five Sculptors from Bennington', *Artforum*, vol.X, no.8, April 1972, pp 72–5

Moorhouse, Paul (ed.), *Anthony Caro*, exh.cat. with essays by Michael Fried and Dave Hickey, Tate Publishing, London, 2005

Rubin, William, *Anthony Caro*, Museum of Modern Art, New York, 1975

Tuchman, Phyllis, 'An Interview with Anthony Caro', *Artforum*, vol.X, no.10, June 1972, pp 56–8

White, Gabriel, and Fried, Michael, *Anthony Caro*, exh.cat., Hayward Gallery, London, 1969

Vogel, Carol, 'A Passage for the Master of Heavy Metal', *New York Times*, 25 July 2007

Selected Works

1 Warrior

1953–4

Monotype on vellum
25.3 x 20.2 cm (10 x 8 in)
(D97)

This *Warrior* monotype is one of a series of numerous early works on paper, in which Caro's interest in traditional subject matter is combined with his new appreciation of the pre-Columbian and African cultures that inspired artists such as Henry Moore, Pablo Picasso, Paul Gauguin and Henri Matisse. The overall sparse quality of line and rough appearance of this warrior foreshadow Caro's *Trojan War* series created 40 years later.

2 Bull

1954

Brush and ink on newsprint
45.7 x 58.4 cm (18 x 23 in)
(D184)

Part of a large series of brush-and-ink works on paper, this bull also displays Caro's preoccupation with the work of Picasso. Since he was from Spain, it is not surprising that Picasso would make the bull, the bull fight and eventually the Minotaur an important part of his visual repertoire. Here, Caro takes this bull imagery and makes it his own. Like Picasso, he strips down the bull to a contour line yet by pushing the image to the very edges of the paper, he is able to retain all of the brute force that this animal evokes.

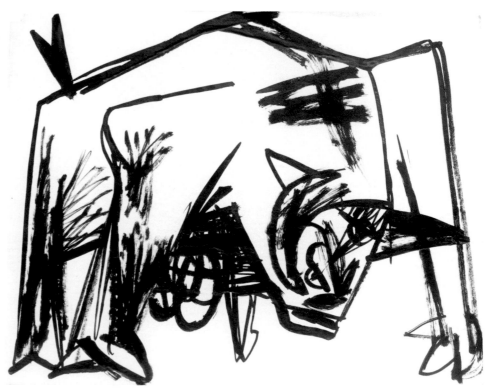

3 Figure

1954
Brush and ink on newsprint
45.7 x 58.4 cm (18 x 23 in)
(D205)

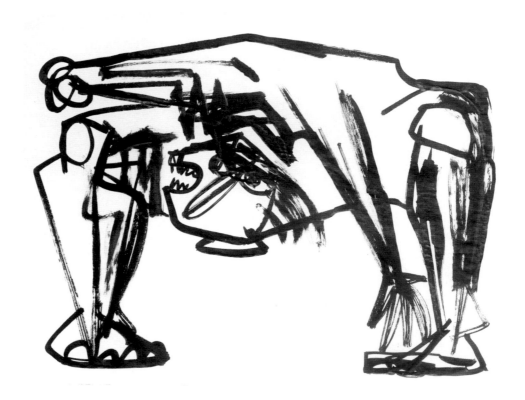

4 Baby with a Ball

1954
Brush and ink on newsprint
58.4 x 45.7 cm (23 x 18 in)
Collection Dieter Blume
(D233)

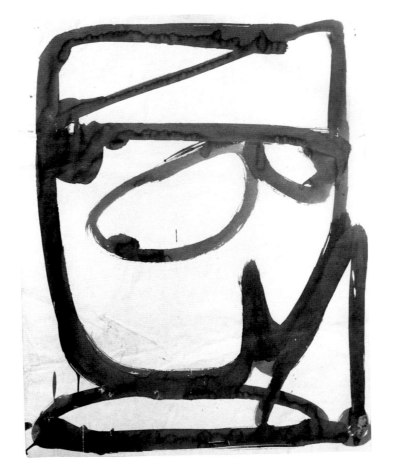

5 Midday

1960
Steel, painted yellow
240 x 96.5 x 366 cm (94½ x 38 x 144 in)
The Museum of Modern Art, New York
Mr and Mrs Arthur Wiesenberger Fund
(B822)

Midday recalls the bold line used in Caro's brush-and-ink
works on paper. Caro had interpreted art critic Clement
Greenberg's advice of 1959 of changing his art by changing
his habits (see p.13) as a means to breakaway from the
figurative subject matter and the materials that he had
worked with up until that time. Caro turned to common
building materials and, as evident in *Midday*, began to
experiment with steel girders and I-beams. An important
development is Caro's deliberate decision to remove the
base and to place the sculpture directly on the ground,
forcing it to exist in the 'real' world.

6 Sculpture Two

1962
Steel, painted green
208.5 x 361 x 259 cm (82 x 142¼ x 102 in)
Private Collection
(B827)

Having worked through some of the initial technical issues
of creating with steel girders, Caro progressed towards
more refined, elegant and linear compositions as demon-
strated in *Sculpture Two*. A balancing act of sorts, this
work is playful in its arrangement yet maintains a crucial
internal tension that holds the piece precariously still, as
if (just for a moment) preventing it from tumbling away.
The smallest curved bracket element on the far-right side
beckons to the viewer as it breaks the continuity of straight
diagonal lines jockeying for support and resistance.

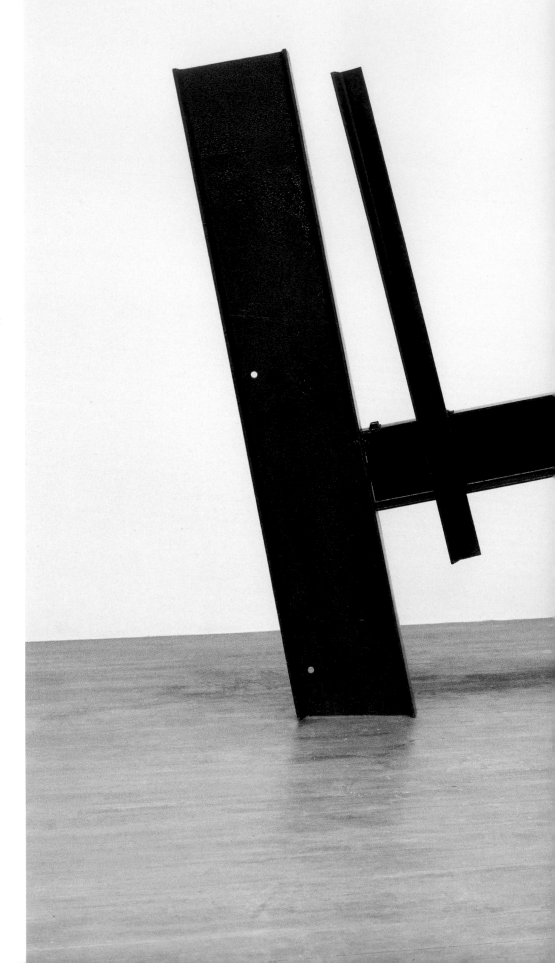

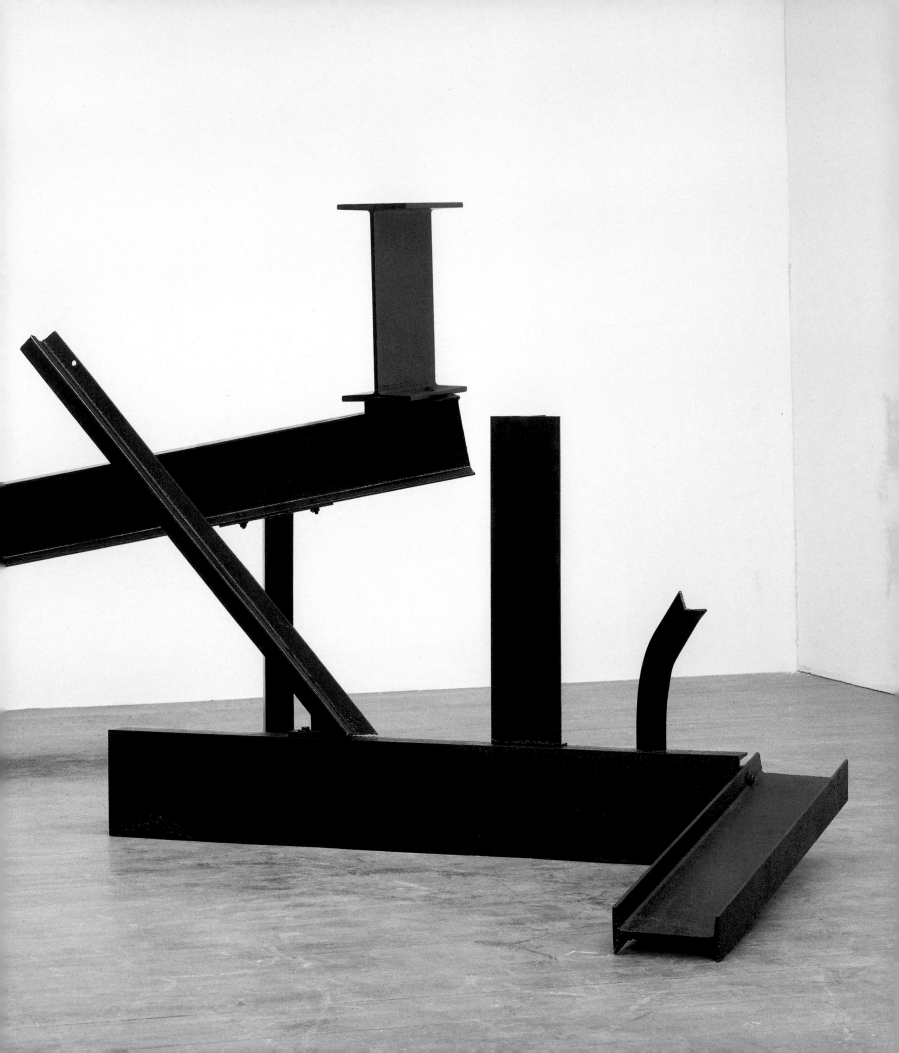

7 Sculpture Three

1962
Steel, painted red
274.5 x 460 x 170.5 cm (108 x 181 x 67¼ in)
Collection Walker Art Center, Minneapolis
Gift of the T.B. Walker Foundation, 1967
(B828)

In *Sculpture Three*, Caro's elements have become sleeker,
thinner and, more importantly, more fluid. A large trape-
zoidal shape anchors the work, while a series of long,
extending appendages curl up to and off the high crossbar.
The work mimics the natural elements of trees, vines and
vegetation that surround it at the Walker Art Center's
Sculpture Garden. As the seasons change from spring
to autumn, *Sculpture Three* seems to take on the con-
trasting characteristics of both growth and death,
shifting and transforming in the light and weather
of its permanent home.

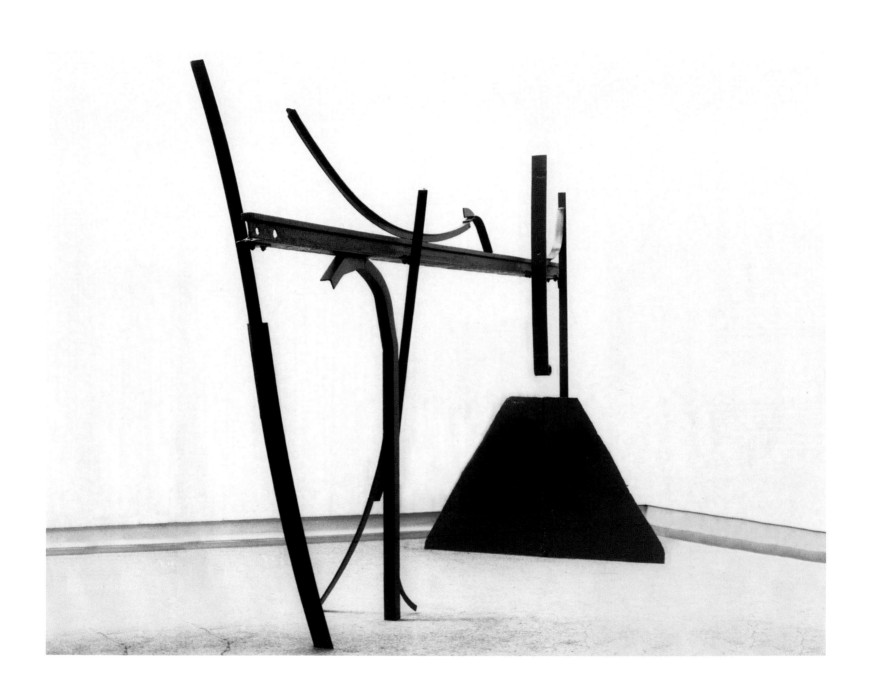

8 Hop Scotch

1962
Aluminium
250 x 213.5 x 475 cm (98½ x 84 x 187 in)
Caro Family Collection
(B829)

Caro's impulse towards straight, open line reaches a new
achievement in *Hop Scotch*. In contrast to his practice in
many other works from this period, Caro chose to retain
the silver sheen of the raw material employed, aluminium.
The work itself is a result of the limitations of working in
his one-car garage studio at home. The narrow dimensions
of his workspace allowed him to wedge the long horizontal
bars of the work across the entire width, creating a ladder
structure of sorts and enabling him to play with adding
and subtracting a variety of elements, without worrying
about the necessity of support, until he felt the work was
finally resolved.

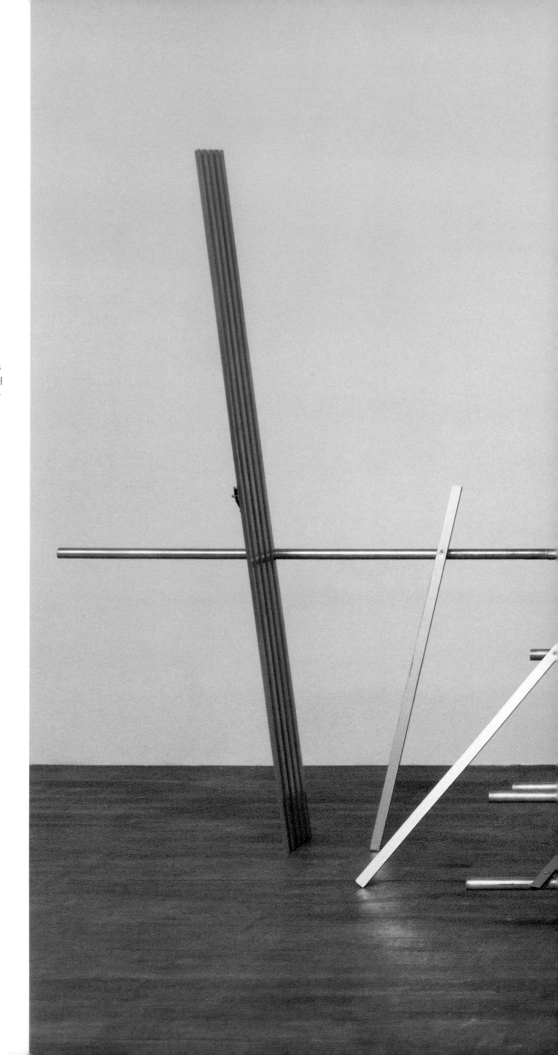

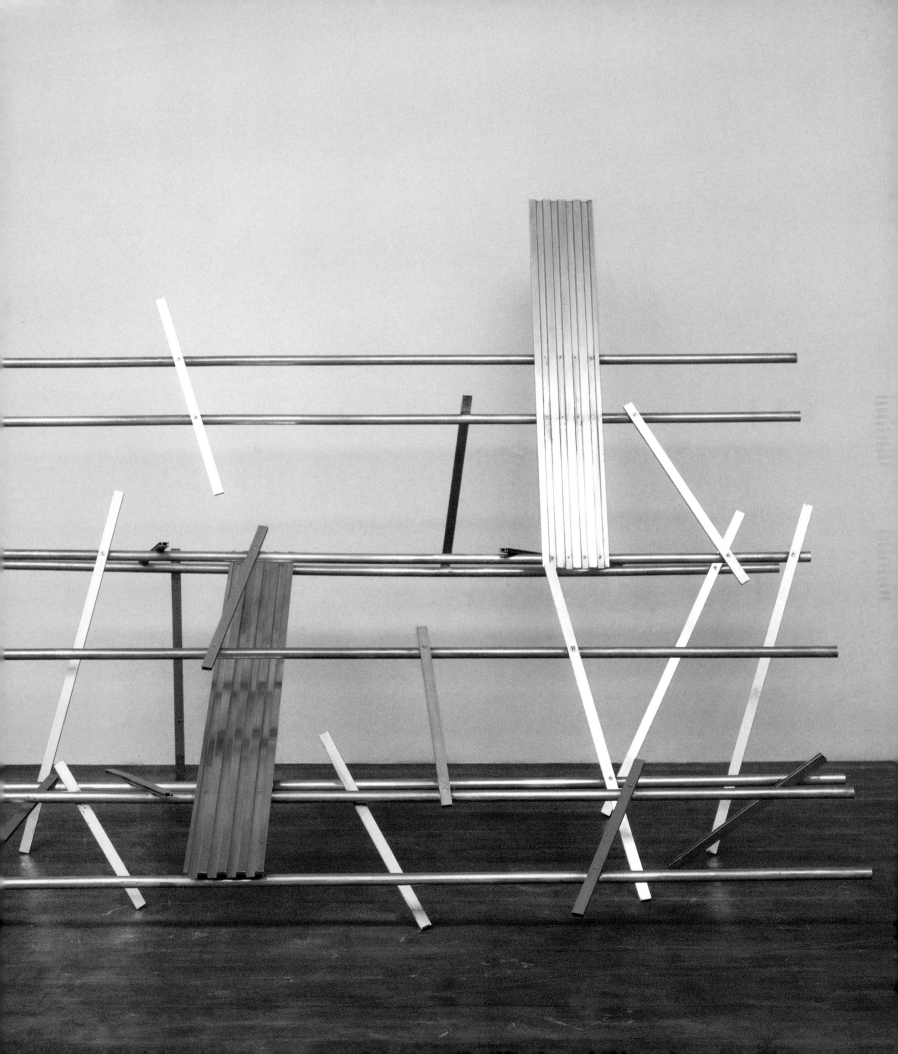

9 Month of May

1963
Steel and aluminium, painted magenta, orange and green
279.5 x 305 x 358.5 cm (110 x 120 x 141¼ in)
Caro Family Collection
(B833)

Another celebrated early work, *Month of May* was also
part of Caro's solo exhibition at the Whitechapel Art
Gallery. The most linear work that the artist had created to
date, *Month of May* reaches up and out, into the air that it
defines and shapes. Drawing in space is further emphasised
by the fluid, lyrical lines of the corresponding elements.
That parts are distinguished by being painted orange,
magenta and green increases the rhythm and compositional
tension of the work. Caro's quest to defy gravity, to put a
work up in the air and have it stay there is successfully
achieved (see p.16).

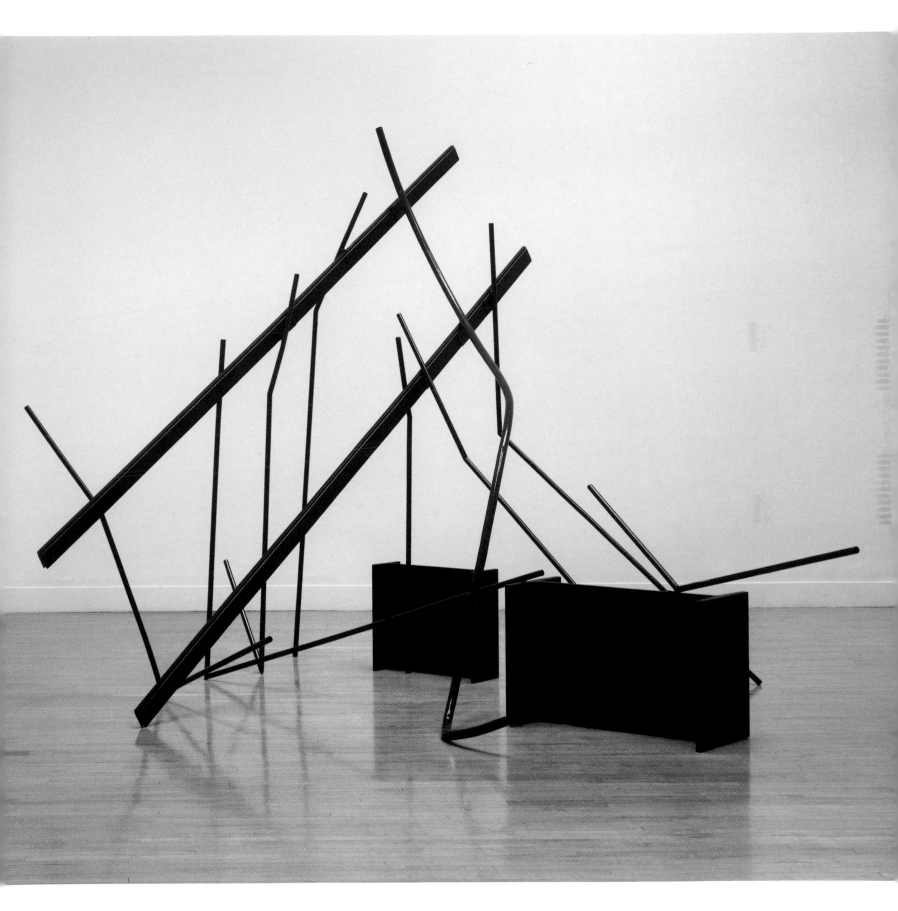

10 Prospect

1964
Steel, painted red, orange, blue and green
272 x 251.5 x 30.5 cm (107 x 99 x 12 in)
Museum Ludwig, Cologne
(B834)

Prospect is the first piece created by Caro at Bennington
College, Vermont, and it retains the vestiges of the
sculptor's previous experiments with I-beams in his
London studio. Very vertical in its orientation, with the
three long beams reaching diagonally into space, the work
seems to have been caught in mid-stride, walking along
the ground.

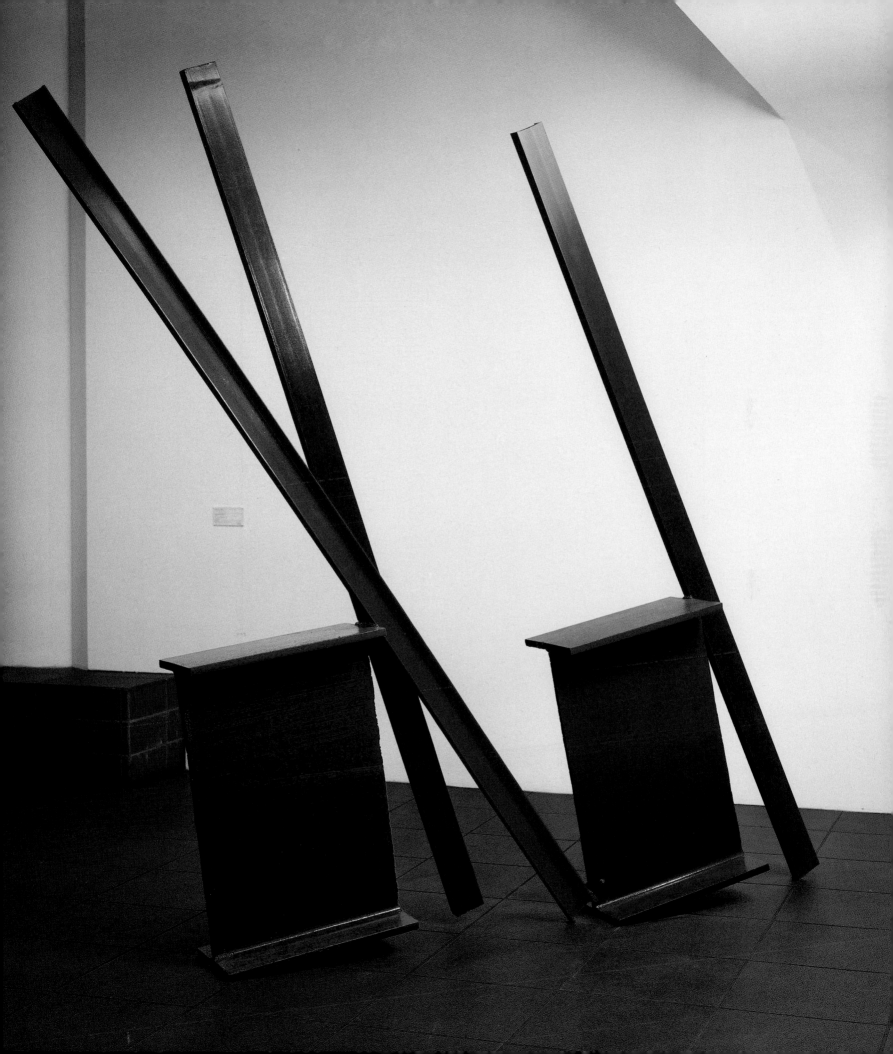

11 Shaftsbury

1965
Steel, painted purple
68.5 x 323 x 274.5 cm (27 x 127¼ x 108 in)
Private Collection, Maine, partially owned by The Museum
of Fine Arts, Boston, Massachusetts, USA
(B847)

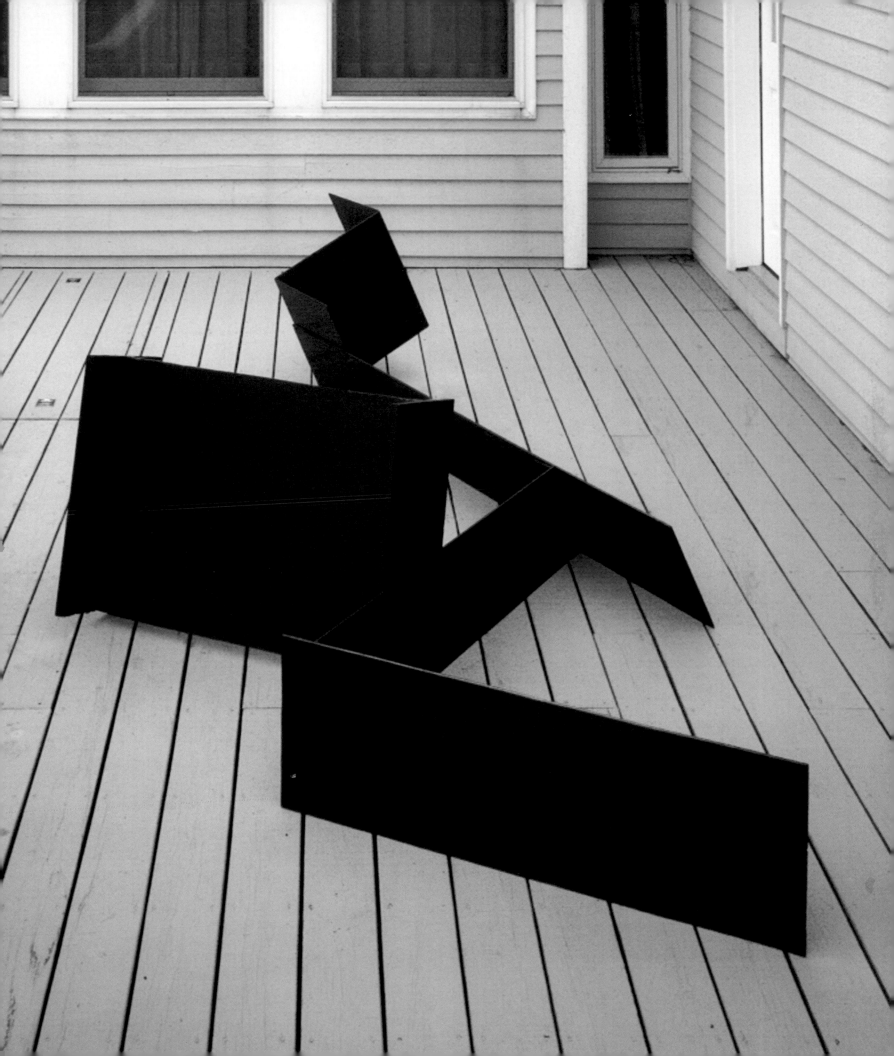

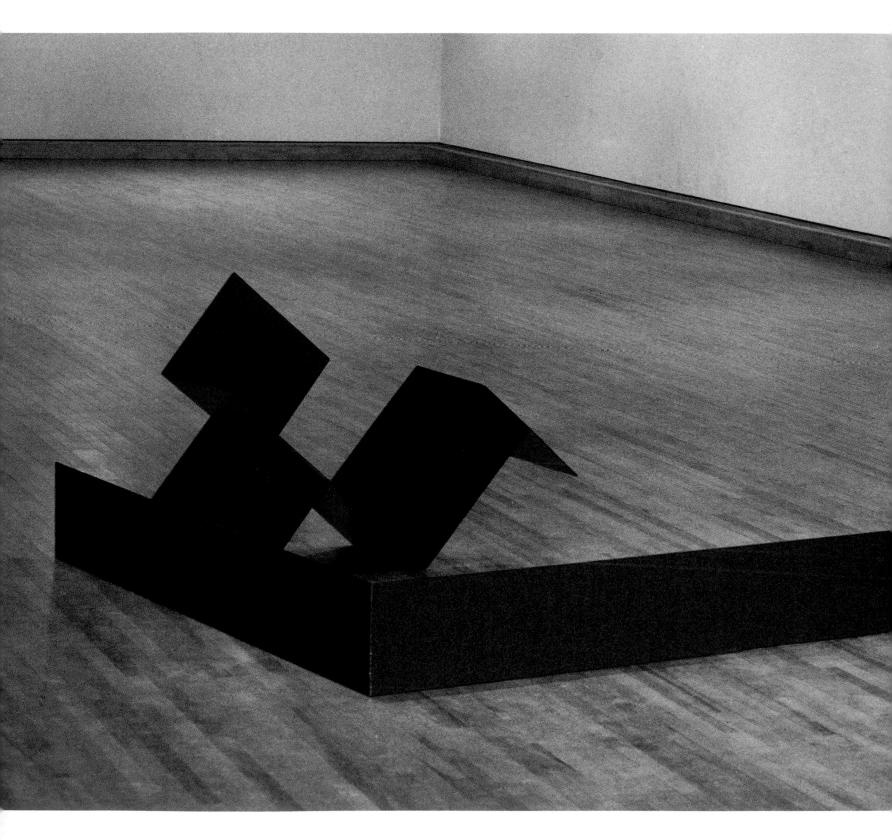

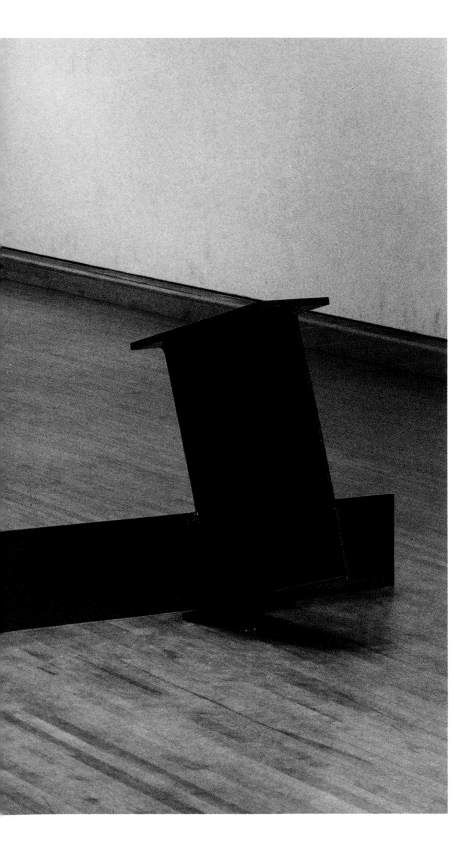

12 Titan

1964
Steel, painted blue
105.5 x 336 x 290 cm (41½ x 132¼ x 114¼ in)
Art Gallery of Ontario, Toronto
(B840)

Titan was created at Bennington College along with several other related pieces, some including the I-beams that Caro was working with in London and others incorporating the Z-shaped steel panels that the artist discovered in the USA. *Titan* is composed using both types of material. Like the rest of the works in the Bennington series (with the exception of *Prospect*), *Titan*'s short walls extend along the floor, exemplifying what Greenberg noted in his 1965 essay as the 'ground-flung' nature of Caro's work from this time.

13 Pulse

1964
Steel, painted pink and green
54.5 x 142.5 x 282 cm (21½ x 56¼ x 111 in)
Private Collection, USA
(B839)

Pulse is indicative of many other works created during Caro's time at Bennington College in 1964, which move away from a vertical formation and instead become more parallel to the ground. The zigzag steel panels that make up the body of *Pulse* are so delicately balanced that the long pole which extends beyond the breadth of the work appears to be in imminent danger of rolling off. As in *Month of May*, the work's opposing elements are painted in different colours adding to this palpable tension.

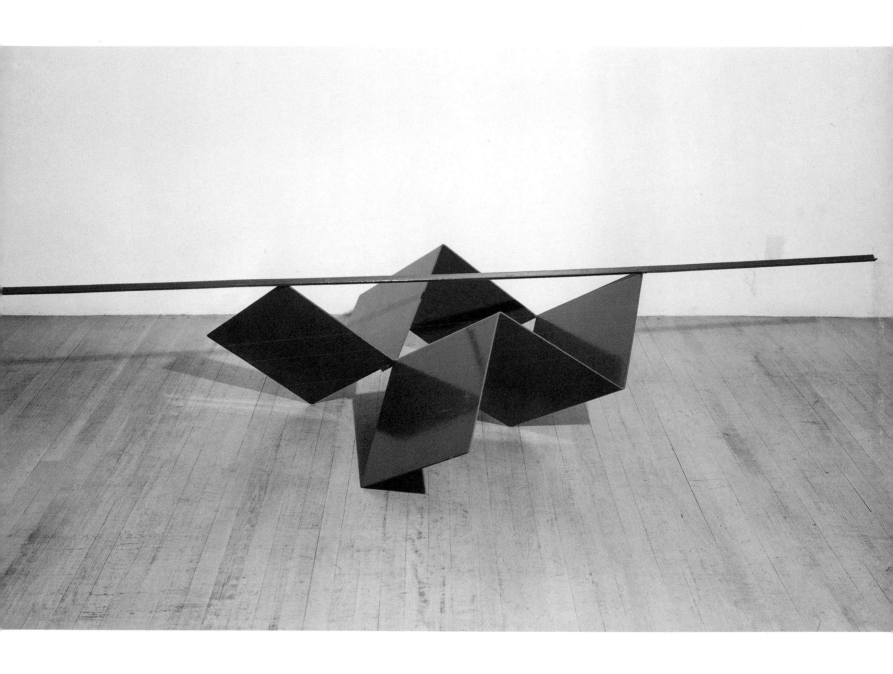

14 Wide

1964
Steel and aluminium, painted burgundy
149.5 x 152.5 x 406.5 cm (59 x 60 x 160 in)
Caro Family Collection
(B843)

This piece, created upon Caro's return to London from his
initial stint at Bennington College, is a culmination of the
lessons learned and the experiments undertaken in the
previous months. Utterly linear in its formation, *Wide* is
stripped down to essentials, yet it explodes with energy
and dynamism. The sculpture was exhibited alongside
another London-created work, *Lal's Turn*, and three other
pieces Caro made while at Bennington, *Prospect*, *Titan*
(plates 10, 12) and *Bennington* (all 1964), in his first
exhibition in New York at the André Emmerich Gallery.
The exhibition received considerable positive response
and marked Caro's arrival onto the New York art scene.

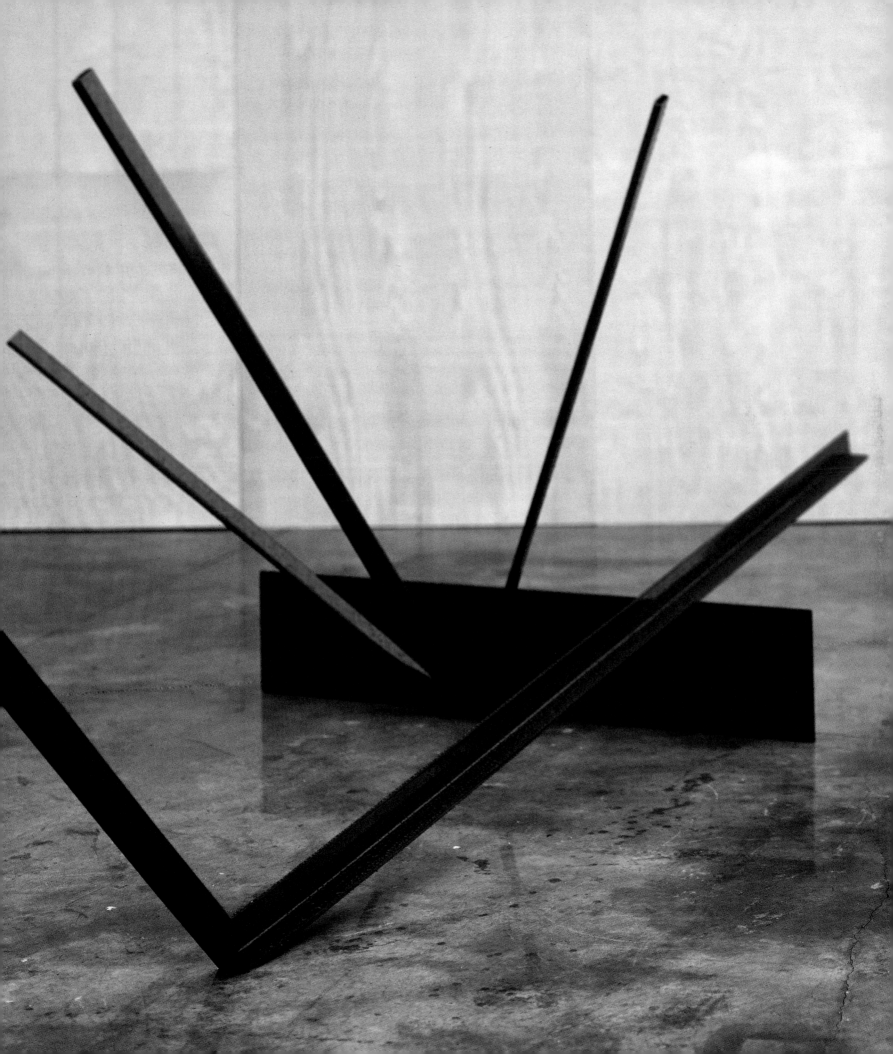

15 Glengarry Radish

1965
Steel, painted red
295 x 61 x 30.5 cm (116 x 24 x 12 in)
The Dayton Art Institute, Museum purchase
(B848)

Composed of two steel poles shooting up and to the side
at a discrete angle from a rather short, wave-like foot,
Glengarry Radish is characteristic of the 'naked' sculptures
Caro strove to create when he returned to Bennington
College in 1965. Similar in composition to another work in
this series, *Eyelit* (1965; plate 16), *Glengarry Radish* exploits
the tension inherent in balance, leverage and weight.
However, in contrast to *Eyelit*, *Glengarry Radish* has two
parallel arms that vibrate in the natural light, creating
wonderful illusory linear effects in shadow that run over
and out from the modest foot.

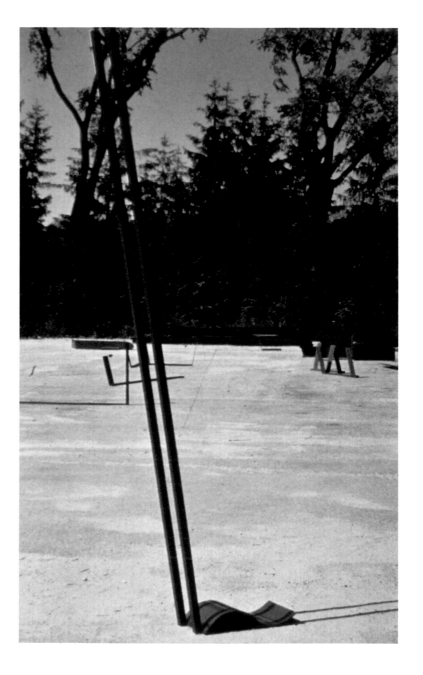

16 Eyelit

1965
Steel, painted blue
286 x 168 x 7.5 cm (112½ x 66¼ x 3 in)
Mr and Mrs William S.Ehrlich, New York
(B853)

Quite literally a line in space, *Eyelit* became a launching
point for Caro to explore drawing in space through the
most economical and elegant means. Caro has described
how with *Eyelit* he had tried to get so close to the edge
of the piece that it was hardly there at all. During his
six-week teaching stint at Bennington College, the artist
created a whole series of works stripped back to their most
essential and purest aspects. These new 'naked' pieces were
executed with the advice and encouragement of his fellow
faculty member, the American Colour-Field painter, Jules
Olitski, who had suggested that Caro abandon the 'walls'
in his sculptures (see p.19).

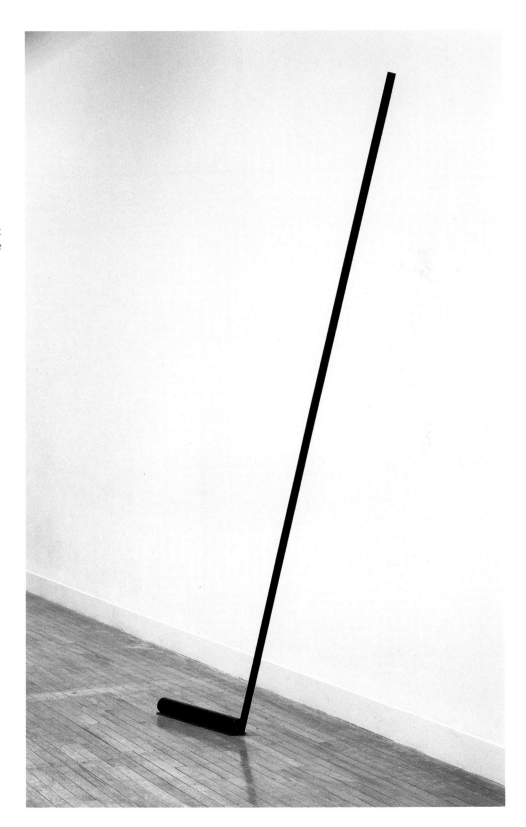

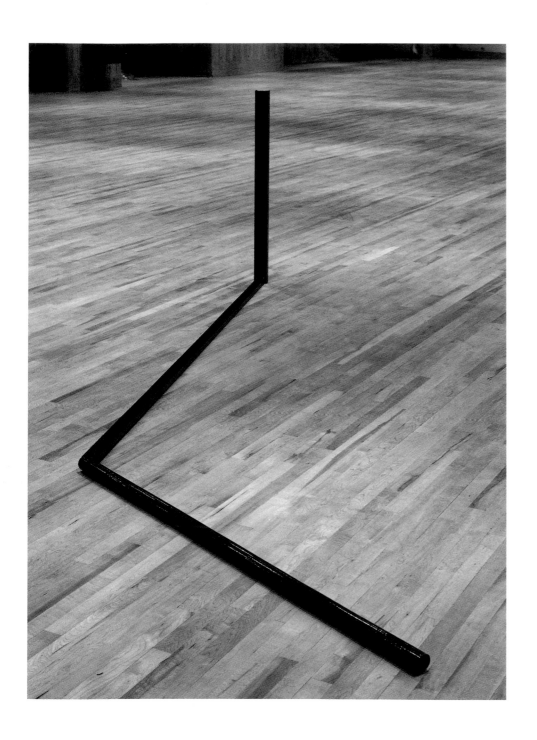

17 Smoulder

1965
Steel, painted purple
106.5 x 465 x 84 cm (42 x 183 x 33 in)
Caro Family Collection
(B857)

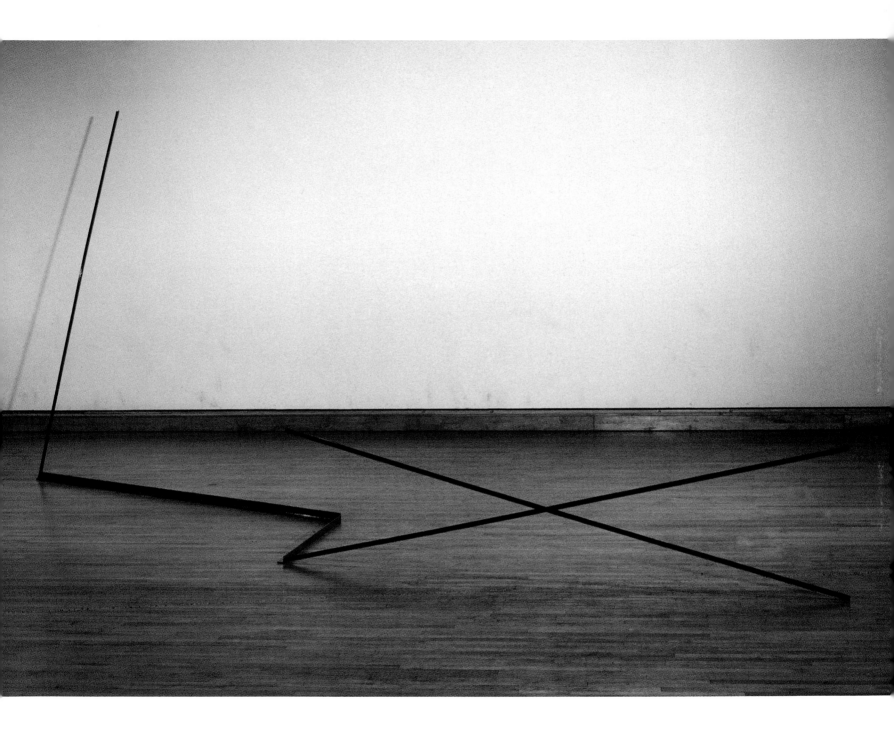

18 Sleepwalk

1965
Steel, painted orange
279.5 x 254 x 731.5 cm (110 x 100 x 288 in)
Collection of David Winton Bell Gallery, Brown University,
gift of Richard and Hélène Rubin
(B862)

19 Sill

1965
Steel, painted green
44 x 142 x 190.5 cm (17½ x 56 x 75 in)
Collection of Frank Stella
(B873)

Another 'naked' sculpture, Sill is probably the most
'grounded' piece, with the majority of the sculpture residing
on the floor. At first sight, the sculpture appears as a
counting scheme of sorts, in which the four straight bars
are stroked through by the long curving fifth bar. However,
it is the freshness of the work that is really striking. While
looking at this work, the viewer gets the sense of Caro's
ability to play with the various elements, laying them side
by side, and across, adding and subtracting, and more
significantly knowing when to stop and consider the
piece completed.

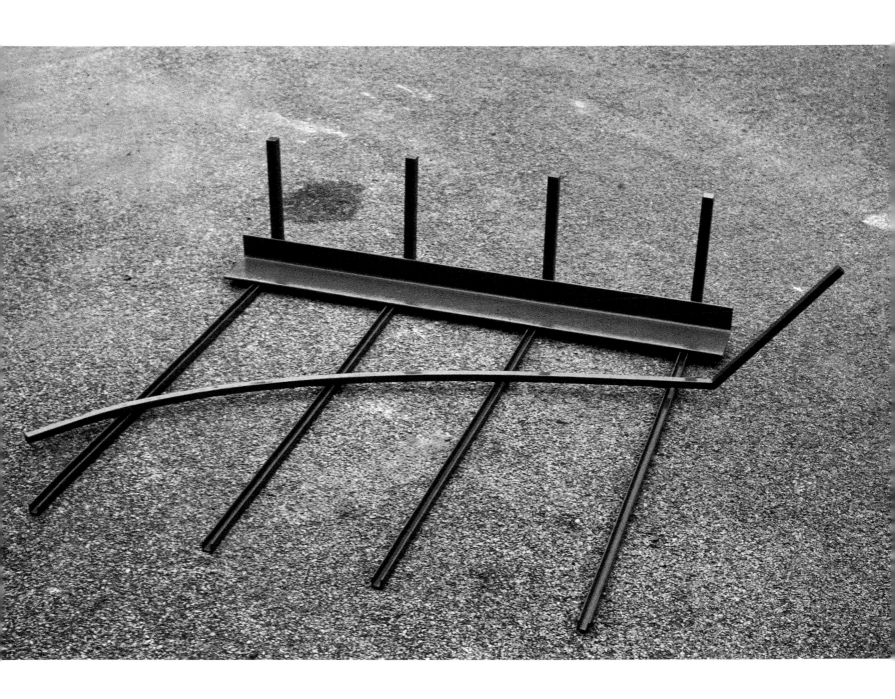

20 Table Piece VIII

1966
Steel, polished
58.4 x 9.5 x 35.6 cm (23 x 3¾ x 14 in)
Caro Family Collection
(B8)

In 1966, during a conversation with Caro, the art critic
Michael Fried pointed out that a table was similar to the
ground in terms if its flat horizontal orientation, but unlike
the ground it was more human in scale. This potent idea
sparked an entirely new body of work for Caro – his series
of *Table Pieces*. By employing the table surface as an
integral part of his sculpture, Caro was provided with
unlimited possibilities to create much smaller-scale works
than he had in the past. The *Table Pieces* have been a
parallel method of working that has persisted in Caro's
practice throughout his entire career.

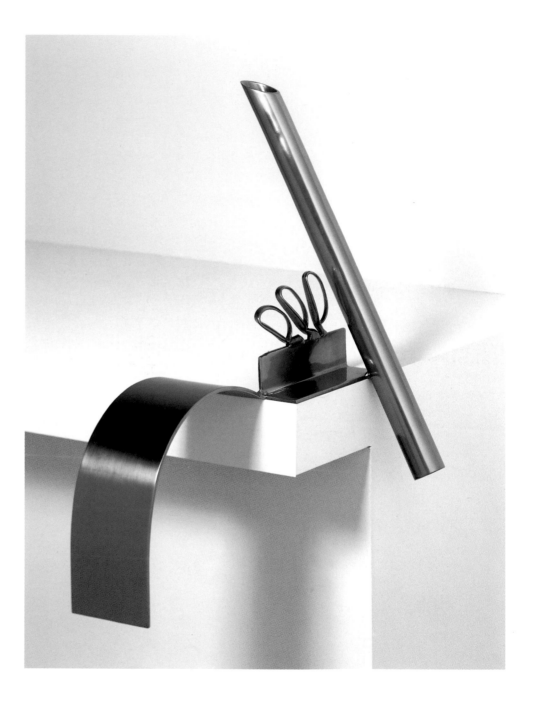

21 Table Piece XVII

1966
Steel, polished and lacquered
88.9 x 53.3 x 14 cm (35 x 21 x 5½ in)
Collection of Frank Stella
(B17)

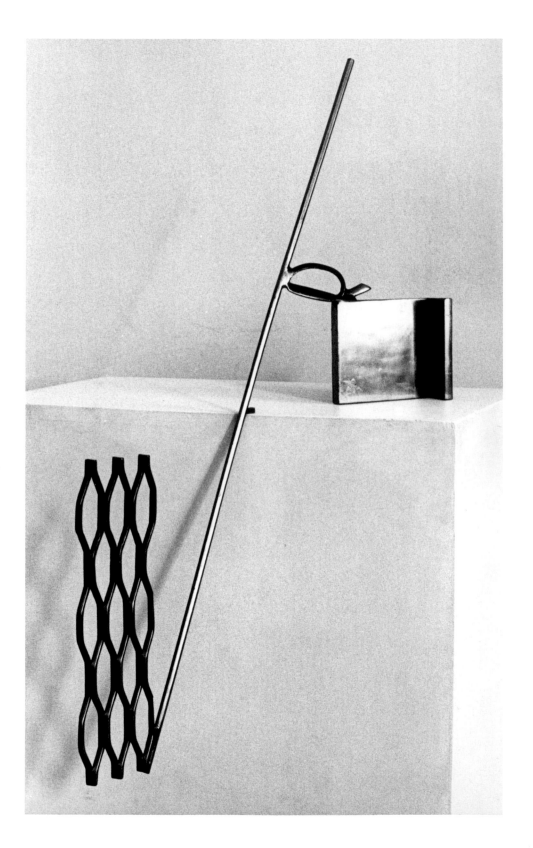

22 Carriage

1966
Steel, painted blue
195.6 x 203.2 x 396.2 cm (77 x 80 x 156 in)
Raymond and Patsy Nasher Collection, Dallas, Texas
(B894)

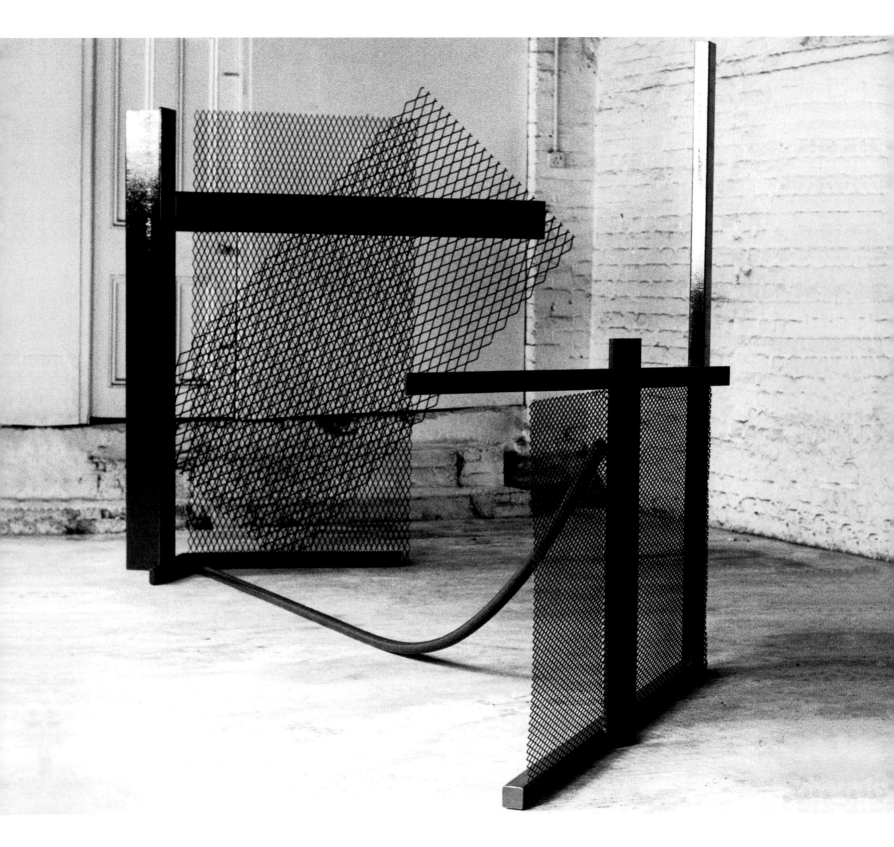

23 Deep Body Blue

1967
Steel, painted stark blue
149 x 256.5 x 315 cm (58¾ x 101 x 124 in)
Private Collection, Maine, partially owned by The Museum
of Fine Arts, Boston, Massachusetts, USA
(B908)

Deep Body Blue spreads its arms out open to the viewer,
beckoning one to come closer. The two main vertical
elements mirror each other, while their contrasting and
opposing arms, one straight and more substantial, the other
curling and delicate, reach towards each other into the
interior space. This outline effectively acts like a door that
breaks up the environment into two categories: in front and
behind; before and after. Caro is skilled at using a minimum
of items to create an evocative work that not only defines
space, but also creates a representation of a threshold,
connoting a type of transformation or change.

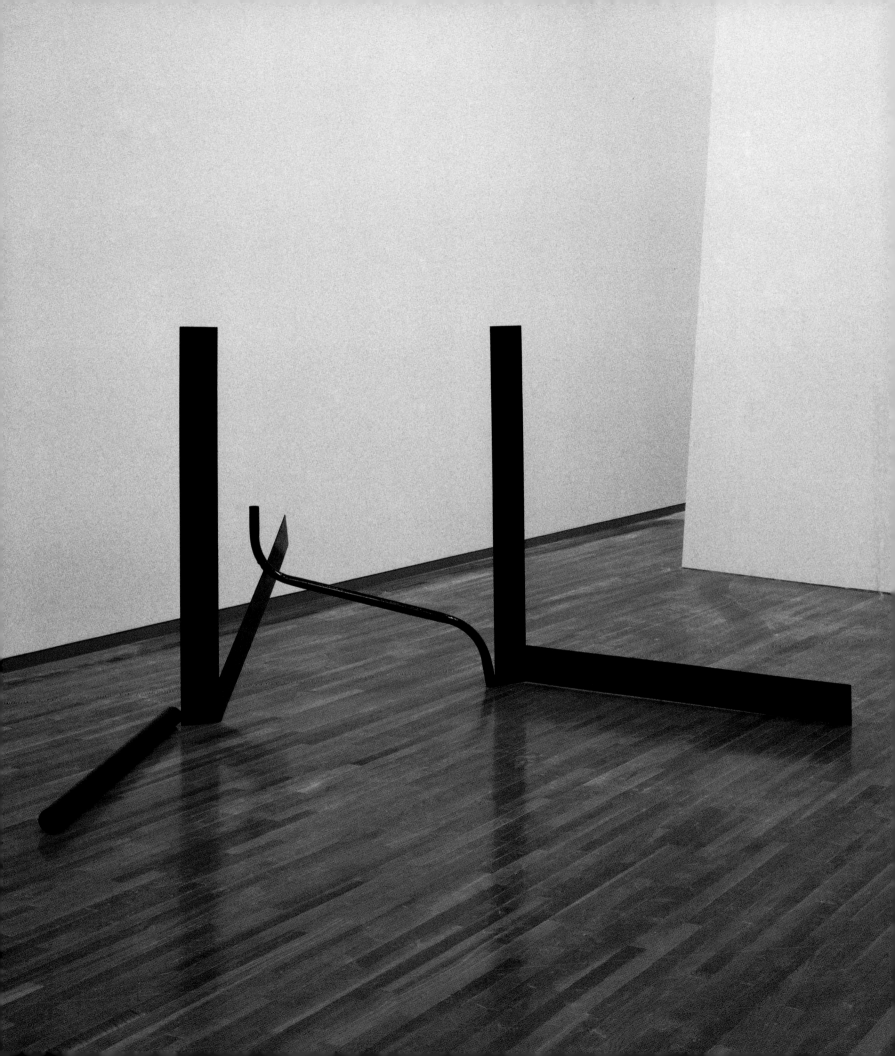

24 Aroma

1966
Lacquered blue over polished steel
96.5 x 294.5 x 147.5 cm (38 x 116 x 58 in)
Private Collection, Germany
(B877)

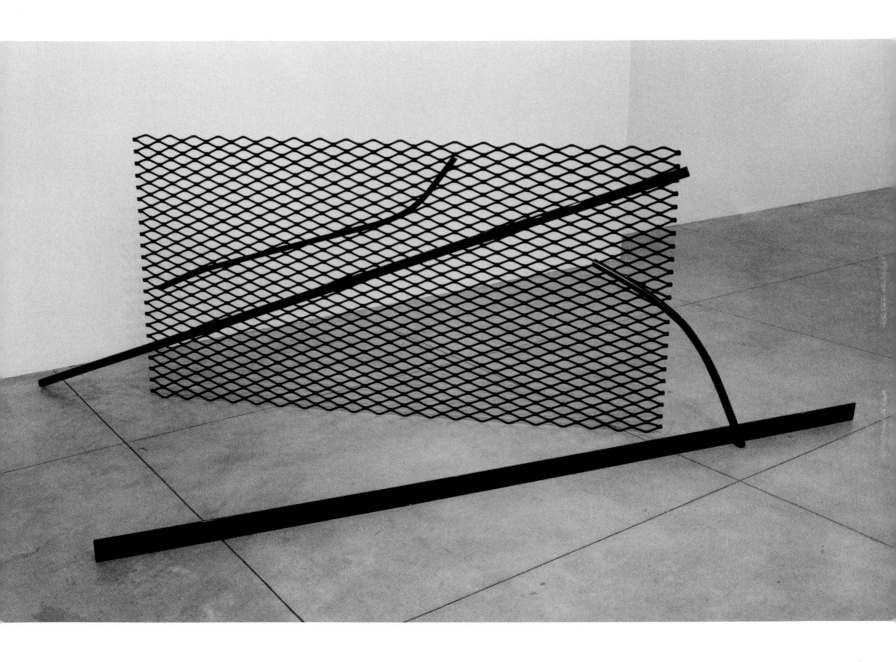

25 Red Splash

1966
Steel, painted red
115.5 x 175.5 x 104 cm (45½ x 69 x 41 in)
Collection of Audrey and David Mirvish, Toronto, Canada
(B879)

Red Splash is an example of Caro's experiments with large
sections of steel mesh composed in such a manner to evoke
a sense of weightlessness. The bright red colour of the
sculpture causes the piece to 'punctuate the space like an
exclamation mark'.[1] As one walks around the work, the
crossed mesh segments create all sorts of optical illusions.
Seeming to defy gravity, the entire central element of the
work appears to be floating in space, and the red vertical
tubes act more like piers upon which to anchor your eye.

1 Andrew Mead quoted in Barker 2004, p.337.

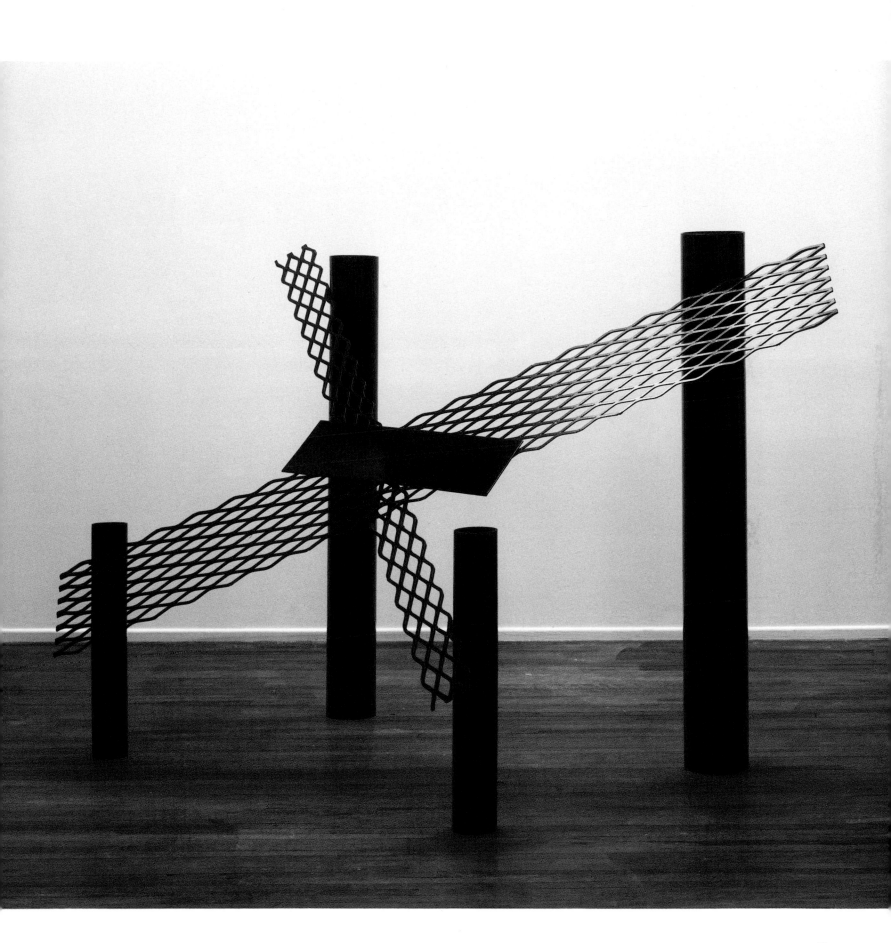

26 Source

1967
Steel and aluminium, painted green
185.5 x 305 x 358 cm (73 x 120 x 141 in)
The Museum of Modern Art, New York
Blanchette Hooker Rockefeller Fund (by exchange)
(B904)

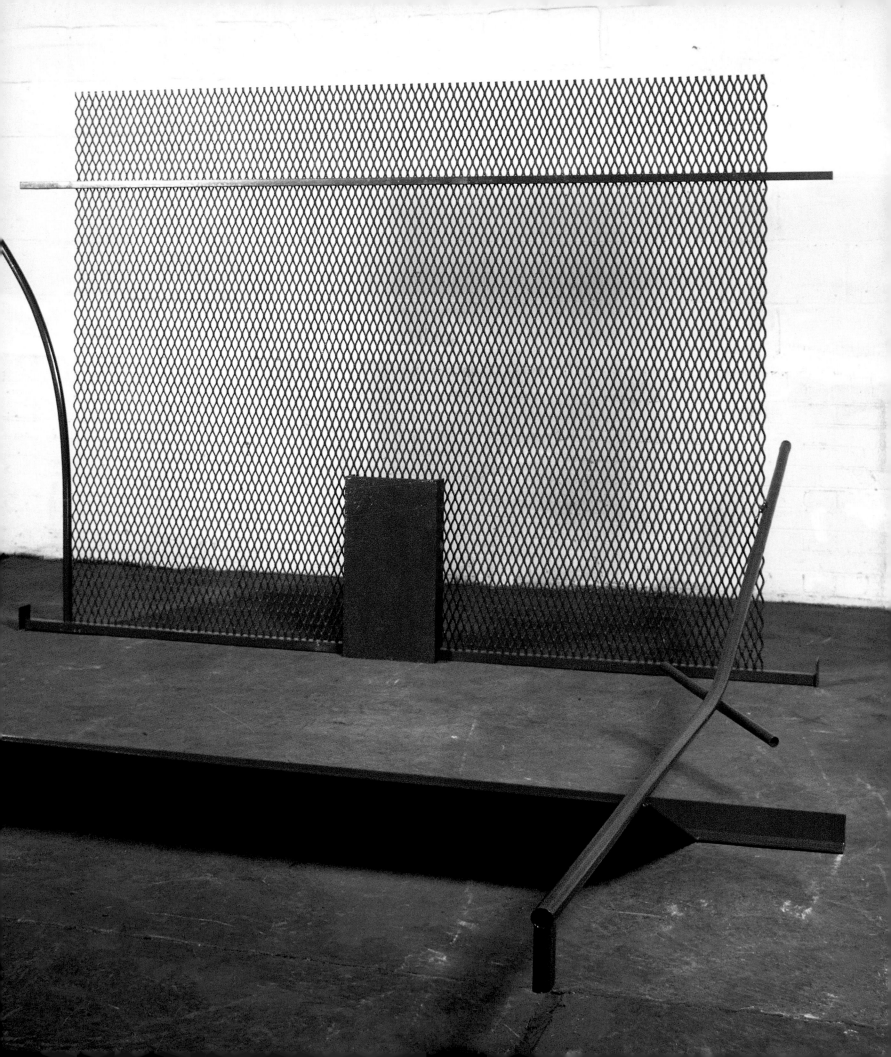

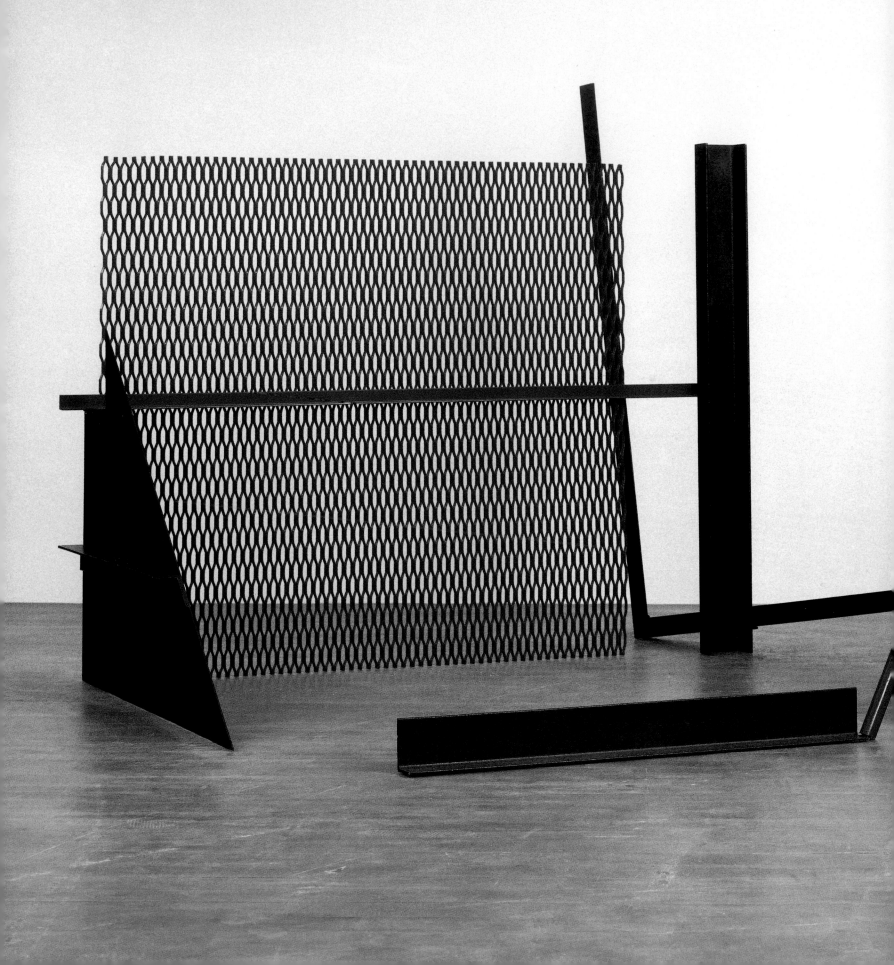

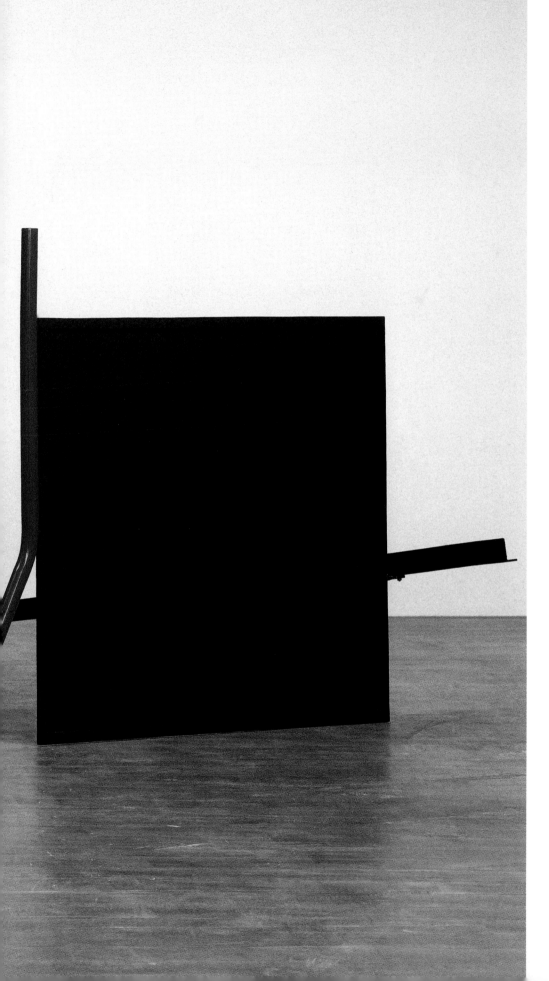

27 The Window

1966–7
Steel, painted green and olive
215 x 320.5 x 390 cm (84¾ x 126¼ x 153½ in)
Caro Family Collection
(B903)

In the mid-1960s, Caro began to incorporate large mesh panels in his work, as if 'clothing' his 'naked' sculptures. Like related works such as *Carriage* (plate 22), *The Window* is characterised by its internal space at the centre of the sculpture, an area that we cannot enter into physically yet are allowed to roam around in with our eyes. This fraught experience is further enhanced by the semi-transparent nature of the mesh, the ability to block off yet also penetrate. This series of sculptures prefigures Caro's most recent galvanised works based on the theme of passages, as exemplified by *South Passage* (2005; fig.16) and *Long Passage* (2007; plate 70).

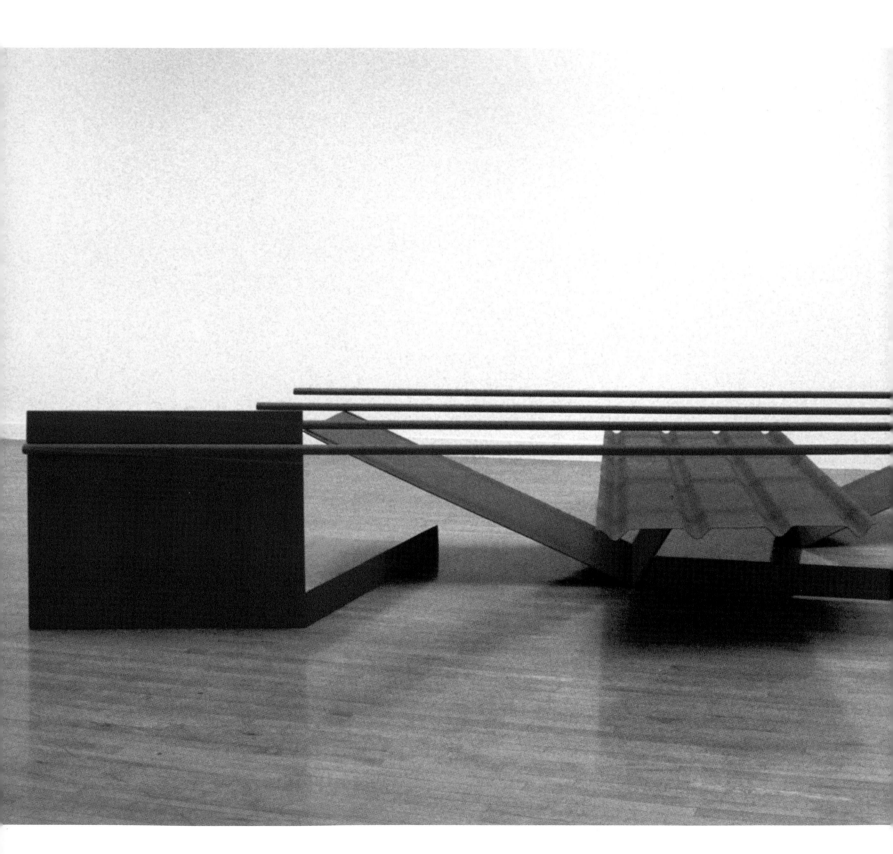

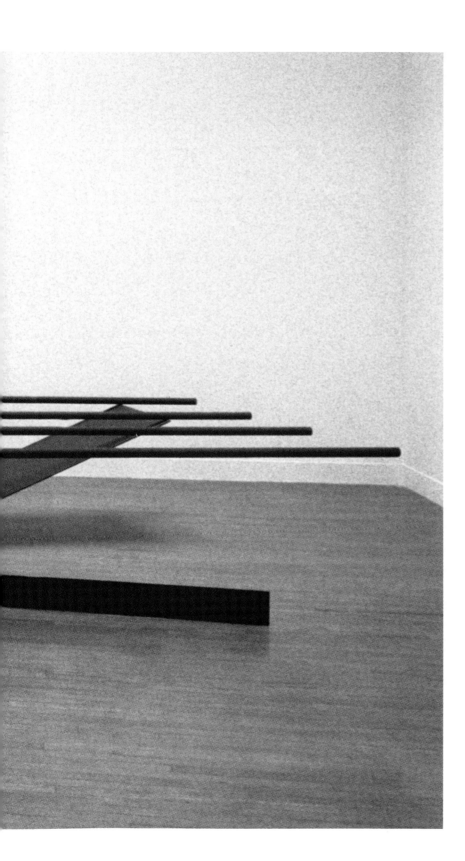

28 Prairie

1967
Steel, painted matt yellow
96.5 x 582 x 320 cm (38 x 229¼ x 126 in)
Collection of Lois and Georges de Ménil
(B911)

Prairie is one of Caro's signature works; it was featured on the cover of the February 1968 issue of the international art magazine *Artforum*. Touted as a masterpiece, since its creation the sculpture has been included in almost every major solo retrospective exhibition Caro has had up to present and as a consequence has been widely written about and critically well received. The magic of *Prairie* lies in the optical illusion of the four floating yellow bars that reach horizontally across its entire length. The 'table' element, an integral part of this work, becomes an especially provocative area that Caro proceeded to explore in future work.

29 Trefoil

1968
Steel, painted matt yellow
211 x 254 x 165 cm (83 x 100 x 65 in)
Collection of Audrey and David Mirvish, Toronto, Canada
(B920)

Taking its cue from Caro's experiments with tabletop
sculptures, *Trefoil* exploits the character of the elevated
'ground plane' in remarkable ways. Poised on three points,
the sculpture seems to be barely grounded – instead the
majority of the piece hovers just over the surface of the
floor. The work evokes the potential for the various arms to
shift and spin around the centre. We catch the work in the
briefest and most fleeting of moments, likened to a spinning
top that has just come to rest and yet is still balanced on
point before the loss of momentum causes it to topple over.

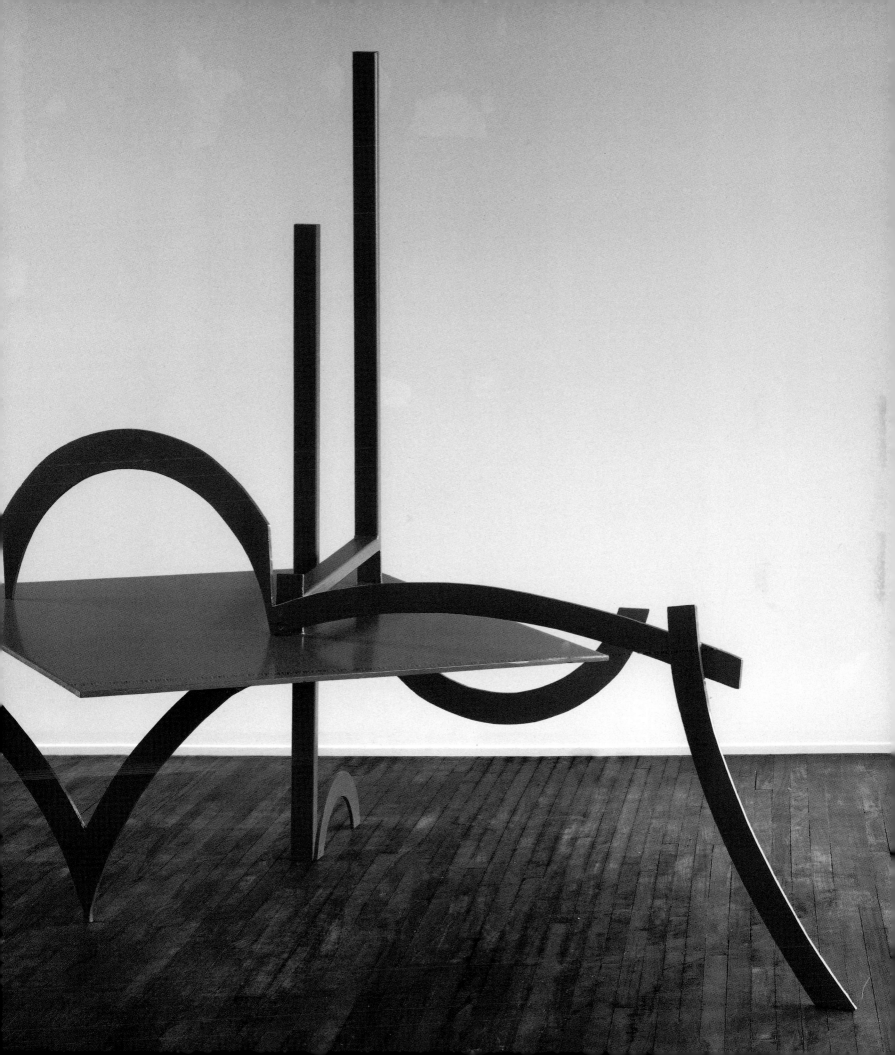

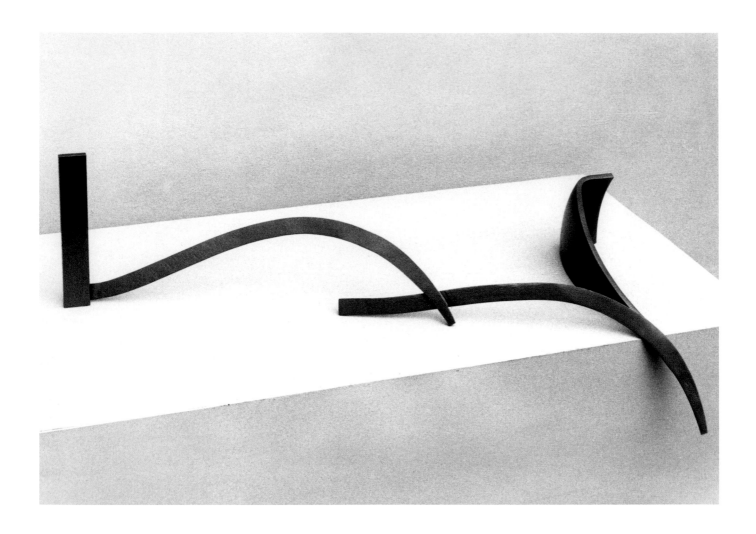

30 Table Piece LXII

1968
Steel, sprayed 'jewelescent' green
Collection of Elizabeth Lyman
58.4 x 115.6 x 35.6 cm (23 x 45½ x 14 in)
(B62)

Table Piece LXII is indicative of Caro's ability to take his
Table Pieces series of works further, making them larger
and more cursive without losing the sense of intimate
collaging. This work is particularly significant because it
incorporates a pair of callipers that Caro purchased from
the scrap metal left in the estate of the sculptor David
Smith. Caro was so pleased with this new progression in
his work that he wrote about it to art critic Michael Fried
incorporating a sketch of this particular sculpture, along
with a couple of others, at the bottom of his letter.

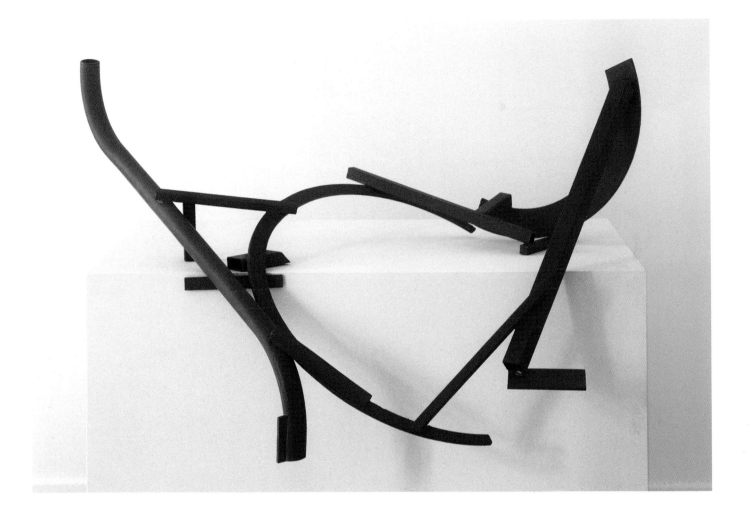

31 Table Piece LXIV (The Clock)

1968
Steel, painted zinc chromate primer
76.2 x 129.5 x 81.3 cm (30 x 51 x 32 in)
Private Collection
(B64)

Originally owned by the art critic Clement Greenberg,
Table Piece LXIV (The Clock) was first exhibited at the
André Emmerich Gallery, New York, in 1968. The *Clock*
is oriented on an axis that tilts at an angle in relation to
the vertical and horizontal plane of the plinth. The effect is
unsettling; as the piece splays it arms out, above and below
the surface of the table, the viewer puzzles on how this
work can freely support itself. The sculpture is indicative
of Caro's ability to collage elements to create internal
tensions that cause viewers to pause and repeatedly
rethink their initial understandings and interpretations.

32 Table Piece LXXXVIII (Deluge)

1969
Steel, painted zinc chromate primer
101.6 x 160 x 96.5 cm (40 x 63 x 38 in)
The Museum of Modern Art, New York
Gift of Guido Goldman in memory of Minda de Gunzberg
(B86)

Here we see direct evidence of Caro's interest in looking
to the paintings and drawings of a wide variety of artists
to find new ideas and ways to approach a problem.
Inspired by the Italian Renaissance master, Leonardo
da Vinci's *Deluge* series of drawings of a fierce, swirling
storm (fig.10), *Table Piece LXXXVIII* takes the curling and
twisting lines of wind and water and translates them into
three dimensions. The organic nature of the composition
of this work allies it with large-scale sculptures such as
Orangerie (1969; plate 35) and *Sun Feast* (1969–70; fig.9)
made around the same period.

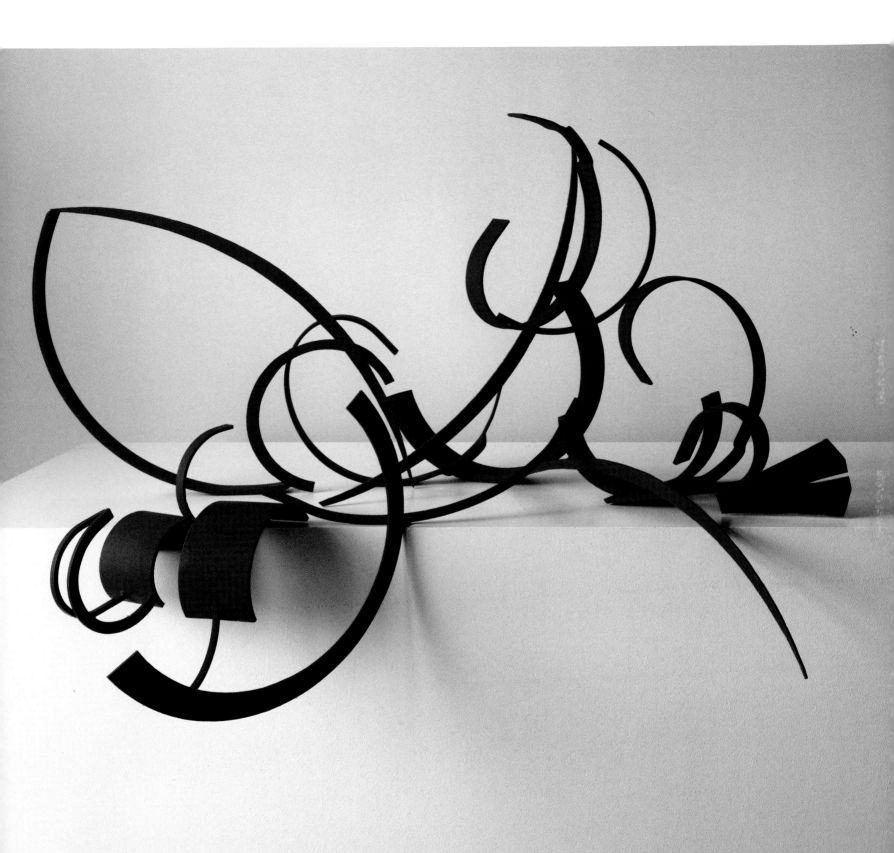

33 Wending Back

1969
Steel, painted grey
190.5 x 320 x 153.6 cm (75 x 126 x 60½ in)
The Cleveland Museum of Art
Contemporary Collection of the Cleveland Museum of Art
(B931)

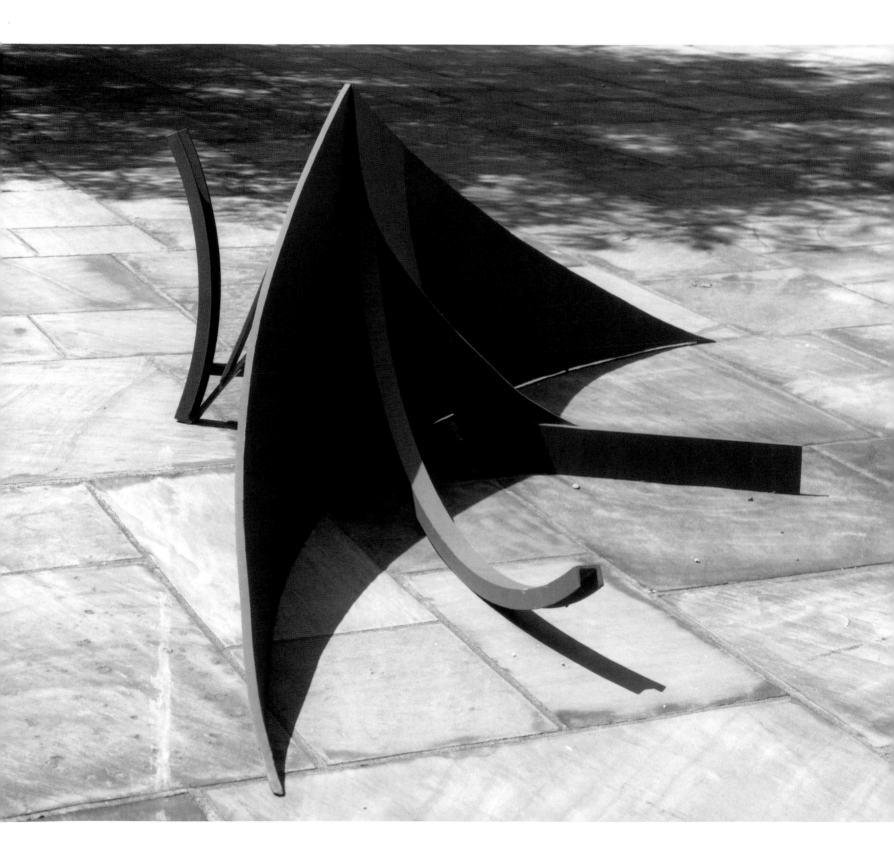

34 Georgiana

1969–70
Steel, painted red
155 x 292 x 472.5 cm (61 x 115 x 186 in)
Collection Albright-Knox Art Gallery, Buffalo,
New York
Gift of Seymour H. Knox, Jr., 1970
(B934)

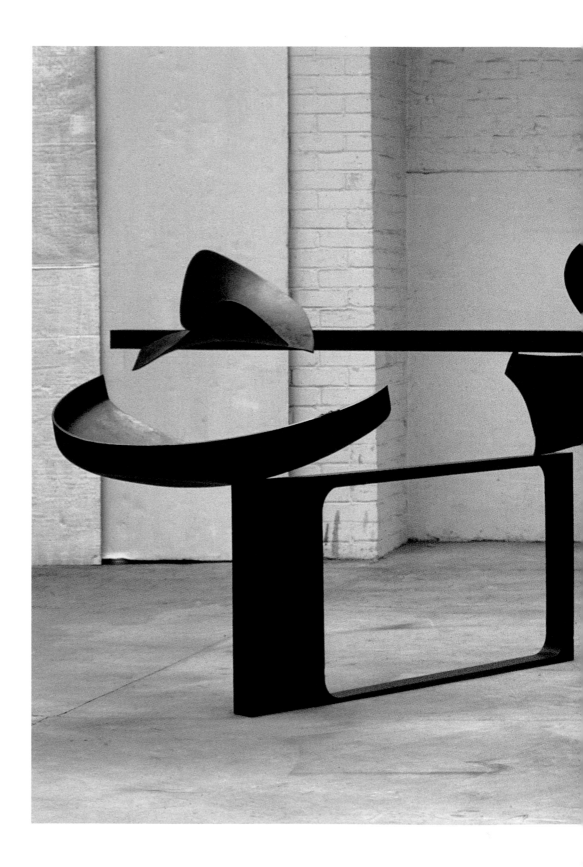

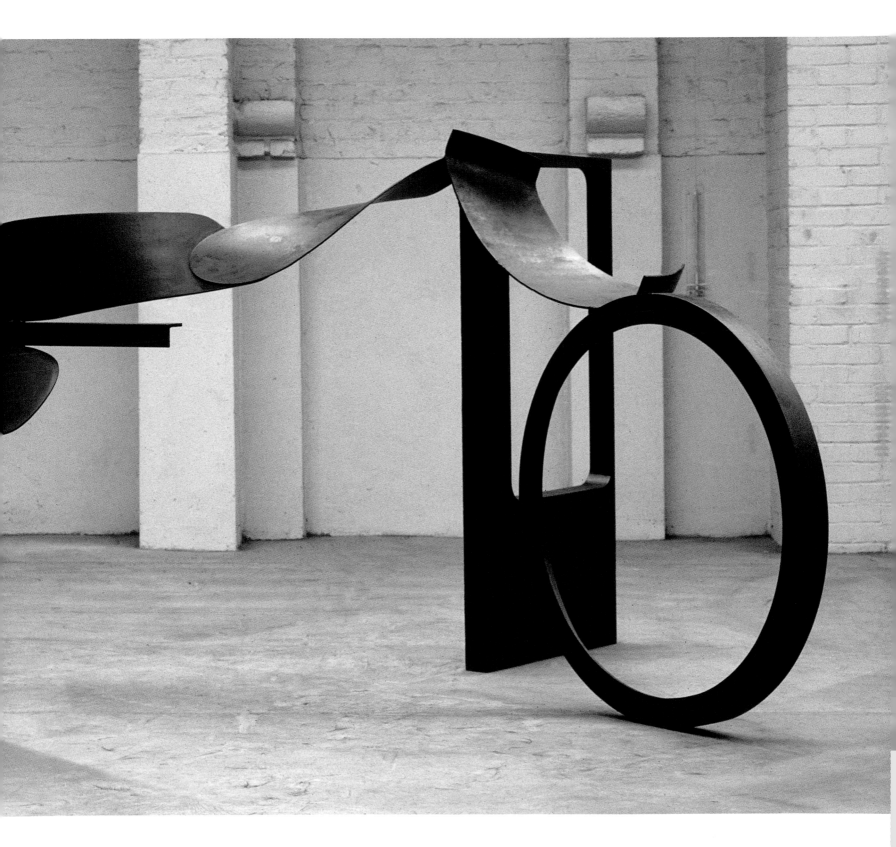

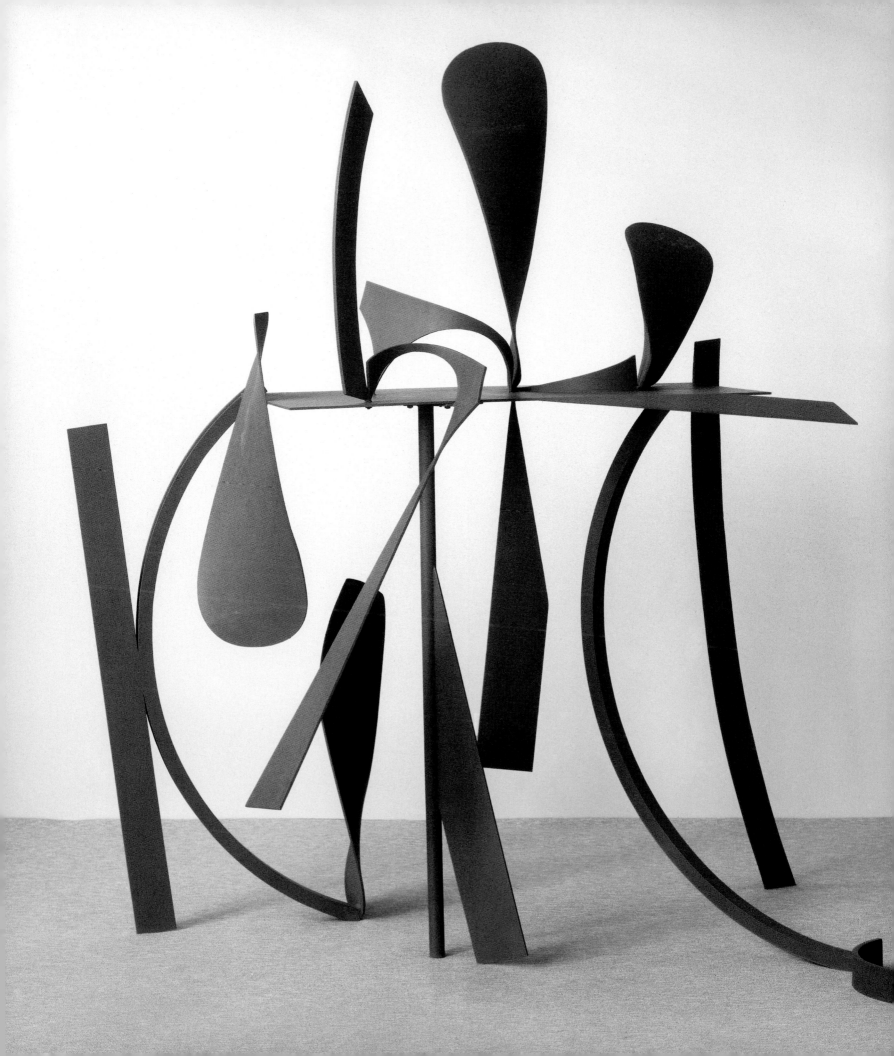

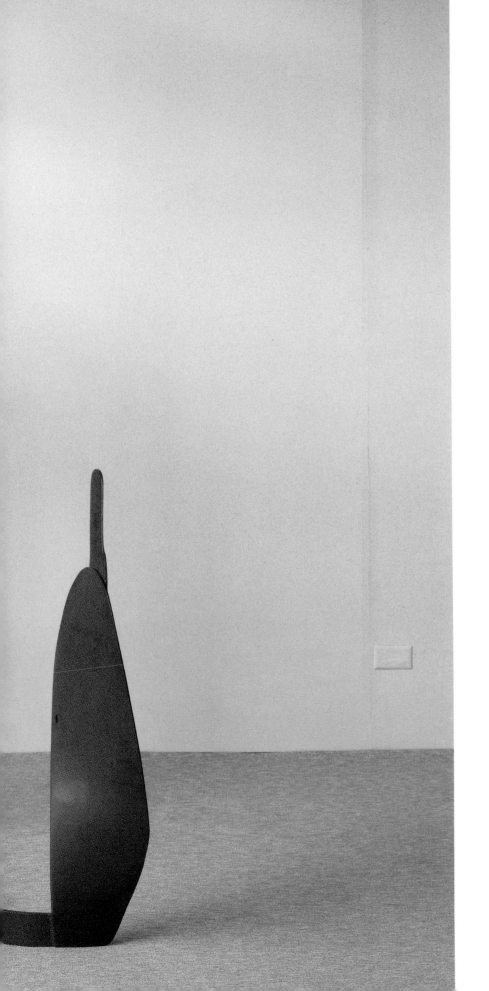

35 Orangerie

1969
Steel, painted red
225 x 162.5 x 231 cm (88½ x 64 x 91 in)
Collection of Kenneth Noland
(B929)

This elegant composition of curves and bends is fluid,
lush and almost leaf-like in its arrangement. The sculpture
incorporates the 'table' aspect explored in works such
as *Prairie* (1967; plate 28), but now simplification and
economy have been replaced by an effusive baroque
quality. The various elements, although retaining some
of their original identity as farm equipment, bend, greet,
swing and delight. From the 'table' section of the work,
the figures spiral out, reaching into the space of the viewer.
This exaggerated, implied motion is further emphasised
by the deep, rich colour. Almost theatrical in its presence,
Orangerie expresses exuberant drama that is completely
palpable and almost irresistible.

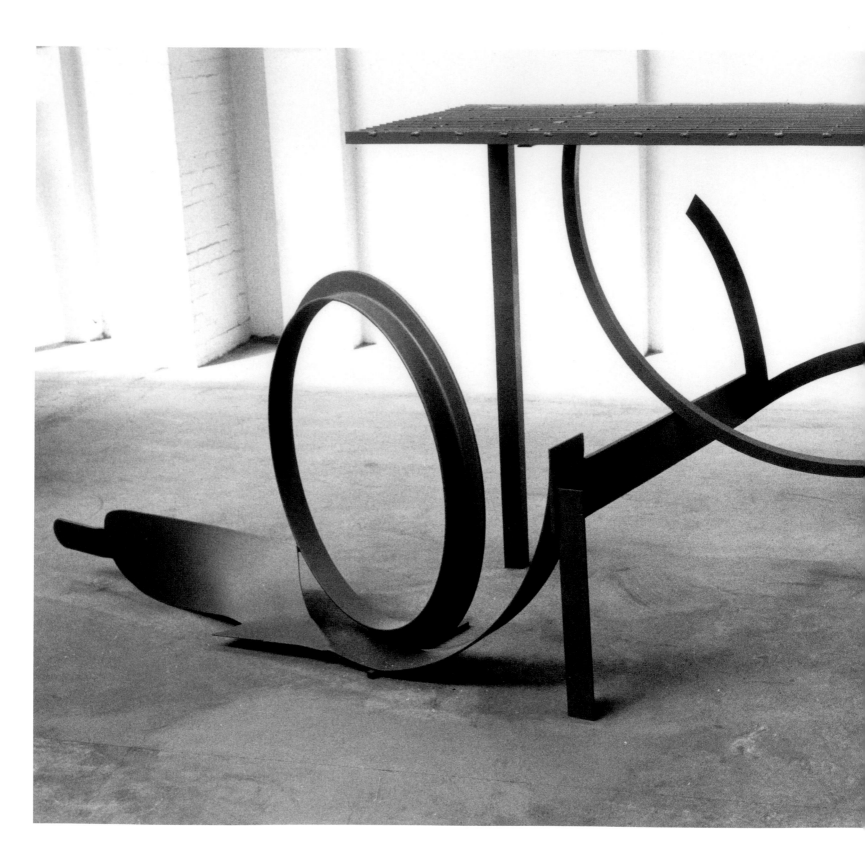

36 Clearing

1970
Steel and aluminium, painted burgundy
145 x 152.5 x 376 cm (57 x 60 x 148 in)
Gift of the Friends of the Philadelphia Museum of Art, 1972
(B941)

Like earlier pieces, *Clearing* is also indicative of
Caro's interest in incorporating a 'table' form into his
compositions. Instead of acting as an element upon
which various appendages, shapes and forms spring
off of or hover below, the table shape in *Clearing*
creates a ceiling plane that pushes the centre of
gravity down; in turn, the piece sprawls along the floor.
The thickness and height of the three table supports are
varied, which causes the 'tabletop' to rest at an angle,
suggesting a diagonal force that further enhances the
motions of downwards and outwards.

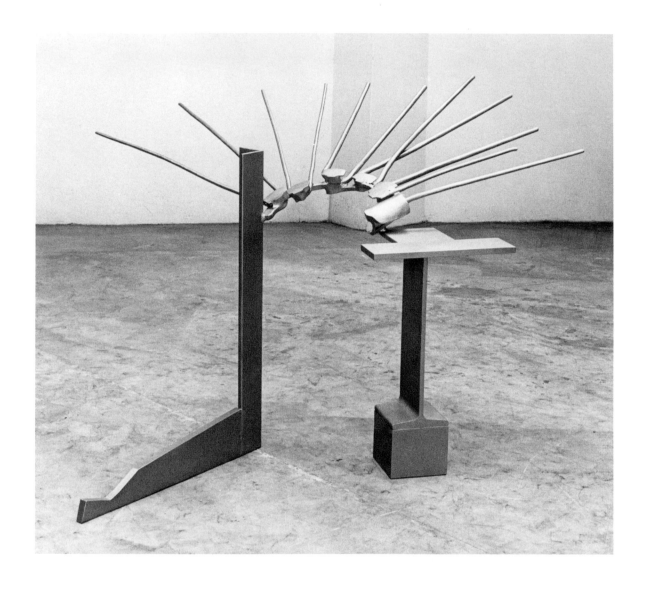

37 Semper

1970
Steel, painted grey
122 x 211 x 201 cm (48 x 83¼ x 79 in)
Collection of Audrey and David Mirvish, Toronto, Canada
(B943)

Semper is indicative of Caro's tendency to push forward in
new directions while still playing with consistent elements –
in this case the table plane and substantial legs with feet
that spread out and along the ground. Slim bars, which
seem to twist on various teeth, radiate from the centre of
the sculpture in a uniform yet slightly haphazard manner,
as if a bicycle wheel has just sprung its spokes wide open.
This fan of lines that reach out into the space of the viewer
is bracketed by the more solid, heavier legs that ground the
entire piece, prefiguring later 'cousin' works such as *Poise*
and *Serenade* (both 1970–71; plates 38, 39).

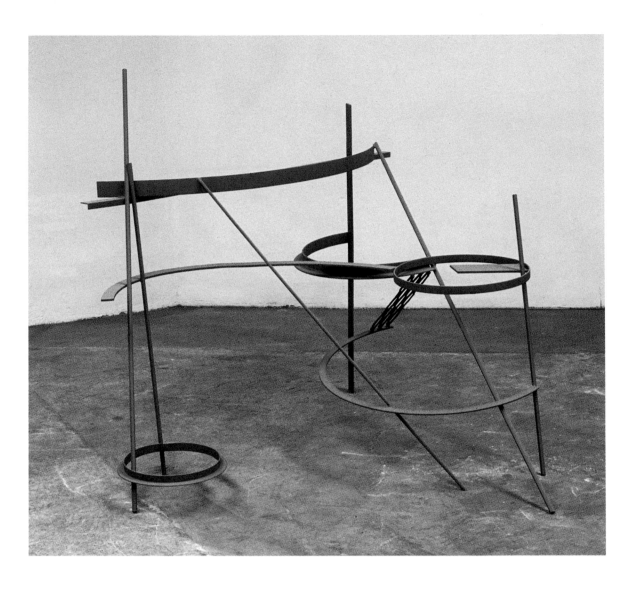

38 Poise

1970–71
Steel, painted grey
124.5 x 155 x 160 cm (49 x 61 x 63 in)
The Nelson-Atkins Museum of Art, Kansas City, Missouri
Gift of the Friends of Art
(B971)

Poise is a culmination of Caro's investigations of the
preceding years, with its extremely linear and open
construction. The circular elements in *Poise* define an
interior space that is compressed at one central axis point
and then expands outwards, above and below. Of note is
the small mesh segment collaged near the centre acting
as a connector between the various curling ribbons of steel.
This little mesh piece may have been a leftover from works
such as *The Window* (plate 27) and is indicative of Caro's
process – nothing is wasted, all bits of materials have the
potential to be made into art, if they remain in the studio
long enough.

39 Serenade

1970–71
Steel, painted
119.5 x 264 x 228.5 cm (47 x 104 x 90 in)
Private Collection, USA
(B967)

As he does in *Poise* (1970–71; plate 38), Caro incorporates
straight linear lines and curling elements to create a
rather magical piece, where lines float and hover; however,
in *Serenade* this happens just above and parallel to the
ground. Because of this, *Serenade* recalls the earlier
Prairie (1967; plate 28) in its composition, in which the
lines and joins create various optical illusions. *Serenade*
also prefigures Caro's production of 'bench-like' work in
Barcelona almost 16 years later – drawing-like works
in which the interior space is limited and compressed by
the bars that make up the dominant central plane.

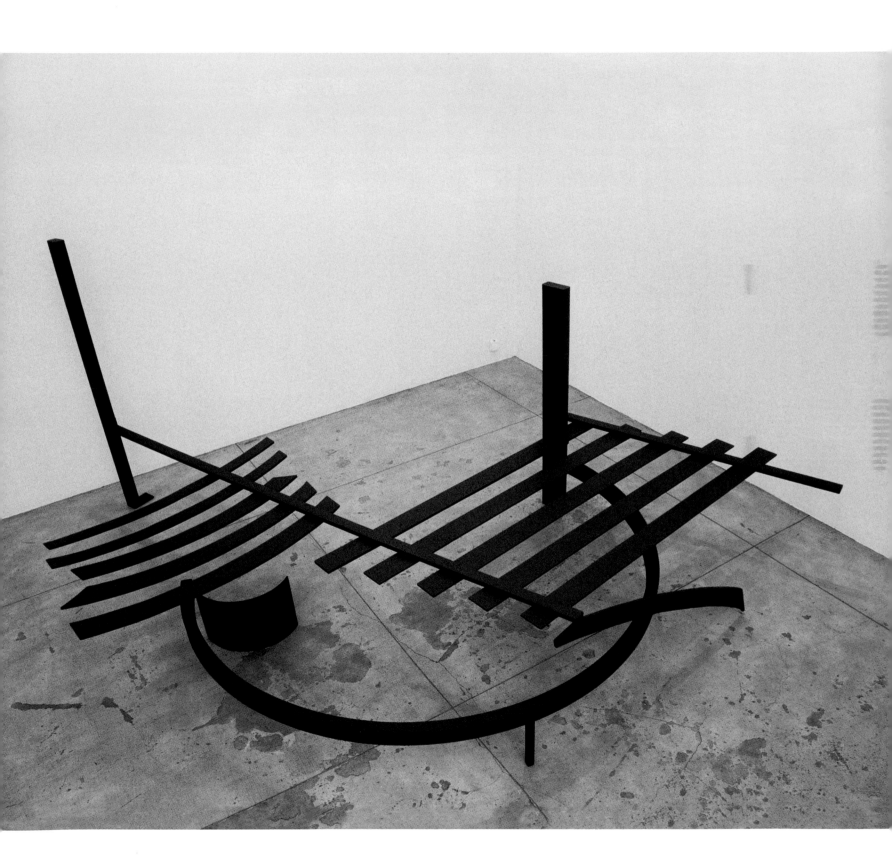

40 Silk Road

1971–4
Steel, rusted and varnished
152.5 x 388.5 x 86.5 cm (60 x 153 x 34 in)
Collection of Audrey and David Mirvish, Toronto, Canada
(B1064)

Part of Caro's *Racks* series, *Silk Road* shows the artist's
progression towards more substantial, aggressive and raw
use of line. This architectonic series seems to refer back
to Caro's earlier work with steel girders and I-beams, and
prefigures the very massive *York Pieces* created in the
autumn of 1974. As with many of the works in the *Racks*
series, *Silk Road* was started at Bennington College in
1971 and then completed in early 1974 for exhibition.
Silk Road demonstrates Caro's new way of unifying the
various elements of the piece by allowing the natural 'skin'
of the material to rust and then be varnished, rather than
painting it.

41 Table Piece CC

1974
Steel, varnished
64.8 x 194.3 x 111.8 cm (25½ x 76½ x 23¾ in)
Caro Family Collection
(B204)

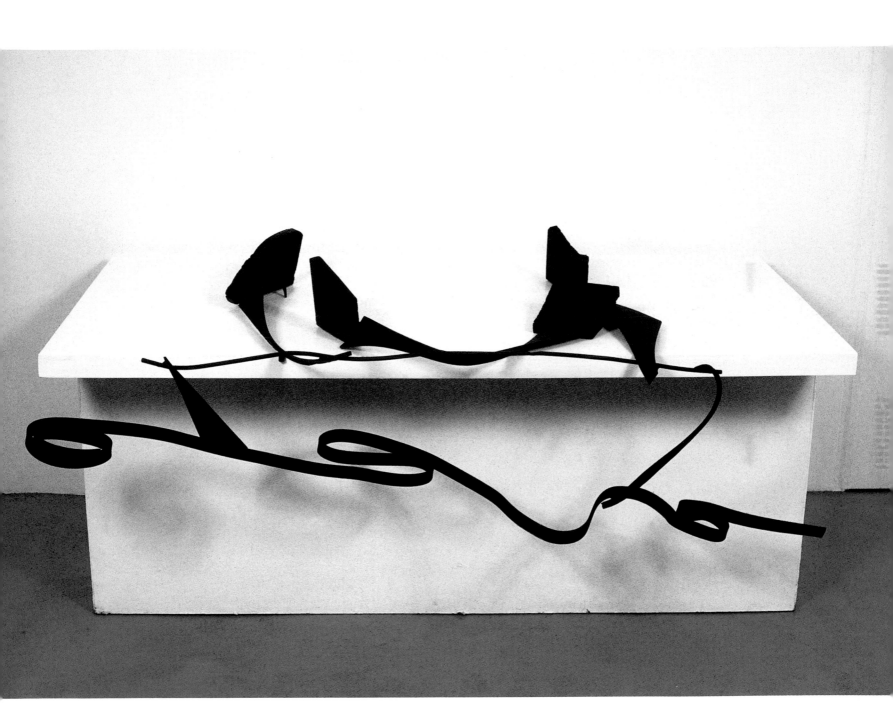

42 Silver Piece 1 (Jubilee)

1974
Silver
24.8 x 56.5 x 40 cm (9 ¾ x 22¼ x 15 ¾ in)
Caro Family Collection
(B633)

Caro's *Silver Pieces* were created when he began
experimenting with silver as a result of wanting to
create a 25th-wedding anniversary present for his wife,
Sheila Girling. Given the scale and thinness of the silver
elements, the *Silver Pieces* are smaller yet much more
complex in their linear composition then any previous table
sculptures to date. *Silver Piece 1 (Jubilee)*, the gift Caro
gave to his wife, swirls about the table, orbiting around
a central vortex, revelling in the light.

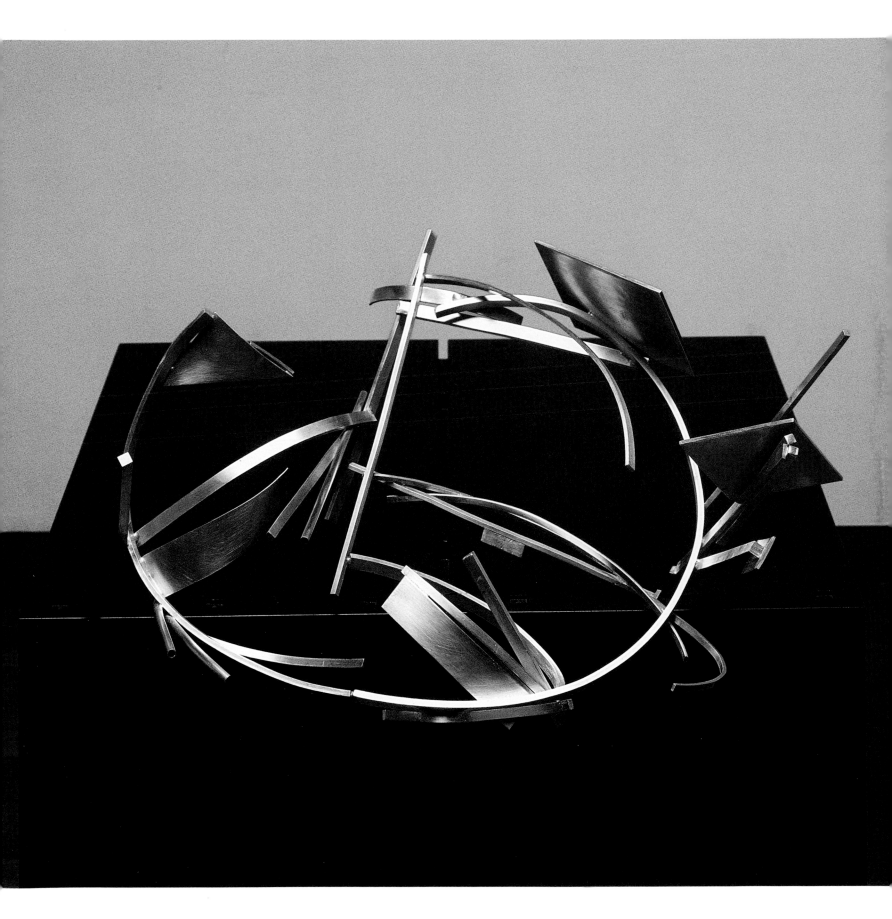

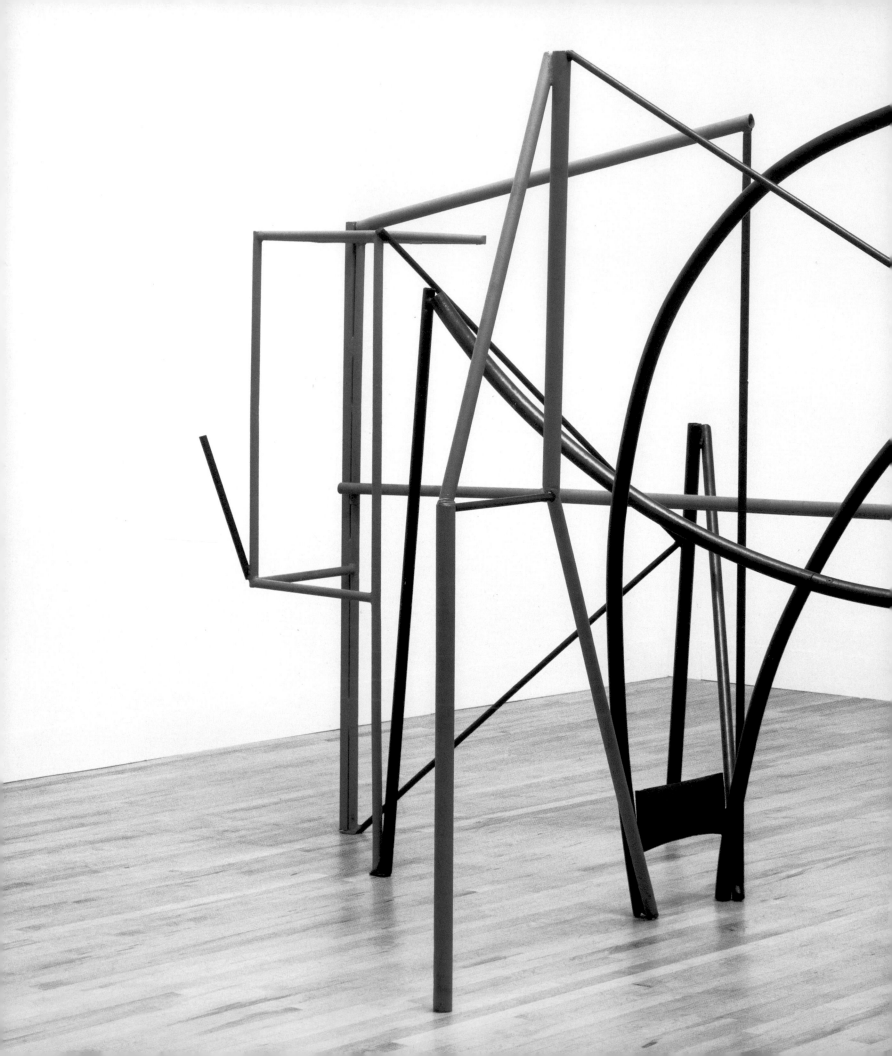

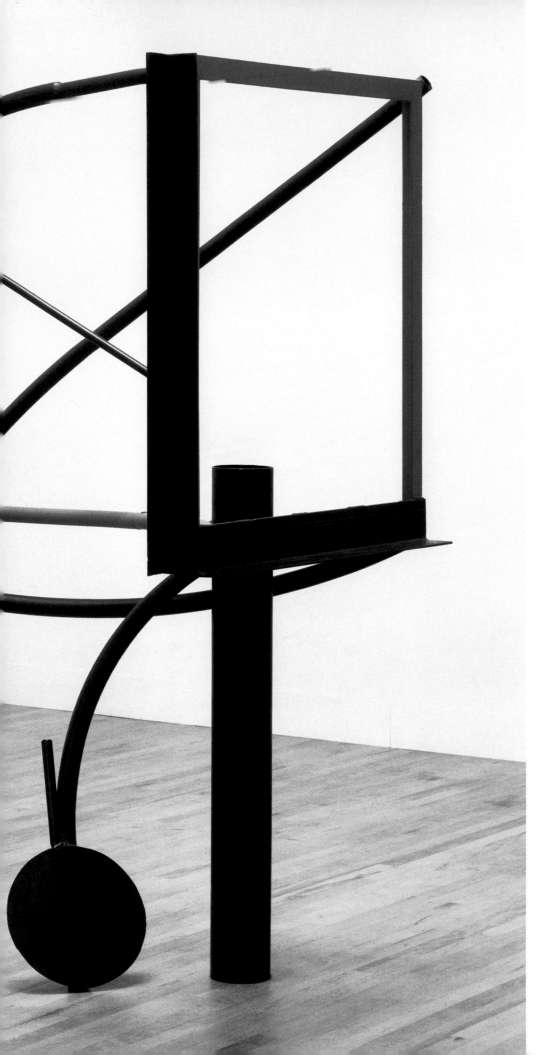

43 Emma Dipper

1977
Steel, rusted and painted grey
213.5 x 170 x 320 cm (84 x 67 x 126 in)
Tate Gallery, London
(B1173)

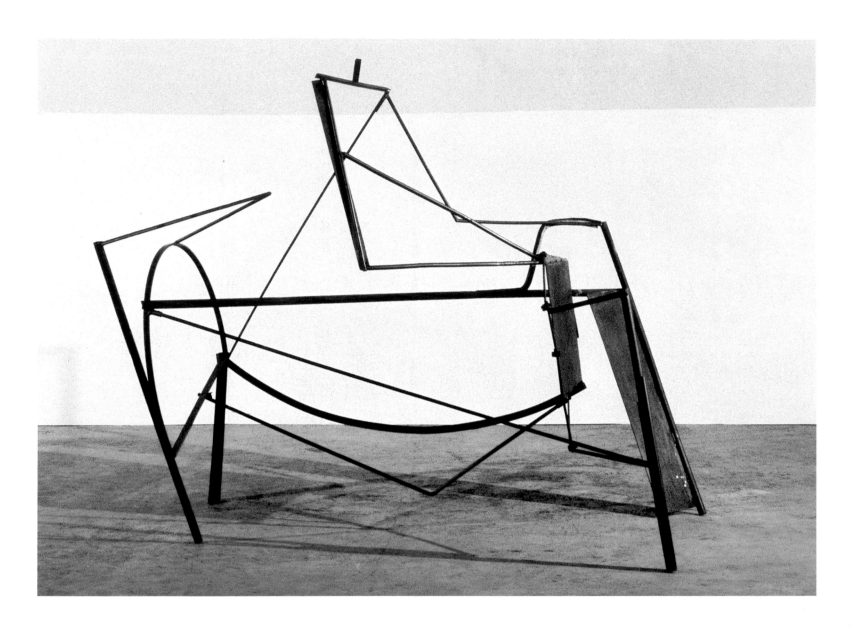

44 Emma Dance

1977–8
Steel, rusted, painted and blacked
240 x 249 x 282 cm (94½ x 98 x 111 in)
Caro Family Collection/Annely Juda Fine Art, London
(B1176)

Caro participated in a session of the Emma Lake Artists'
Workshop, located in a remote area in Saskatchewan,
Canada, in 1977. Emma Lake's isolated location meant it
was impossible to transport large, heavy materials to the
workshop, and the basic working environment provided
was devoid of any mechanised equipment. These limitations
had a direct influence on Caro's working process and
offered him the opportunity to explore drawing in space
in a new direction, which is exemplified in *Emma Dance*.

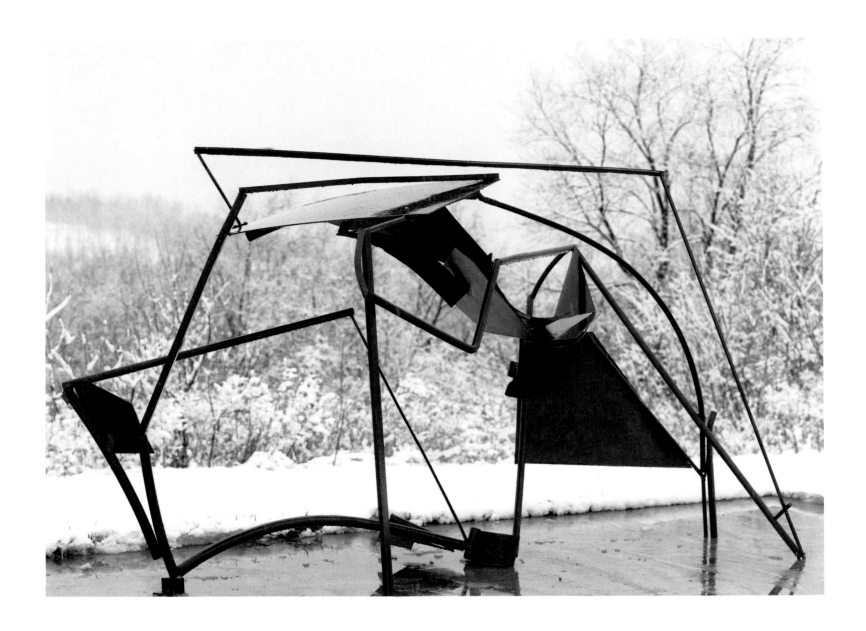

45　Emma Spread

1977–9
Steel
185.5 x 320 x 150 cm (73 x 126 x 59 in)
Private Collection, USA
(B1177)

The series of sculptures that Caro created at Emma Lake
are characterised by their cage-like exoskeletons that move
up and off the ground, and out into space. In comparison
to Picasso's wire constructions from the late 1920s (fig.14)
– which seem to be remote antecedents, albeit with major
differences in scale – sculptures such as *Emma Spread*
employ a more fluid approach to line, gracefully curving
and bending, outlining space as much as containing it.
Like earlier mesh pieces, the *Emma Lake* series offers
the viewer a study of both interior and exterior spaces.

46 Emma Scribble

1977–9
Steel, rusted and painted red
198 x 231 x 137 cm (78 x 91 x 54 in)
Musée d'Art Moderne de Saint-Étienne Métropole
(B1183)

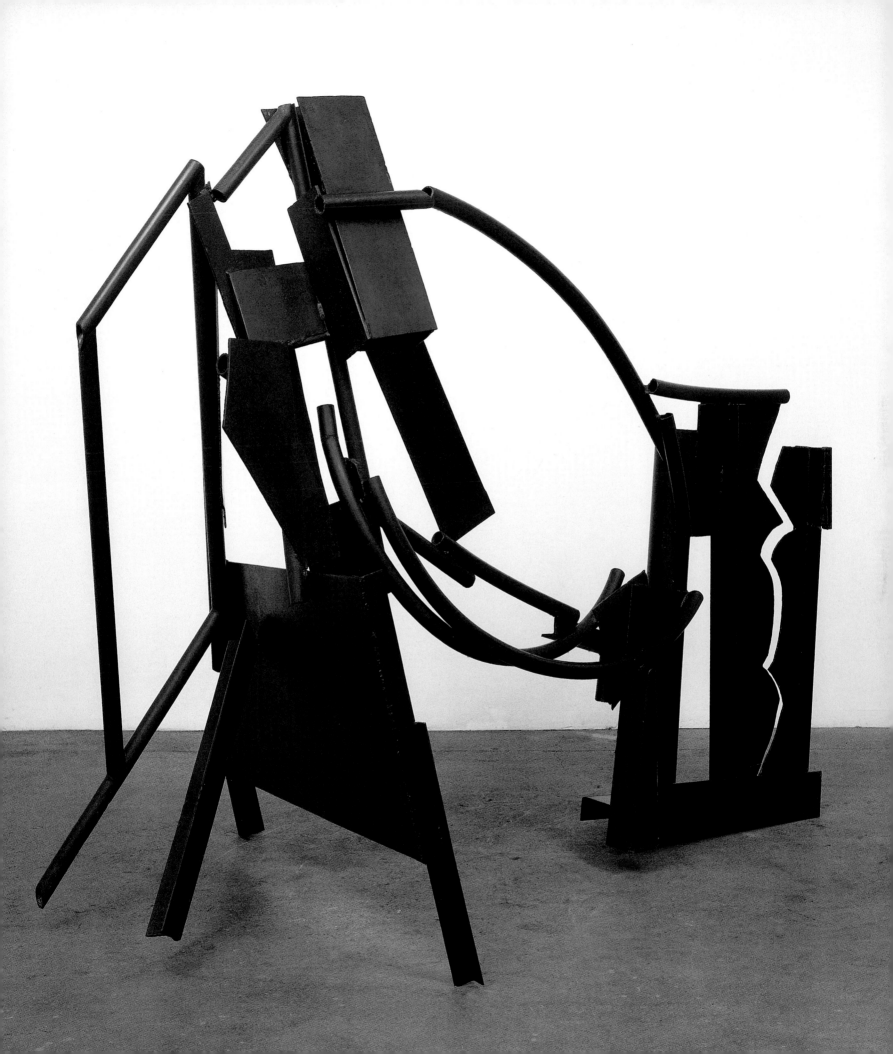

47 Table Piece CCCLXXXVIII

1977
Steel, rusted and varnished
102.9 x 111.8 x 53.3 cm (40½ x 44 x 21 in)
Scottish National Gallery of Modern Art
(B400)

On his return to London after his time at the Emma Lake
workshop in Saskatchewan, Caro created a series of *Table
Pieces* inspired by the works he had just recently composed.
With its cage-like appearance and thin, fluid lines, *Table
Piece CCCLXXXVIII* bears a striking similarity to *Emma
Dipper*. And, like the *Emma Lake* series, this *Table Piece* not
only outlines space, it defines it. With its highly calligraphic
overall composition, this sculpture prefigures the later
series of *Table Pieces* aptly called the *Writing Series*.

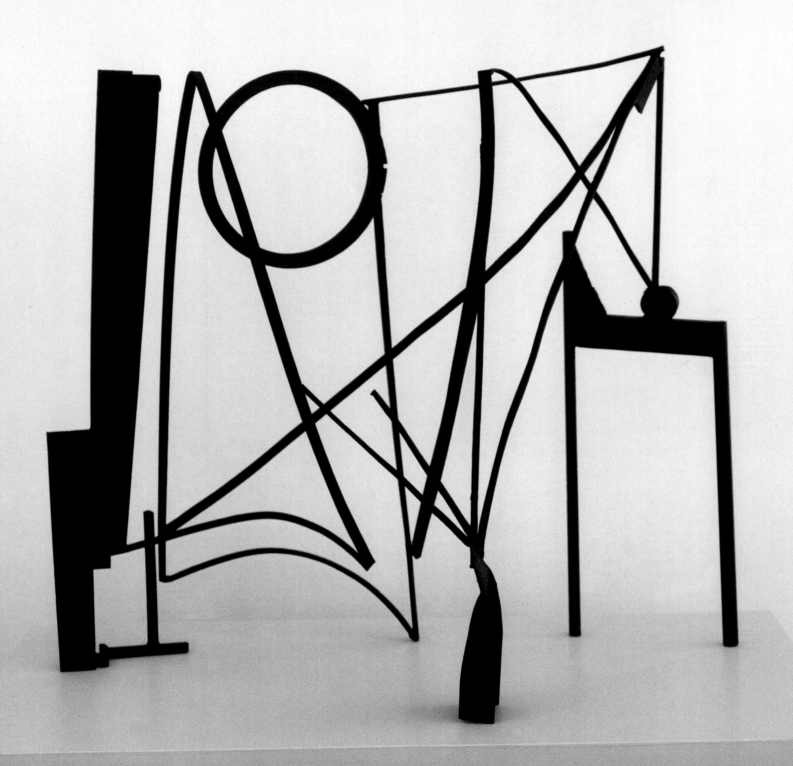

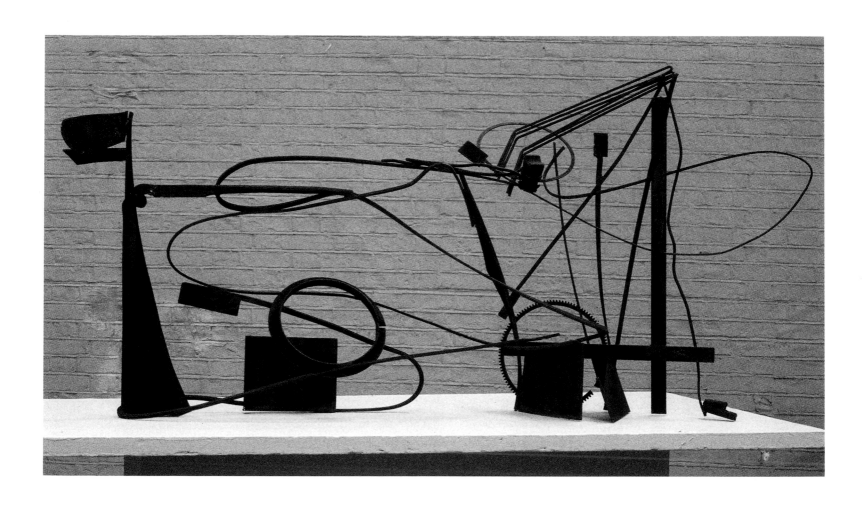

48 Table Piece CCCCXIV (Caro to Miró)

1977–8
Steel, rusted and varnished
90.2 x 188 x 55.9 cm (35½ x 74 x 22 in)
Successió Miró, Spain
(B431)

Table Piece CCCCXIV (Caro to Miró) is not a direct
reference to a work by Spanish artist Joan Miró but there
are certain shared sensibilities between this sculpture and
the work of the surrealist artist, as evident in the dangling,
biomorphic bits to the left of the piece, and the open circles
that are part of the composition. Caro frequently consults
the work of other artists to research ways of depicting
unexpected forms as 'real' as anything else we encounter
in the world. He has found that painting provides some
clues or ideas on what to do but no direct instructions
on how to do it – which he finds especially provocative.

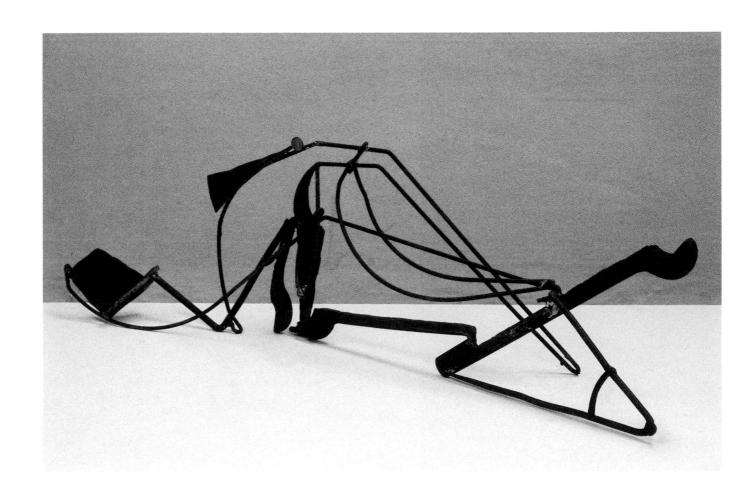

49 Writing Piece 'Does'

1979
Steel
35.6 x 109.2 x 26.7 cm (14 x 43 x 10½ in)
Private Collection, USA
(B504)

The *Writing Pieces* are a combination of Caro's experience
at the Emma Lake Artists' Workshop in Saskatchewan and
his constant engagement with his *Table Pieces*. Most of
the *Writing Pieces* are not as 'dependent' on the table edge
as are the earlier *Table Pieces*. As in *Writing Piece 'Does'*,
many of these works also include 'found objects' and studio
instruments such as wrenches, pincers, tongs, callipers,
hatchet blades, nuts and scissors. Here, line takes centre
stage and develops an even more fluid, cursive approach.
According to Caro, he called these works *Writing Pieces*
because for him 'they are like writing'.[1]

1 Caro to author, 25 November 2008.

50 Ceiling Piece A

1979
Steel, rusted and varnished
124.5 x 86.4 x 57.2 cm (49 x 34 x 22½ in)
(B555)

Created in tandem with the *Writing Pieces* are the *Ceiling Pieces*, which were intended to be suspended from above. *Ceiling Piece A* orients itself as a right-angled triangle, with one leg running parallel just below the ceiling and the other pointing straight down to the floor, ending with four delicate thread-like loops. The substance of the sculpture plays itself out within the hypotenuse angle. The *Ceiling Pieces* loom over us, and yet their delicate lines are reminiscent of spider webs. The overall presence of these sculptures is both familiar and uncomfortable.

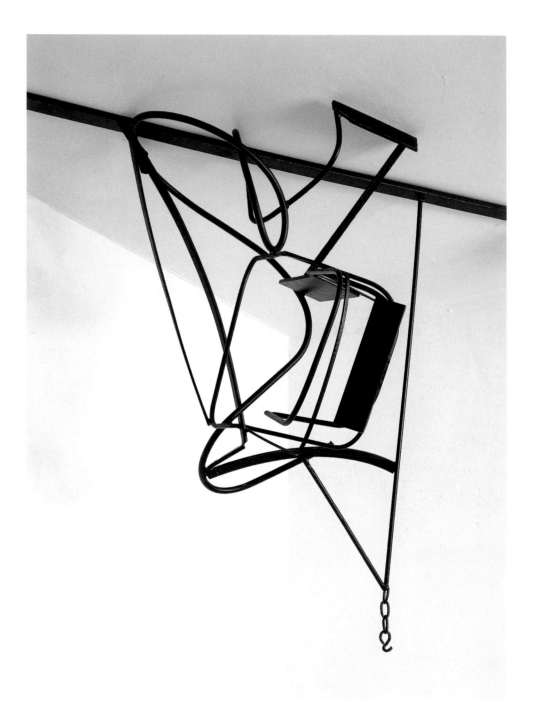

51 Ceiling Piece D

1979
Steel, rusted and varnished
142.2 x 106.7 x 61 cm (56 x 42 x 24 in)
(B558)

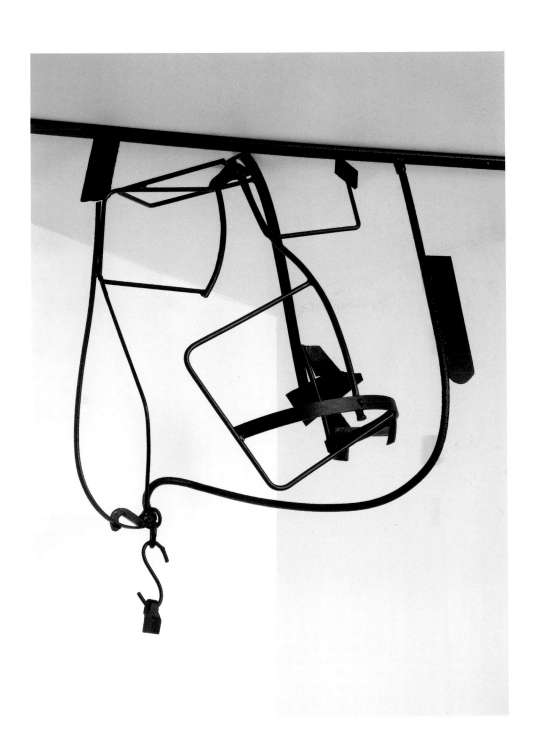

52 Paper Sculpture No.12

1981
Pencil, chalk, spray paint, handmade paper
on Tycore in wooden frame
80 x 64.8 x 15.2 cm (31½ x 25½ x 6 in)
Private Collection, Germany
(B1385)

Caro created a series of very sculptural, collaged and
relief-like works on paper in the early 1980s, which also
explored line moving through space. The process would
begin with the paper being dampened with a sizing agent
so when dry there was enough 'body' in the paper that it
could hold a form and shape. Caro would then draw lines
very assuredly on the wet paper and leave it to dry in a
three-dimensional form.

53 Paper Sculpture No.24 (As You Are)

1981
Pencil, acrylic, handmade paper on Tycore
97.2 x 61 x 10.2 cm (38¼ x 24 x 4 in)
Private Collection, USA
(B1396)

Delicate graphic lines curve across the surface, bending and
shifting with the folding of the paper of *Paper Sculpture
No.24 (As You Are)*. In this work, the viewer can take
note of the artist's various experiments with line: drawing,
folding, embossing, layering and collaging are all used to
investigate volume, form and most importantly positive
and negative space. The white areas of the paper oscillate
between foreground and background, inside and outside,
while the graphic lines harness this tension in a similar
fashion to Caro's linear sculptures.

54 Paper Sculpture No.98

1981
Pencil, chalk, acrylic, handmade paper, Tycore on cardboard
tubes filled with lead shot
76.2 x 38.1 x 40.6 cm (30 x 15 x 16 in)
(B1466)

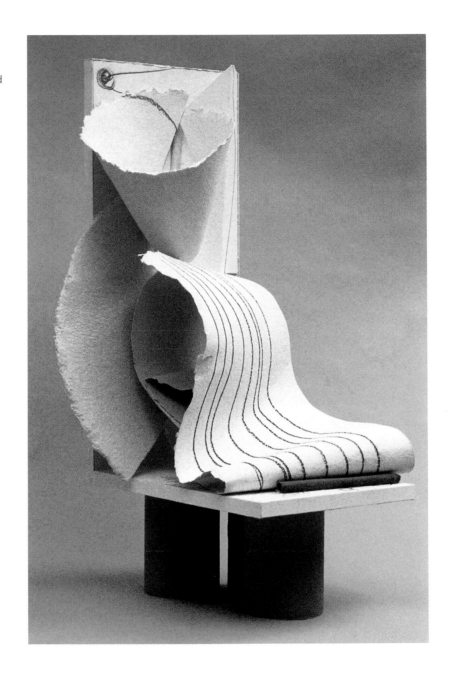

55 Egyptian Table

1986
Steel, rusted, blackened and varnished
151 x 130 x 53.5 cm (59½ x 51¼ x 21 in)
John and Eleanor Morris, Toronto
(B1804)

Overall, *Egyptian Table* is very substantial; however its
size imbues it with a figurative presence. Its impressive
'torso' is composed of a collage of various odd elements,
which all seem precariously perched on top of one another
evoking the fragility of a house of cards. The blackened
patina that covers the entire work unites its disparate
parts yet this harmony is disrupted by the broad use of line,
from bold and forceful to folded and undulating. The variety
of parts, shapes and lines, combined with positive and
negative space, makes *Egyptian Table* an incredibly
provocative sculpture.

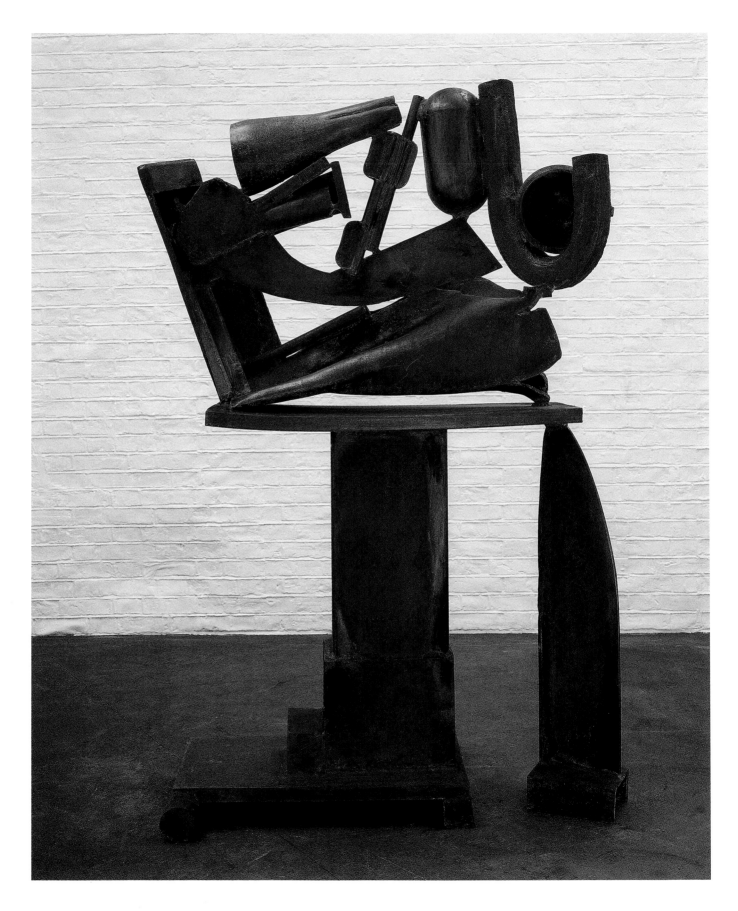

56 Mint Chiffon

1978-9
Bronze, cast and welded
137.2 x 83.8 x 61 cm (54 x 33 x 24 in)
Acquavella Contemporary Art
(B696)

Created before Caro participated in the special 'Art
Triangle Barcelona' workshop in 1987, *Mint Chiffon*'s
deconstructed xylophone shape evokes references to jazz –
forms that look like giant musical notations seem to hover
above and below. Due to this association, Caro's interest
in the work of Matisse can also be considered another
reference point for this sculpture, as evident in the
large solid curving shapes that are juxtaposed against
thin, straight angular lines. The sculpture also carries
certain vestiges of pieces such as *Serenade* (1970–71;
plate 39). However it is the central grate/table element
that anticipates the 'bench' works which Caro went on to
create in Barcelona.

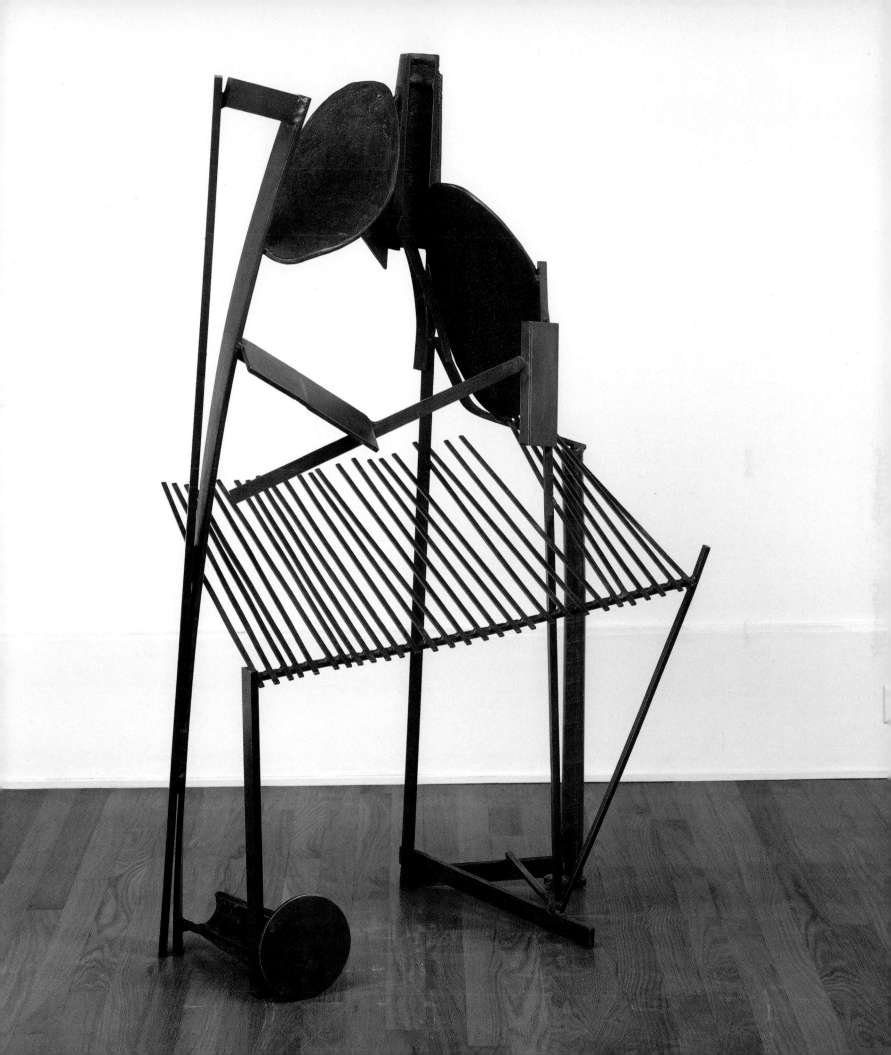

57 Barcelona Ballad

1987
Steel, rusted and waxed
249 x 238.5 x 104 cm (98 x 94 x 41 in)
Collection of the Tokyo Metropolitan Government
(B1884)

Caro produced his series of linear-styled works, the
Barcelona series, while participating in the 1987 'Art
Triangle Barcelona' workshop. His fascination with the
architecture of the city and the traditional Catalonian
art of wrought iron inspired him to create works such as
Barcelona Ballad. Caro would define a window-like outline
and then load up indiscriminately the interior space of the
sculpture with all sorts of pieces of found metal shapes,
grilles, gates, balcony railings, and other fragments of
typical structures from the Catalan city. Once he felt he
had something he would then begin taking away anything
that wasn't sculpture, paring down the piece to a series
of drawn lines that move through space.

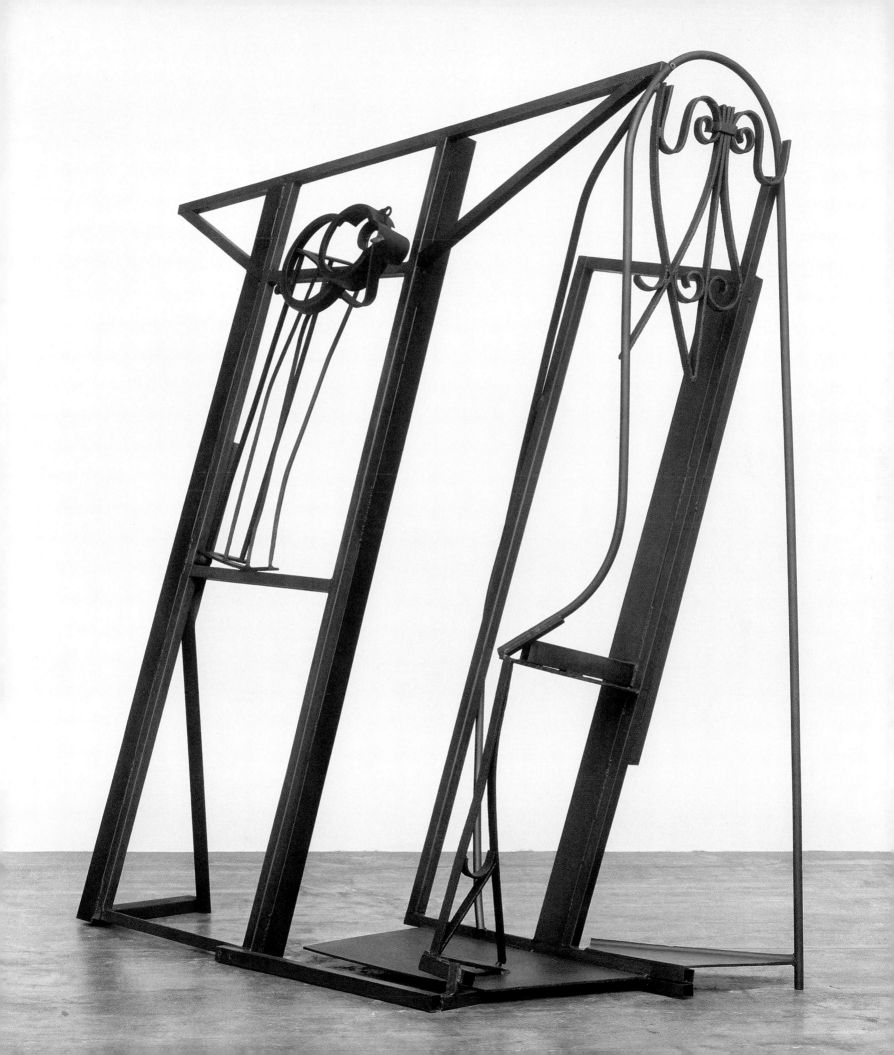

58 Barcelona Concert

1987
Steel, rusted and varnished
73.5 x 203 x 223.5 cm (29 x 80 x 88 in)
(B1899)

Barcelona Concert is an excellent example of a group
of bench-like works that were created in Barcelona in
tandem with the vertical 'window'-shaped sculptures.
Still maintaining the same approach, only this time
working on the horizontal, Caro would again pile up all
sorts of material, including heavy wrought-iron grilles laid
one on top of the other at differing angles, and then cut
back what was not needed. This resulted in the 'bench'
pieces having a more oppressive interior presence than
the openness possessed by the 'window' works.

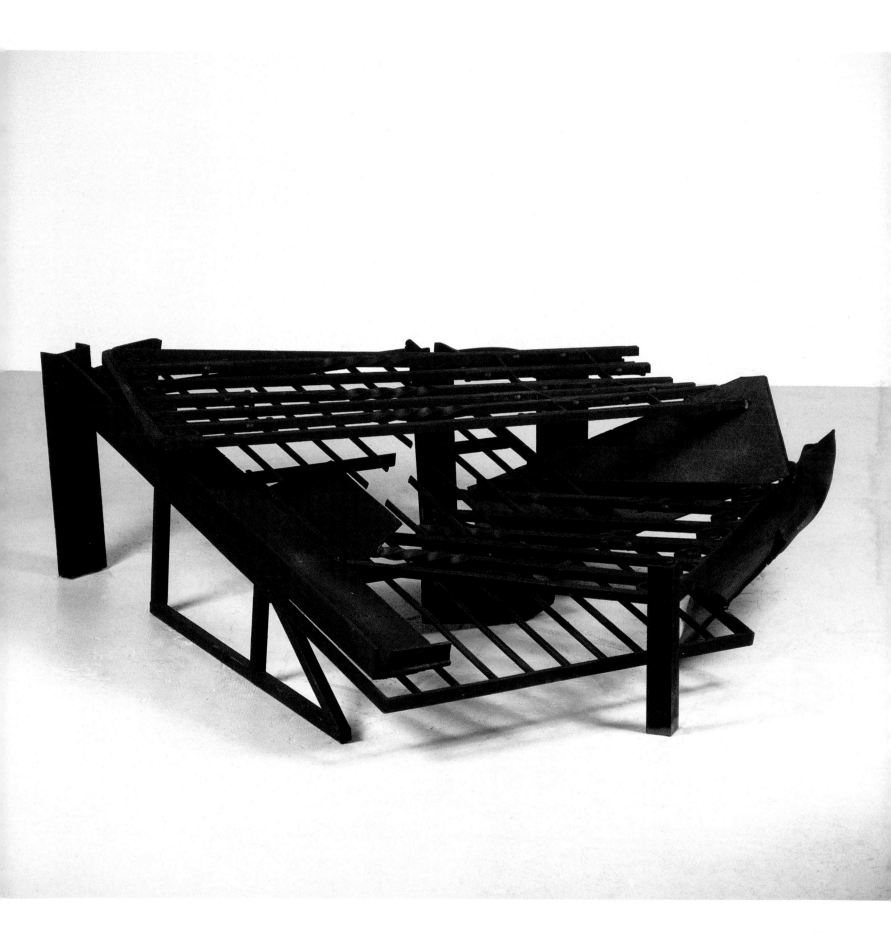

59 Barcelona Rose

1987
Steel, rusted and waxed
200.5 x 131 x 104 cm (79 x 51½ x 41 in)
Private Collection, Mallorca
(B1890)

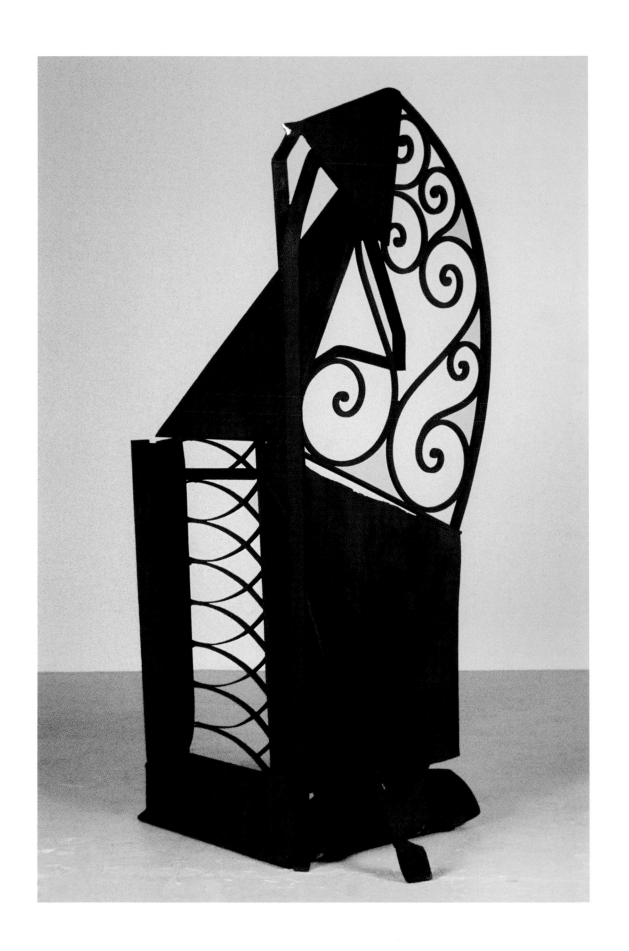

60 Table Piece 'Catalan Double'

1987–8
Steel, rusted and fixed
137 x 73.5 x 30.5 cm (54 x 29 x 12 in)
Hessisches Landesmuseum, Darmstadt
(B1842)

After his time in Barcelona, Caro was so taken with the scrap material he was working with that he had some of it shipped back to his London studio. As a result of this, and typical of his working habits, he created a series of *Table Pieces* all inspired by his time in Spain. *Table Piece 'Catalan Double'* reflects the more 'window' orientation approach the artist used to create large-scale works. Somewhat unusual for Caro, *Table Piece 'Catalan Double'* was enlarged and put through a series of changes to create one of Caro's largest public sculptures, *Sea Music* (1991; plate 61).

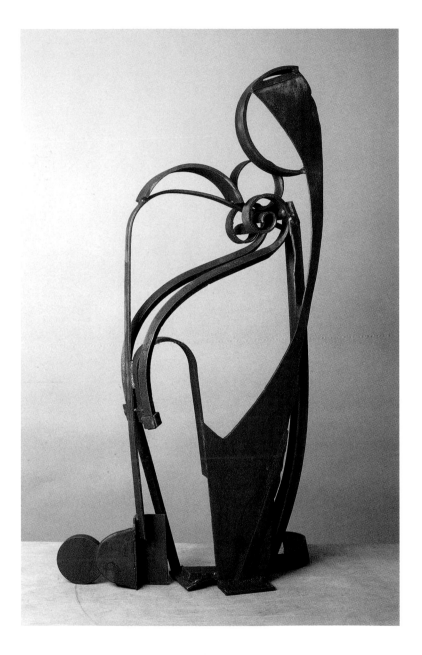

61 Sea Music

1991
Steel, painted blue, handrail galvanised steel
1125 x 1699 x 465 cm (443 x 669 x 183 in)
Borough of Poole
(B2201)

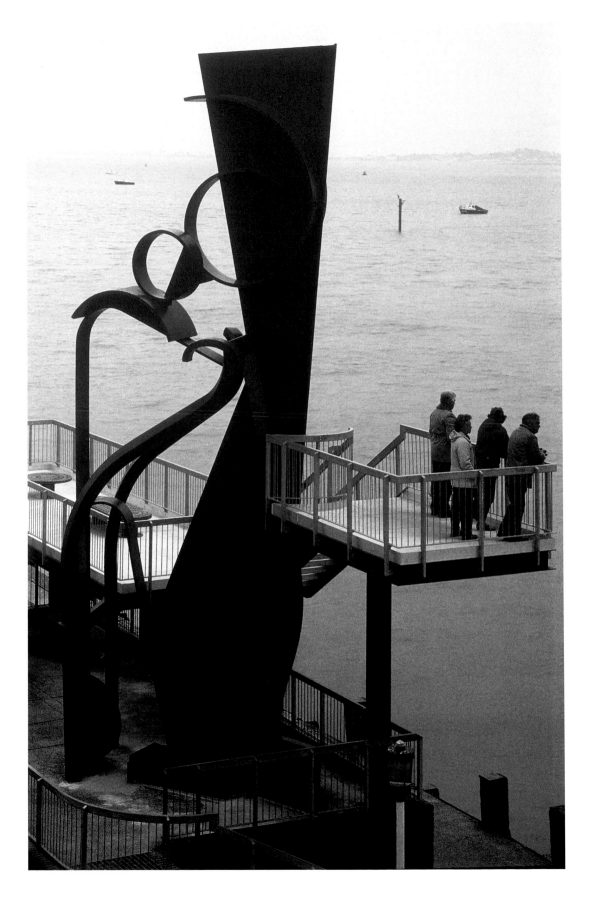

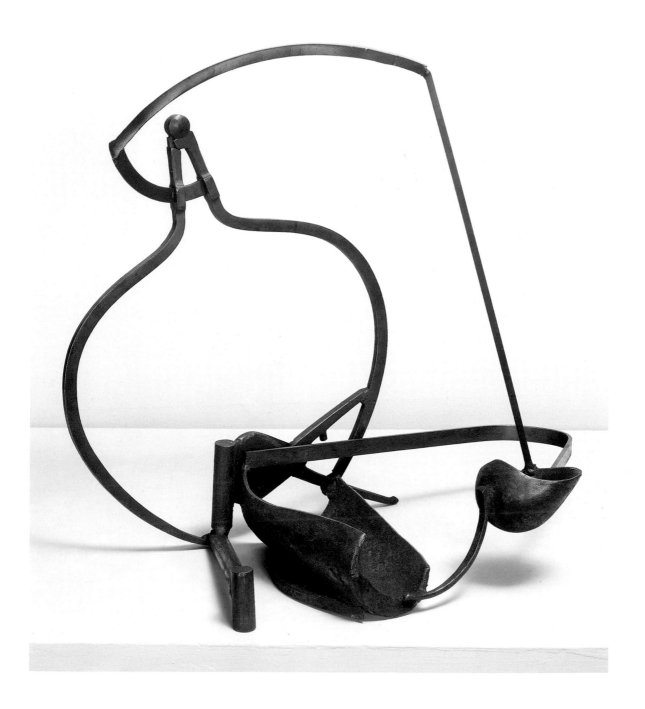

62 Writing Piece 'Cross Wind'

1988–9
Steel, rusted and painted
61 x 66 x 37 cm (24 x 26 x 14½ in)
Collection Seigfried Weishaupt
(B1952)

63 Writing Piece 'She's Terrified'

1988–9
Steel, rusted and waxed, and wood
76 x 51 x 29 cm (30 x 20 x 11½ in)
Daimler Contemporary, Berlin
(B1954)

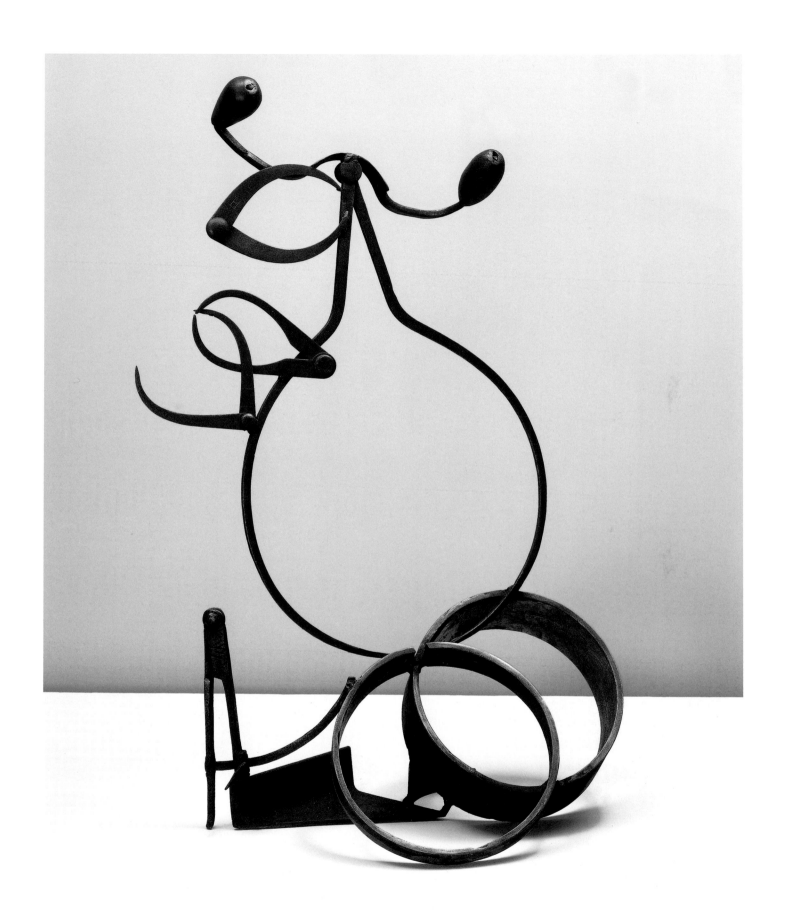

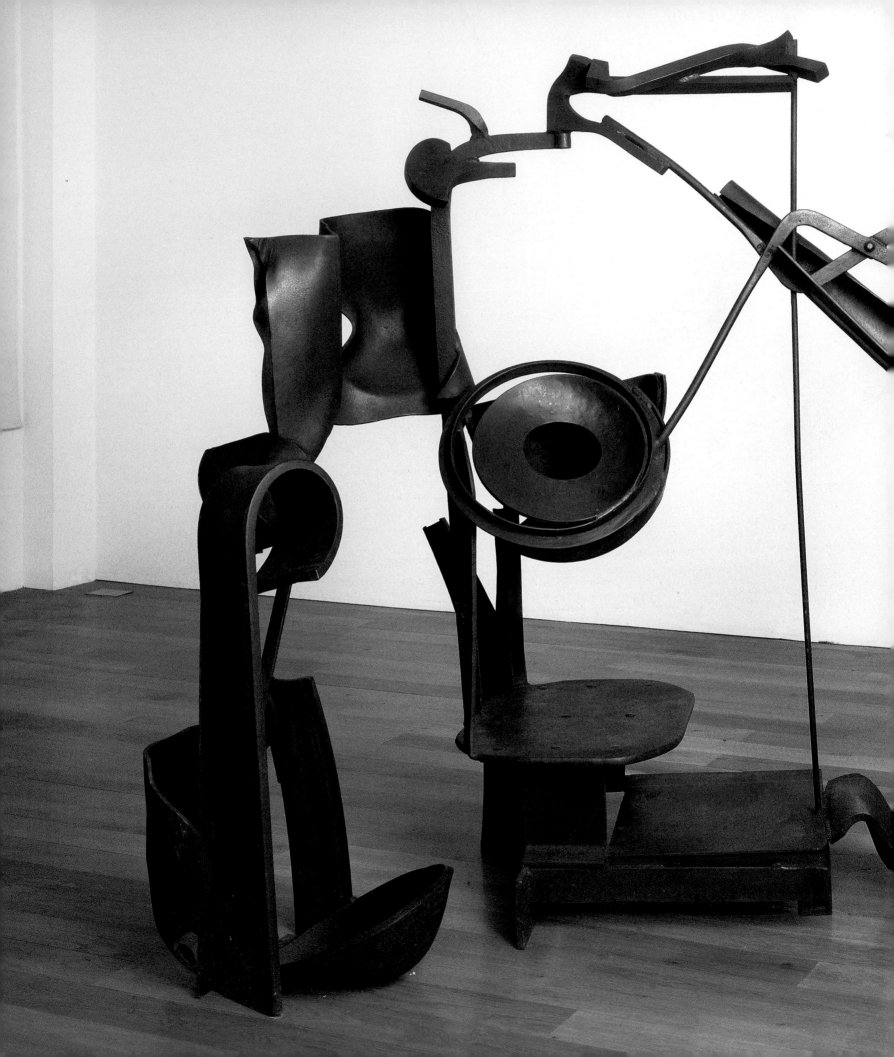

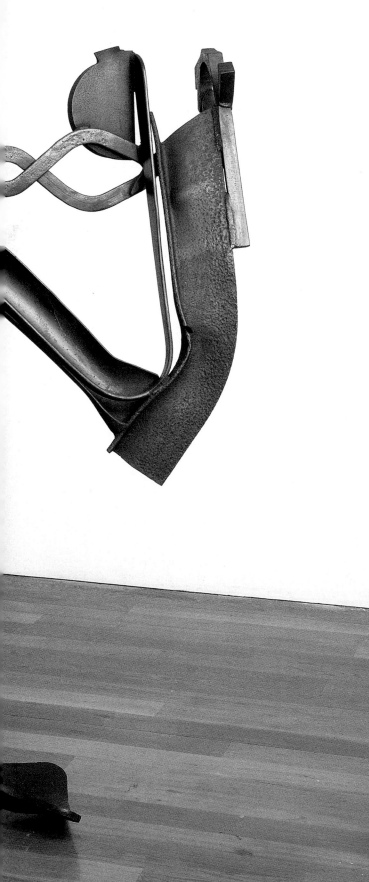

64 Medusa

1989
Steel, waxed
180.5 x 198 x 119.5 cm (71 x 78 x 47 in)
Private Collection, USA
(B2068)

In *Medusa* Caro takes his love of line and expands it, creating an increasingly more complex composition where steel is twisted, bent and rolled, transforming it into a work that seems to defy logic. On one side of the sculpture the balance of the drawing is suspended in mid-air, floating, all the while still seeming to expand, while the opposing side is forcefully connected and rooted to the floor with its collage of heavy feet that anchor the entire piece. An inherent tension is embodied in *Medusa*, where delicate lines are juxtaposed against massive, solid shapes; one part of the work wants to fly in the wind while another appears to be growing out from the floor below.

65　Hermes (*The Trojan War* series)

1993–4
Stoneware and steel
119.5 x 56 x 30.5 cm (47 x 22 x 12 in)
Private Collection, USA
(B2269)

Some sculptures from Caro's *Trojan War* series evidently incorporate the sculptor's sense of drawing in space, in particular the piece *Hermes*. The subject matter and the stylisation recall Caro's early *Warrior* monotypes from 1953 to 1954. Here Caro has stripped back the body of the work to just the whisper of a few lines. These thin elegant lines remarkably support the imposing head that dominates the entire work. Although arguably not intended as such a direct reference, there is a certain sway in the body lines, a shifting of weight, recalling the contrapposto stance of classical Greek sculptures.

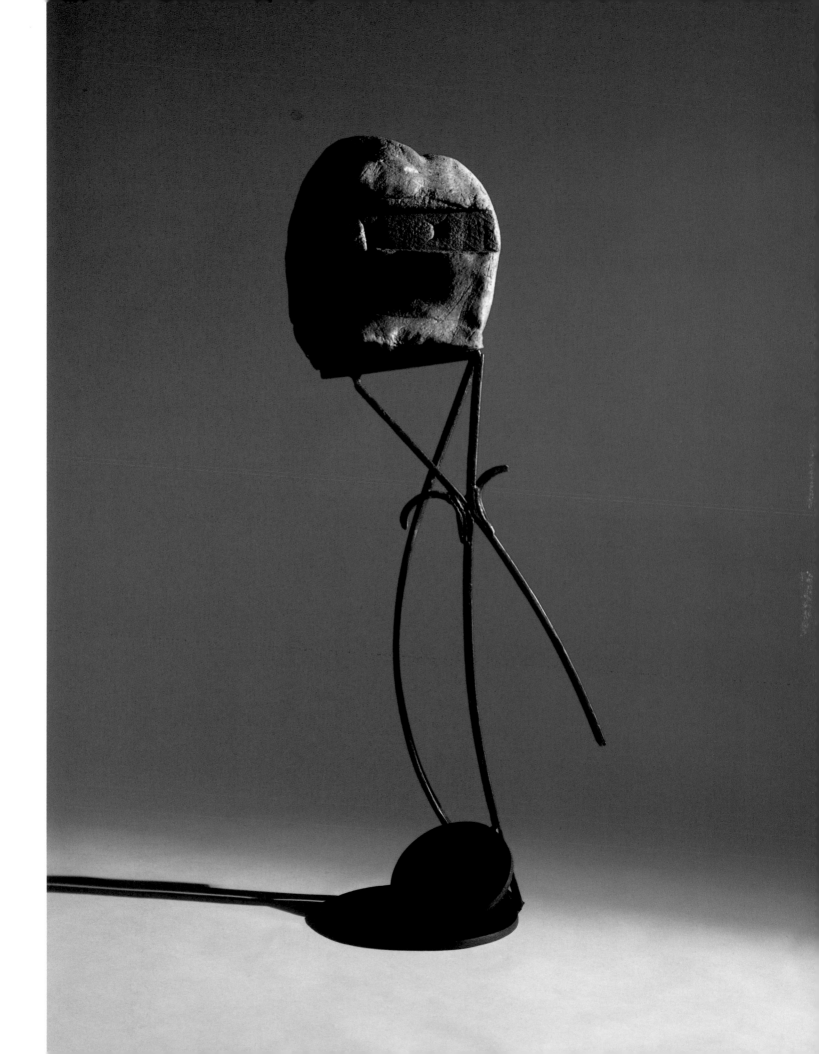

66 Xanthos (*The Trojan War* series)

1993–4
Stoneware and steel
178 x 31.5 x 67.5 cm (70 x 12½ x 26½ in)
(B2272)

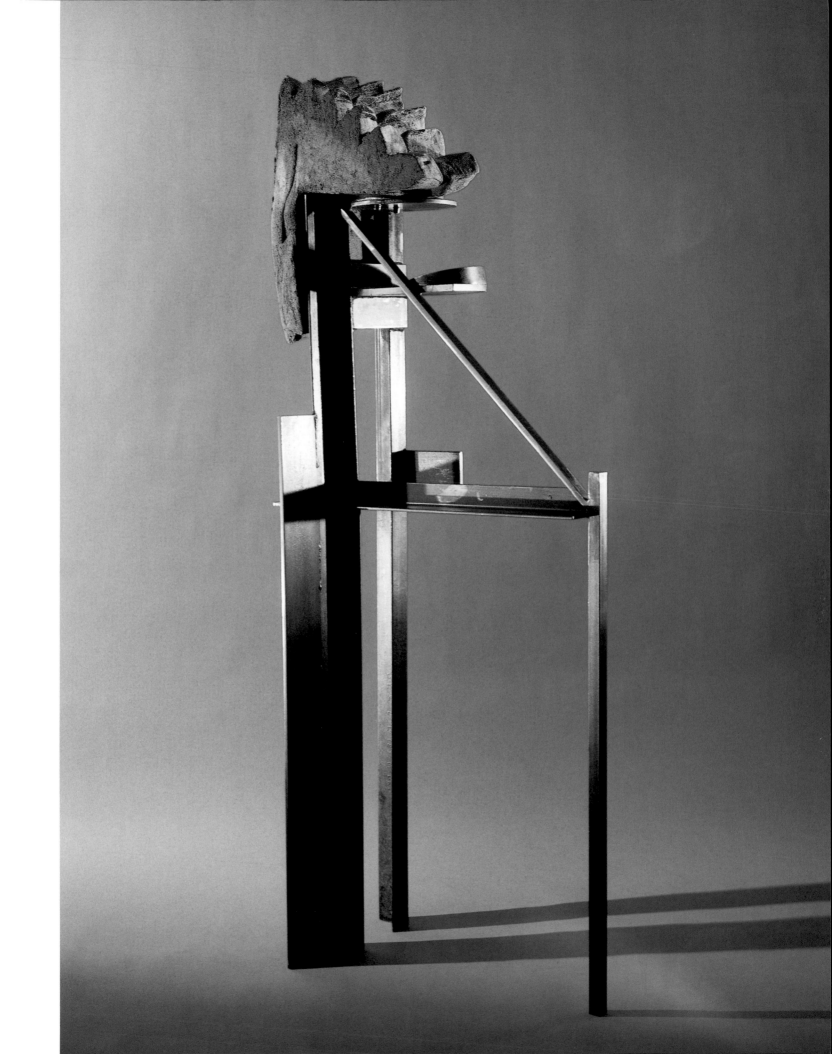

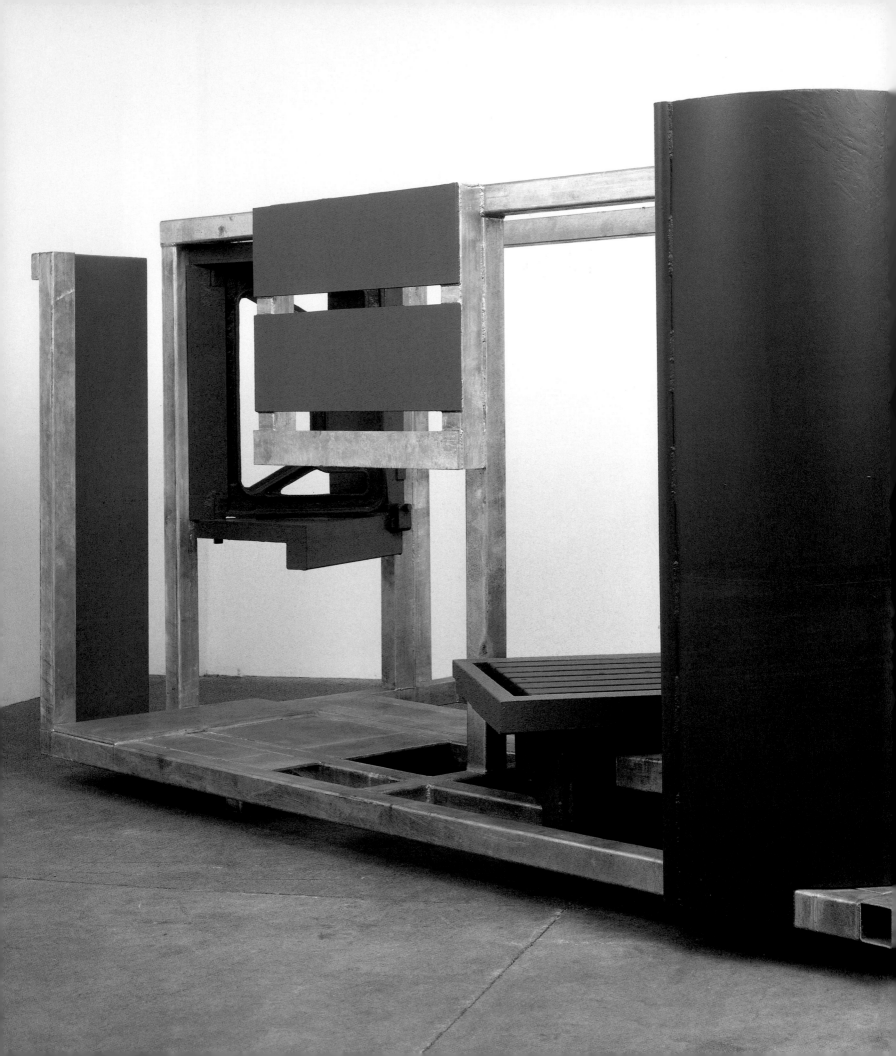

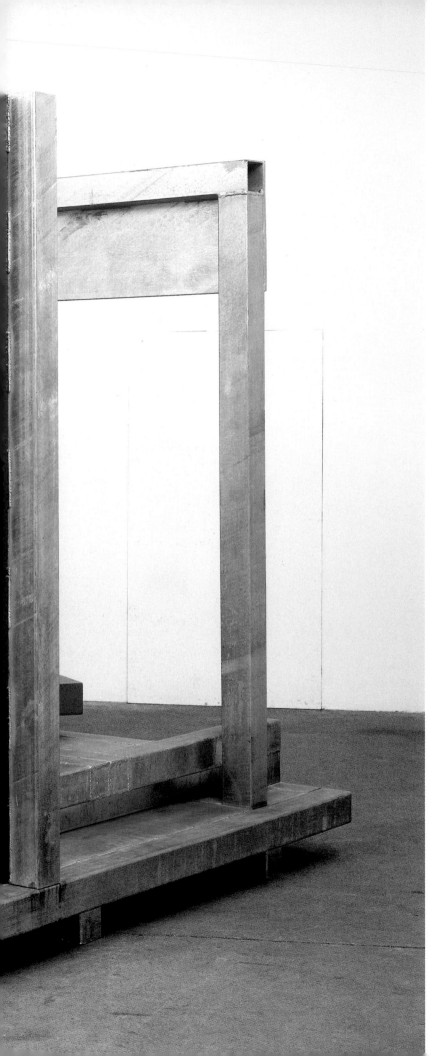

67 Magnolia Passage

2005–6
Steel and cast iron, galvanised and painted
222 x 401 x 236 cm (87½ x 158 x 93 in)
(T0037)

Caro's most recent body of work is based on the idea of passageways, but, as typical with most of his creations, one cannot physically move through these passages. The transition from interior to exterior, from threshold to exit, can only be performed via one's eyes and mind. *Magnolia Passage* is consistent with Caro's working method, where he collages and abstracts industrial materials, equalising their skins, this time through the process of applying a zinc-galvanised coating, and incorporating painted elements to punctuate and highlight certain aspects of the overall composition. With its clean bold lines that divide and enclose, this piece is similar in fashion to Caro's earlier 'mesh' works of the mid-1960s.

68 Kettle Drum

2006
Steel and cast iron, galvanised and painted
195.6 x 221 x 134.6 cm (77 x 87 x 53 in)
(T0039)

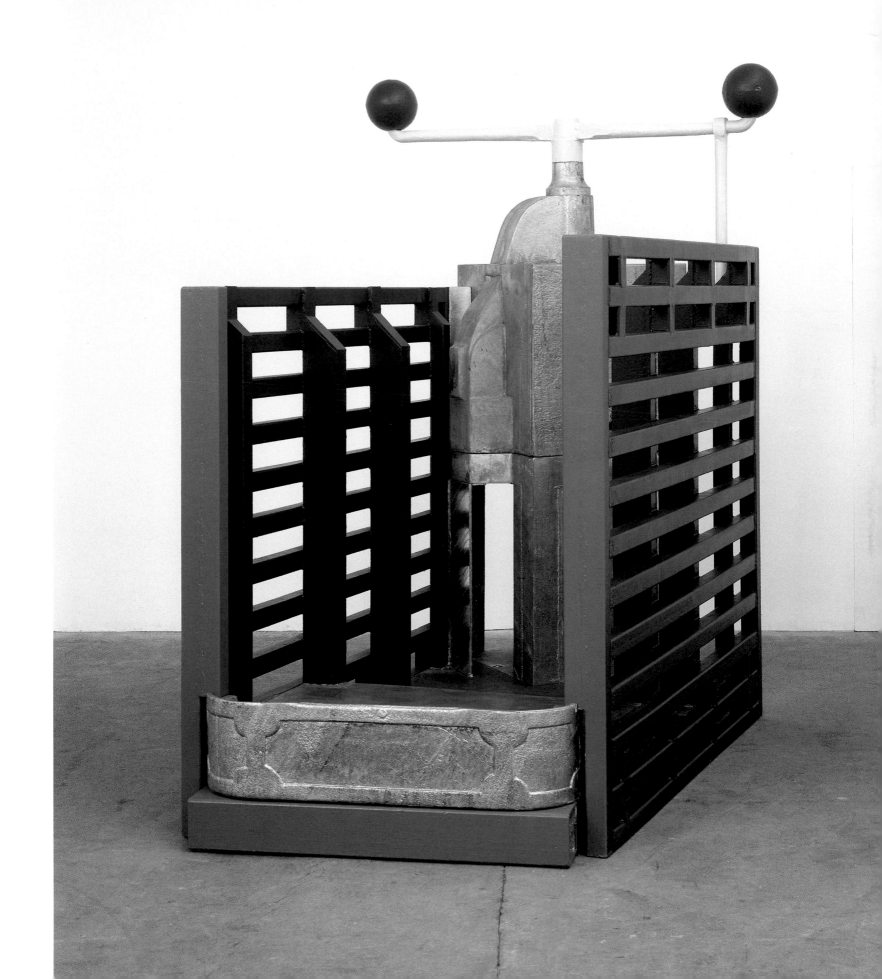

69 The Yellow Room

2005–6
Steel and cast iron, galvanised and painted
186.5 x 230 x 180 cm (73½ x 90½ x 71 in)
(T0043)

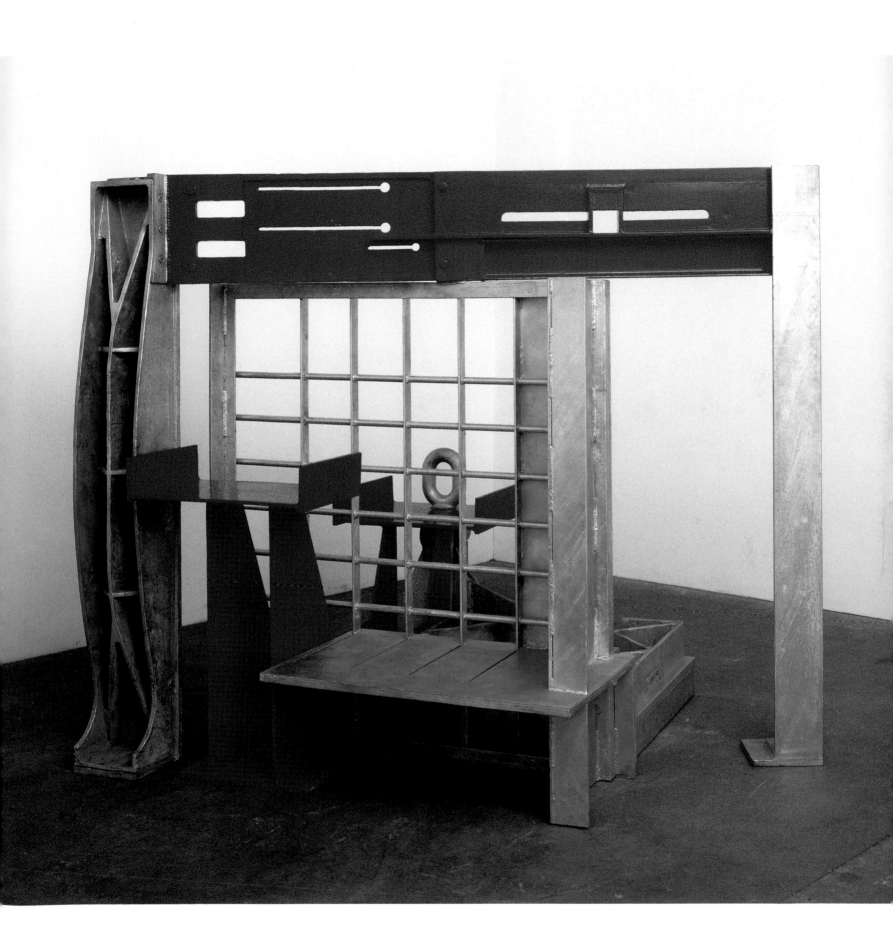

70 Long Passage

2007
Steel, galvanised and painted
143 x 698 x 134 cm (56¼ x 275 x 52¾ in)
(T0048)

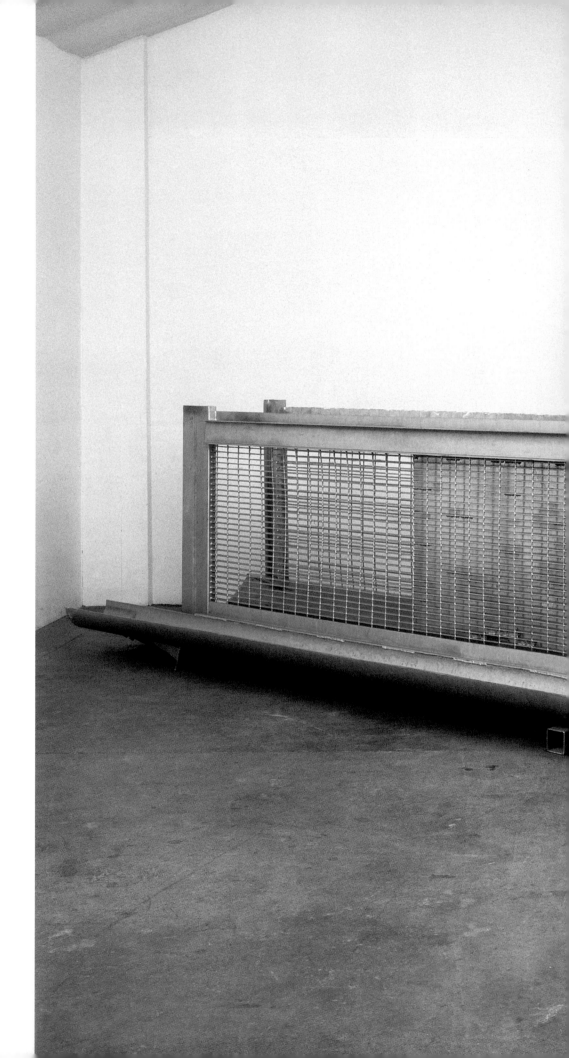

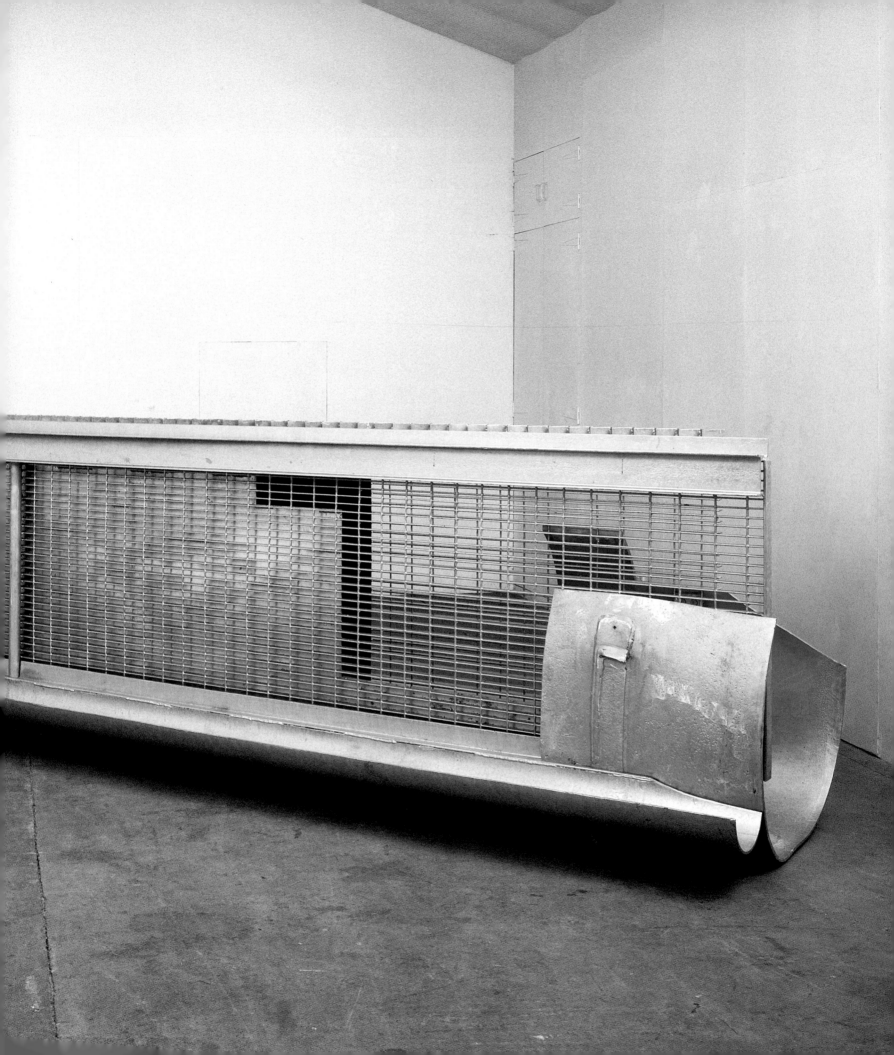

Anthony Caro: Chronology

1924 Born 8 March, New Malden, Surrey, son of Alfred and Mary Caro

1937–42 Attended Charterhouse School, Godalming, Surrey

1942–4 Studied Engineering at Christ's College, Cambridge. During vacations attended Farnham School of Art and worked in studio of sculptor Charles Wheeler

1944–6 Served in Fleet Air Arm of Royal Navy

1946–7 Attended Regent Street Polytechnic, studying sculpture with Geoffrey Deeley

1947–52 Received academic training at Royal Academy Schools, London, taught by several sculptor Royal Academicians (Siegfried Charoux, Alfred Hardiman, Maurice Lambert, William McMillan, F.E. McWilliam and Charles Wheeler). Awarded silver medals for clay figure modelling and carving, and a bronze medal for composition

1949 Married the painter Sheila Girling. Two sons: Timothy (*b*.1951) and Paul (*b*.1958)

1951–3 Worked as part-time assistant to Henry Moore

1953–81 Taught two days a week at St Martin's School of Art, London, where his students included David Annesley, Michael Bolus, Richard Deacon, Barry Flanagan, Hamish Fulton, Gilbert & George, Phillip King, Richard Long, Tim Scott, William Tucker and Isaac Witkin

1954 Moved to Hampstead, London

1955 Two figurative sculptures included in group exhibition *New Painters and Painter-Sculptors*, Institute of Contemporary Arts, London

1956 First one-man exhibition, at Galleria del Naviglio, Milan

1957 First one-man exhibition in London, at Gimpel Fils Gallery

1958 *Man Taking Off His Shirt* (1955–6) exhibited at the Venice Biennale as part of the invitational exhibition in the Palazzo Centrale; also invited were British painters Sandra Blow and Alan Davie

1959 Met Clement Greenberg in London; subsequent conversations and studio visits over many years were a great influence on Caro's approach and attitude to art

First visit to the USA; met sculptor David Smith and painter Kenneth Noland, among other progressive American artists

1960 Made first abstract sculptures in steel

1961 Made first polychrome sculpture, *Sculpture Seven*

1963 Large one-man exhibition of 15 abstract steel sculptures at Whitechapel Art Gallery, London

1963–5 Taught at Bennington College, Vermont, alongside painters Jules Olitski, Paul Feeley and Peter Stroud

1964 First one-man exhibition in New York, at André Emmerich Gallery

1966 Exhibited in the British Pavilion at the Venice Biennale alongside painters Richard Smith, Harold Cohen, Bernard Cohen and Robyn Denny in an exhibition entitled *Five Young British Artists*

Following conversations with Michael Fried Caro started to make small sculptures, *Table Pieces*

First exhibition at the David Mirvish Gallery, Toronto, Canada

1967 Retrospective exhibition at the Rijksmuseum Kröller-Müller, Otterlo, Netherlands

1969 Retrospective exhibition at the Hayward Gallery, London, consisting of 50 works made 1954–68

Made a Commander of the Order of the British Empire

1970 on Worked each year for short periods at Kenneth Noland's studio in Vermont

1974 Worked at York Steel Company factory in Toronto making large sculptures using heavy steel-handling equipment. Returned many times over the next two years, completing 37 sculptures later known as the *York Pieces*

1975 Retrospective exhibition at the Museum of Modern Art, New York (which later travelled to the Walker Art Center, Minneapolis, Museum of Fine Arts, Houston, and Museum of Fine Arts, Boston)

1977 Retrospective exhibition of *Table Pieces* organised by the British Council toured to Israel, Australia, New Zealand and Germany

Artist in residence at Emma Lake Artists' Workshop, University of Saskatchewan, Saskatoon, Canada; sculptures made there were later known as the *Emma Lake* series

1978 Made first *Writing Pieces*: small calligraphic sculptures in steel

Executed commission for architect I.M. Pei's new East Wing building of the National Gallery of Art, Washington, DC

1981 Made a series of sculptures in handmade paper with Ken Tyler and Tyler Graphics, New York

1982 Together with Robert Loder, organised the first Triangle Artists' Workshop for 30 sculptors and painters from the USA, UK and Canada at Pine Plains, State of New York (participating annually thereafter until 1991)

1984 60th birthday solo exhibition at the Serpentine Gallery, London (which later toured to Manchester, Leeds, Copenhagen, Düsseldorf and Barcelona)

Completed first sculpture with an architectural dimension: *Child's Tower Room*

1987 Participated in special Triangle Artists' Workshop in Barcelona and started *Barcelona* series, which he later returned to Spain to finish

Participated in Triangle Artists' Workshop, Pine Plains, State of New York, devoted to collaboration with architects. Caro and Sheila Girling worked with the architect Frank Gehry and Gehry's assistants, Susan Nardulli and Paul Lubowicki, on a 'sculpture village'

Completed *After Olympia* in London, his largest sculpture to date

Was made a Knight Bachelor in the Queen's Birthday Honours

1988 Started a series of 33 table sculptures made from steel elements brought back from the Barcelona workshop to Caro's London studio: the *Catalan* series

1989 Retrospective exhibition at Walker Hill Art Center, Seoul. Caro visited Korea and India

First solo exhibition at Annely Juda Fine Art, London, entitled *Aspects of Anthony Caro*

1991 Exhibition of four recent large sculptures in the Duveen Galleries of Tate, London (*After Olympia*, *Tower of Discovery*, *Xanadu* and *Night Movements*)

1992 Retrospective exhibition in the ancient Trajan's Market, Rome

1993 Worked for the first time with the ceramicist Hans Spinner, in Grasse, France, on stoneware elements that would become part of *The Trojan War*. Future collaborations with Spinner would produce elements incorporated into *The Last Judgement*, *The Barbarians*, the *Kenwood Series* and the *Chapel of Light*

1994–5 Several exhibitions organised to celebrate the artist's 70th birthday, including *Sculpture through Five Decades* at Annely Juda Fine Art, London (which later toured to Düsseldorf and Seoul)

The Trojan War (1993–4) exhibited at The Iveagh Bequest, Kenwood, London, and Yorkshire Sculpture Park, Wakefield

1996–7 With architect Norman Foster and engineer Chris Wise, Caro won the competition for a new footbridge spanning the Thames from St Paul's to Tate Modern at Bankside, London (completed 2000)

1998 *Caro – Sculpture from Painting* exhibited at the National Gallery, London

1999 *The Last Judgement* (1996–9), a 25-part sculpture in terracotta, wood and steel, shown at the 48th Venice Biennale

2000 Received the Order of Merit from the Queen

2002 *The Barbarians* (1999–2002), a group of mythical horsemen assembled from stoneware, wood and steel, first shown at Mitchell-Innes & Nash, New York

2004 Caro's 80th birthday marked with a display of *Sculpture Two* (1962) outside Tate Britain and exhibitions all over the world, as well as the publication of several new books, television programmes and extensive newspaper coverage

The *Kenwood Series* (2003–4), a group of allusive still-life tables, exhibited at The Iveagh Bequest, Kenwood, London

2005 Major retrospective at Tate Britain, covering all principal phases of Caro's career, from the 1950s to the present. Included was a huge new architectural commission for the South Duveen Gallery, *Millbank Steps* (2004)

2007 Joint exhibition with Sheila Girling at the New Art Centre, Wiltshire

Passages series and other important works made 2003–7 exhibited at Annely Juda Fine Art, London, and Mitchell-Innes & Nash, New York

2008 Inauguration of Caro's *Chapel of Light* at the church of St John the Baptist, Bourbourg, France, accompanied by museum exhibitions in Calais, Gravelines and Dunkirk

Index

Picture Credits